KT-571-621

062461

THE HENLEY COLLEGE LIBRARY

PAPER AND INK WORKSHOP

Printmaking Techniques Using a Variety of Methods and Materials

JOHN FOSTER

Rockport Publishers
100 Cummings Center, Suite 406L
Beverly, MA 01915

rockpub.com • rockpaperink.com

© 2014 Rockport Publishers

First published in the United States of America in 2014 by
Rockport Publishers, a member of
Quayside Publishing Group
100 Cummings Center
Suite 406-L
Beverly, Massachusetts 01915-6101
Telephone: (978) 282-9590
Fax: (978) 283-2742
www.rockpub.com
Visit RockPaperInk.com to share your opinions, creations,
and passion for design.

All rights reserved. No part of this book may be reproduced
in any form without written permission of the copyright owners.
All images in this book have been reproduced with the knowledge
and prior consent of the artists concerned, and no responsibility
is accepted by producer, publisher, or printer for any infringement
of copyright or otherwise, arising from the contents of this
publication. Every effort has been made to ensure that credits
accurately comply with information supplied. We apologize
for any inaccuracies that may have occurred and will resolve
inaccurate or missing information in a subsequent reprinting
of the book.

10 9 8 7 6 5 4 3 2 1

ISBN: 978-1-59253-860-7

Digital edition published in 2014
eISBN: 978-1-61058-944-4

Library of Congress Cataloging-in-Publication Data

Foster, John, 1971-
 Paper & ink workshop : printmaking techniques using a variety
of methods and materials / John Foster.
 pages cm
 ISBN 978-1-59253-860-7 (pbk.)
 1. Prints--Technique. I. Title. II. Title: Paper and ink workshop.
 NE860.F67 2013
 769'.4--dc23

 2013023747

Design: John Foster at badpeoplegoodthings.com
Cover Image: background detail by Seripop

Printed in China

CONTENTS

THE HENLEY COLLEGE LIBRARY

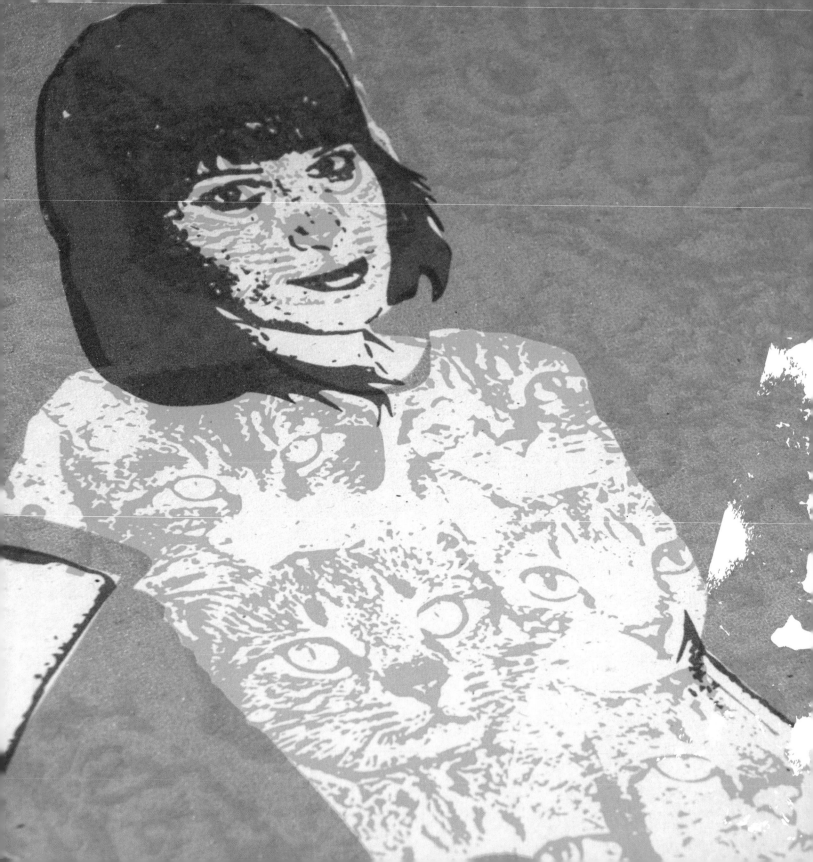

INTRODUCTION

Have you ever wondered how that print hanging on your wall was created, how those cards you just bought on Etsy came to be, or what cutting-edge artists are using to enthrall audiences? Do you wonder how you could use those same techniques to improve your work or possibly even launch your own business? It is all right here! We'll give you a crash course in the history of small-press printing and take you behind the scenes with many of the world's leading creatives as they show you how they brought their prints to life using silk screening, letterpress, woodblock, and equal parts inspiration and elbow grease.

PRINTMAKING EXPLOSION

The market for handmade prints has exploded, whether through cutting-edge gig posters, folksy stationery, retro letterpress, or Etsy crafters. Whether the makers are established design icons, experimental students, innovative artists, or brand-new entrepreneurs, the allure is undeniable for both those making the prints and those purchasing them. Filled with unique characteristics, small signed and numbered editions, quirky printing processes, and the human touch, printmaking has fast become one of the most important segments of both the design and small-business worlds.

Not long ago, many pundits and industry observers were declaring print dead, but they couldn't have been more wrong. As commercial printing was reduced, specialized printing picked up the slack and emerged. Moving from the underground to an economic driver in its own right, it is also one of the most satisfying creative pursuits.

In the post-9/11 world, the desire to have something tactile that can be experienced personally is stronger than ever on both ends of the creation. Consumers appreciate the allure of the limited edition and its implied connection to a tight-knit audience of those with good enough taste to appreciate the same work, as well as the raw qualities of touching ink and paper. Creatives fall in love with the idea of getting their hands dirty, coming out from behind their computers, and quite literally feeling the work they produce, even if it means ruining a pair of pants with ink stains or staying up all night pulling prints.

Now you can find printmakers from around the world online, and those same artists can connect with each other and inspire and grow their work. But you can also find them in your local stationery shop, side by side at some of the biggest craft fairs in the world, collected at massive music festivals, as well as at fine-art galleries, and many have gone so far as to open their own retail outlets. They have also become the definition of cool (and rightly so) and can be seen gracing the back-grounds of the hippest photo shoots, television shows, and movies. Small-press printing truly has arrived.

PRINTMAKING HISTORY

While a lot of our focus in this book is on what is happening currently, and even more so on what individuals can accomplish using some of these tools, it is always important to know how we got here. One of the most amazing things about the explosion in small-press printing is how creatives have turned archaic printing methods and rough-and-tumble processes into the most cutting-edge and innovative forms of design today.

I won't force you to read a long and winding tale of the advent of the printing press, but it is safe to say that civilizations quickly realized the benefits of being able to make multiple copies of something, whether it was written words, symbols, or even a piece of artwork.

In the earliest of times, this was accomplished with a stencil, even going as far back as man cutting holes in leaves and running vegetable dyes through them. Stencils and woodblock printing would be used extensively to create printed material, sometimes in conjunction with one another. Innovations in stencil printing on various textiles and products, traded all throughout the world, would eventually be adapted to silk screen, with the first patent for a silk-screen process awarded to Samuel Simon in Manchester, England, in 1907. Unlike the printing press (letterpress is the continuation of the movable-type presses famously invented by Johannes Gutenberg), this portable process was refined by literally thousands of people before Simon's patent was awarded.

The portability and low cost was quickly maximized with the onset of World War I. John Pilsworth developed a multicolor method for screen printing, referred to as the Selectasine method, which proved wildly popular in the commercial sign market. Its inexpensive nature and ability to adapt to shapes and surfaces meant that screen printing quickly became the preferred low-tech method of printing for most commercial enterprises, where it more or less continues today.

But screen printing also had another life—one that forms a more direct base for what is taking place in the hands of current creatives. The fine-art aspect of the process had been ignored for ages, while the commercial application grew unabated. With the help of WPA (Works Progress Administration), a group of artists during the Great Depression was encouraged to experiment with this form, ultimately creating a new type of fine-art print that they dubbed serigraphs. Exhibitions began a slow process where art critics and various supporters would champion this type of work. When it was later adopted by the Pop Art crowd in the 1960s, most notably by Andy Warhol, it gained widespread acceptance, with the artists embracing its humble and industrial nature, often referencing its commercial applications, even in the imagery.

By the mid-1970s, it had returned to its workhorse roots, and innovations in print quickly began to make it obsolete. Soon, digital printing and other processes would replace screen printing in all but the low-end jobs. It seemed destined to fade away until its main benefits—its portability, low cost, and small learning curve—made it the ideal process for a new wave of artists and designers looking to create small print runs.

> "INK LAYING ON INK LAYING ON INK LAYING ON PAPER IS A SIMPLE YET MAGICAL THING. I AM STILL FASCINATED BY IT."
>
> —Jesse LeDoux

Following pages: (left) detail of a print from Largemammal and (right) letterpress being readied by Dirk Fowler at f2 design.

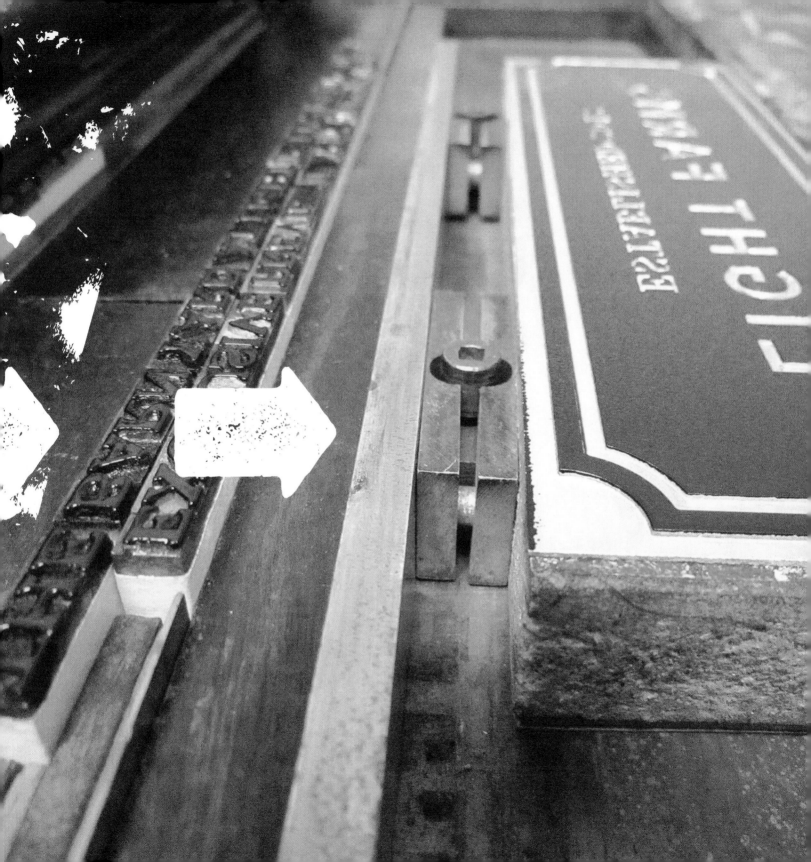

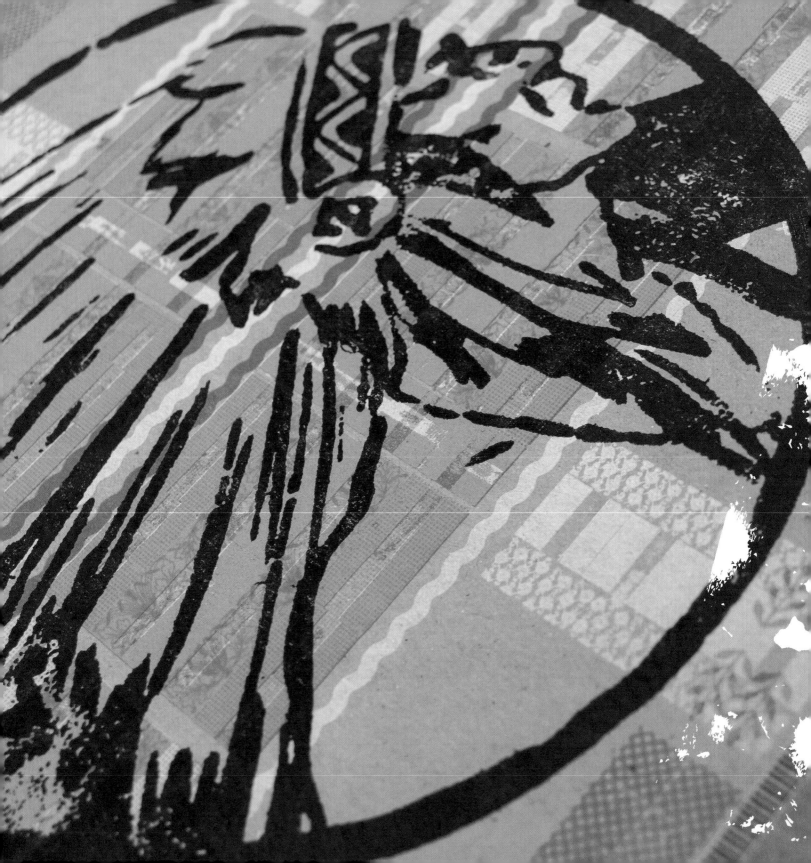

TECHNIQUES AND TOOLS

Now that we know about all of the exciting developments in the burgeoning world of small-press printing, it is time that we find out a little more about how these incredible works come to fruition. The very act of putting ink on paper is simple enough, but getting everything else in place up until that moment can involve everything from a few purchases and planning to some serious heavy lifting and fairly intense learning curves.

close-up of a print by Hammerpress

PRESSES AND PRINTING ENVIRONMENTS

One of the advantages of small-press printing is that it doesn't require a huge amount of space to accomplish the desired results. Some options, such as the old-school woodblock print, or the smaller Japanese Gocco press, can even be squeezed into your coat pocket, if necessary. Others may need a dedicated room, and taking on printing jobs for others might mean that you open up a small industrial space, but the very nature of making each individual print by hand and printing only one color at a time usually leads to some pretty unique environments.

Woodblock and linocuts: Usually produced in a small size, rarely larger than a single sheet of notebook paper, these options require only a block of material, the tools to carve them, and some ink and rollers. These can be used in much the same way that a stamp can; if desired, you can even walk around with them and print on wall-paper sheets to create patterns, and so on.

Screen printing: This can range from the low-tech Gocco press that just needs a flat surface and a refrigerator to store screens (often done in a home environment, for which it was designed) to bigger semiautomated presses that need an industrial warehouse setup. Many silk-screen presses are built by the artists themselves and can be wedged in anywhere big enough to fit a flat surface and some screens. The fun starts when you look for a place to expose your screens, as the need for darkness is important, as well as a place to store the nasty chemicals and a wash basin to clean and reclaim your screens. This could be a cramped city apartment, or a garage in the backyard, or a commercial print shop. The only thing that defines where you work is the scale of what you want to accomplish. For many, working poster size, or smaller, allows them to set up in their basement or spare room or a corner of the office, as long as they are careful with the chemicals and have adequate washing facilities (a power washer goes a long, long way here). Having a drying rack, or lines strewn all about with hanging prints awaiting a second color, is an aesthetic and degree-of-sanity choice.

Letterpress: This is an actual hard-metal (and very heavy) press. Finding room for a letterpress is not difficult, as they don't necessarily have a huge footprint, but moving them into place is certainly a job for more than one person. You also need a set of drawers in which to keep your movable-type pieces in an organized fashion (though you may eventually move on to photopolymer plates if you grow into a bigger commercial enterprise). Several makers of nineteenth-century presses have continued to be popular, with a veritable cult around the Vandercook proof presses for their ease of use and ability to hold detail and impressions as you use the hand roller. Jobber presses, popularized by the Chandler & Price Company, also remain popular for stationery and invitation work. As is not surprising with these durable machines, they endure and find followings in different locales; the UK has affection for the Arab treadle platen press and its almost-soothing machinations as its pedal is pumped into operation. You can find all of these presses lurking in the backroom of some artisan or on the floor of a huge printer that keeps one on hand for specialized high-end invitation jobs. In contrast to the flexibility of screen printing, woodblock, and the like, these presses can print only up to a built-in maximum paper size.

PAPER IS YOUR FRIEND

You may have noticed that all of these printing processes require two things: paper and ink. We will discuss ink a little later in this chapter, but let's embrace paper at the earliest moment possible. Paper can make or break your project. Choosing the correct weight and color and texture and finish is a vital element of a successful print job. Using silver ink on black paper to print what would have been a pretty pedestrian image can suddenly transform it into something much more dynamic. The same is true regarding black ink on silver paper, rather than the standard white. Adding a little tooth and texture can make your print rougher, depending on how hard you apply the ink, and it can also add a tactile element to the final recipient. There are hundreds of different paper options, and each one is ripe with possibilities (and potential pitfalls).

"MY HEAD," KEVIN MERCER SIMPLY STATES WHEN POSED THIS QUESTION. "AS MY FATHER, THE CARPENTER, WOULD SAY, 'MEASURE TWICE, CUT ONCE.' IF YOU TAKE THE CARE TO SET UP YOUR SPACE FOR PRINTING, AND CREATE YOUR DESIGNS TO WORK WELL IN THIS PROCESS, YOU WILL INSTANTLY SOLVE 90 PERCENT OF YOUR PRINTING ISSUES, WELL BEFORE THE INK EVEN HITS THE SCREEN." IT IS CERTAINLY A WORD TO THE WISE FOR THOSE OF YOU JUST STARTING OUT. "YOU HAVE TO HAVE A HEAD FOR TROUBLESHOOTING AND BE ABLE TO COME UP WITH SIMPLE SOLUTIONS WHEN THINGS GO AWRY ON PRESS," MERCER ADDS.

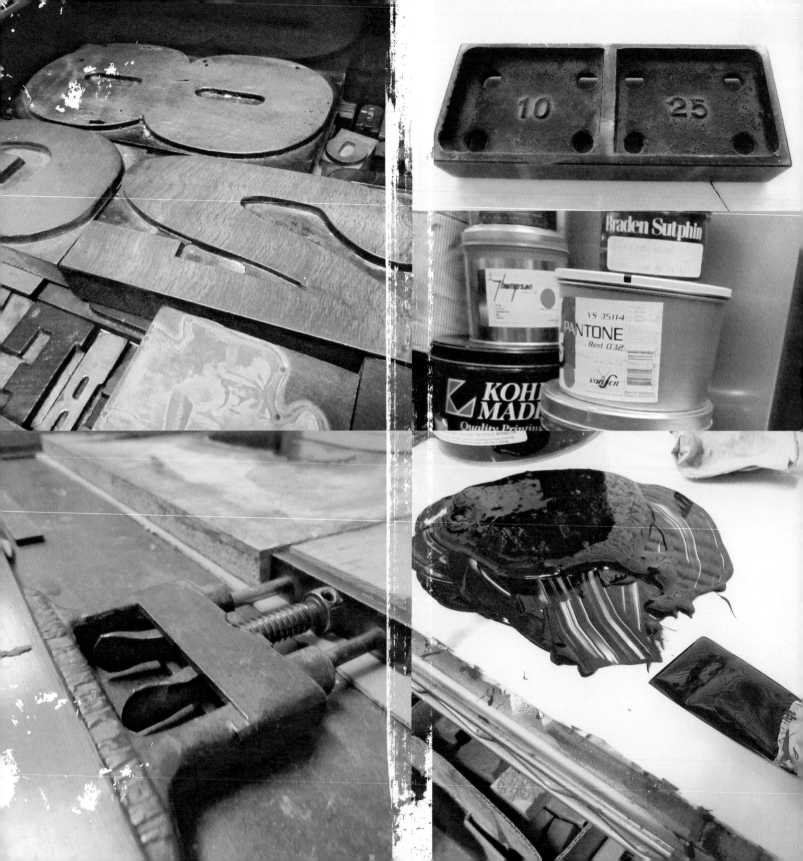

WOODBLOCK:

Wood Block (Remember to get blocks cut across the grain for a tighter look and easier carving.)

Paper

Ink

Carving Materials: You can get specialized tools or work with even the most basic or sharp devices—just be careful! For detailed and professional-level work I would recommend at least a simple six-tool set of carving chisels.

Roller (to spread the ink onto the woodblock)

Things that make life a lot easier: a brush (to clear away sawdust and shavings); a pencil (to do your drawing on the block before carving); a pane of glass (to spread ink onto); something to apply pressure to the paper and the block (some people use a simple spoon for this)

SILK SCREEN:

Press (can be a prefabricated setup or something you construct yourself involving hinges to hold the screens in place)

Paper

Ink

Screens (can be prefabricated or you can build and stretch your own)

Photo Emulsion (used to coat the screen to start the photographic process needed to "burn" the screen)

Film Positive (The printout of the graphic is 100 percent opaque, with the remaining parts clear to allow light to show through when you burn the screen. Commonly these are transparencies, but they can be made with rubylith, or you can actually draw or place shapes/materials to block out the light.)

Light to Expose the Screen (Different light sources or lamps require different exposure times to burn a screen properly.)

Tape (masking or painter's tape to close off screens)

Squeegee (to pull the ink across the screen)

Solvent (to reclaim screens, cleaning away the emulsion for fresh use)

Washout Area (vital for screen printing, as these materials are harsh and need to be cleaned out with care/distance)

Cleanup Materials

Things that make life a lot easier: scoop coater (a simple trough used to coat the screen with the photo emulsion); exposure unit (major time-saver that can eliminate guesswork involved in a ragtag setup); T-square (measuring and lining things up at a true 90-degree angle); rags (this is one of the messier methods of printing); clock/timing device (making sure the screens are burned for the right amount of time); fridge (to store photo emulsion); palette knife (to fill in holes in the screen with extra photo emulsion); spatula (to scrape up excess ink)

LETTERPRESS:

Press (You might own one or be able to borrow one at another location.)

Paper

Ink (oil- or rubber-based ink)

Type (cases of hand-set metal type) You can also make plates, or have them made, in which case you won't need to set your type yourself.

Composing stick (used to hold your type as you assemble it)

Spacing (used to match the sizes of your type)

Leading (different sizes to set the vertical distance between lines of type)

Furniture and Reglet (this refers to the metal blocks [i.e., furniture] and wooden strips [i.e., reglet] used to fill up the large empty spaces in your design)

Composing Stone (a flat surface on which to assemble your form, usually stone or steel, but sometimes glass)

Quoins (at least two and a tool to adjust them, as they are the final pieces for making sure everything stays in position before being placed in the press)

Gauge Pins (used to hold the paper in place when you cycle the press)

Cleanup materials (solvents, etc)

Things that make life a lot easier: a plane, which is a block of wood used to gently tap everything into place—experienced printers will sometimes cover one end of this with leather; tympan paper, which specifically has a very even thickness for use as the backing sheet when you are printing

The color of your paper can directly influence so many things in your print project. Which color inks do you use? How opaque can you run those inks, and how do they change when they interact with a darker color below them? How does the color of the paper impact the viewers' perception of the imagery or message? If you are working on a dark sheet, how do you invert your imagery so that it reads the way you want, or do you?

The weight of the paper is just as important. Heavier paper feels more substantial, and a nice thick sheet can leave a deep impression via letterpress printing and prove to be the deciding factor in elevating it in the eyes of client or consumer. Sometimes, screen prints are celebrated for their transient appeal—the thin and inexpensive stock, even going so far as using newsprint.

If you do your own printing, you will soon find your favorite sheets, but it is always worth remembering that paper is inexpensive for small print runs, and it is a great time to experiment, especially with the option to just feed in another style of sheet, if needed, for the next pull.

PRINTING TECHNIQUES

Small press runs have so many unique features that many people consider them printing techniques in their own right, and silk screen and letterpress would certainly fall into that category, but additional techniques, used in various printing processes, can be incorporated into the way our small-press operators work. As letterpress and woodblock printing are relief methods of printing, they fall under the same theory as embossing/debossing, where a raised or depressed impression is created on the paper stock by exerting pressure from an ink-free piece (likely metal) on the press. Screen printing is much the same process in which varnishes and foils are applied, as it requires a separate pass on the sheet. Varnishes apply a liquid coating in the place of ink, with a finish in varying degrees of reflectivity, to highlight an area or to act as its own effect. Foils require heat as well to affix but add a shiny reflective surface to the final print.

EXPERIMENTATION AND INNOVATION

Now that you know all of the rules, it's about time to start breaking them.

Creating artwork to print seems like a pretty straightforward endeavor. We draw or paint something, or we want to make copies of a photograph or some type created on the computer, so we burn a screen or make a plate to run an edition. But it can be so much more, and once you have a press set up, or ready access to one, making the art to print can be an adventure in its own right. You can slash at your screen, lay old patterns or leaves rubbed in olive oil between two pieces of acetate, or have bits of cut paper strewn about as you burn your screens. You can substitute plates and metal type on your letterpress with actual pieces of objects, going so far as to use an actual broken LP to serve as a print of a broken record. Once you know your equipment (don't break anything!), you can stretch its abilities.

Laying ink down is also one of those givens in the process, but the order and manner in which you do so can change everything. Under- and overprinting are elements crucial to expanding the range of what you can do in making unique screen prints, as are techniques like a split fountain, where each print is sure to be unique as the inks meet in the middle. A little bit of thought beforehand can go a long way when creating art that appears the way you want it to on paper.

Finishing techniques are exactly what they sound like, the last thing done to a piece, and they often take the final product into another realm. Embossing, diecuts, varnishes, and so on, all make a piece unique and special, which also makes them prime candidates to get pretty wild on a small-print edition. The expense of a die or emboss can be substantial, but a small run also means that you could build your own emboss or use existing metal pieces and type to accomplish that, and you could hand cut (or even stitch) what would have needed an expensive die for a larger run. Once you realize you can do anything fifty to a hundred times to get the final piece you desire, you are limited only by your time and imagination.

THE COOLEST THING I HAVE EVER SEEN

The Little Friends of Printmaking's "Blush"

The husband and wife team of JW and Melissa Buchanan set out to adapt an illustration they had done for the paperback edition of Joe Meno's short-story collection *Demons in the Spring*, only to encounter some complications. "Sometimes, when we are making an illustration that we think will never be screen-printed, we have a tendency to go a bit crazy with the colors and the kinds of details that don't work in that process," JW explains. When they posted the image online, there was soon an onslaught of requests for an art-print version. "It became a nagging question in the back of our minds," JW admits. "How would we accomplish a 'Blush' screen print?" A year later, they had a mental breakthrough and were determined to realize this project fully. "The background is printed last, with outrageously big and willfully stylized trapping on all of the layers below," he adds. "We never wanted to use halftones; we don't like that fuzzy, noisy look. So it ended up requiring eight different screens in order to get all of the colors in there. Eight inks and about sixty distinct color variations."

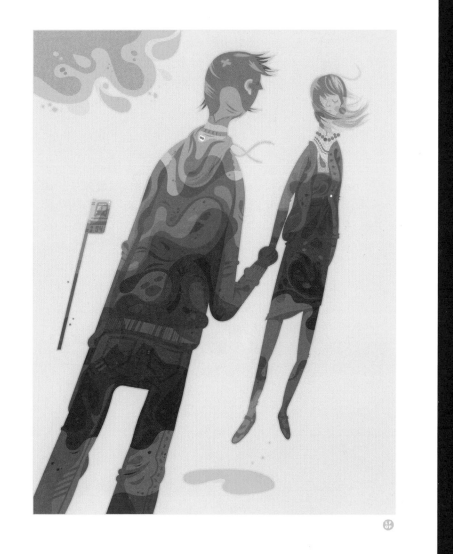

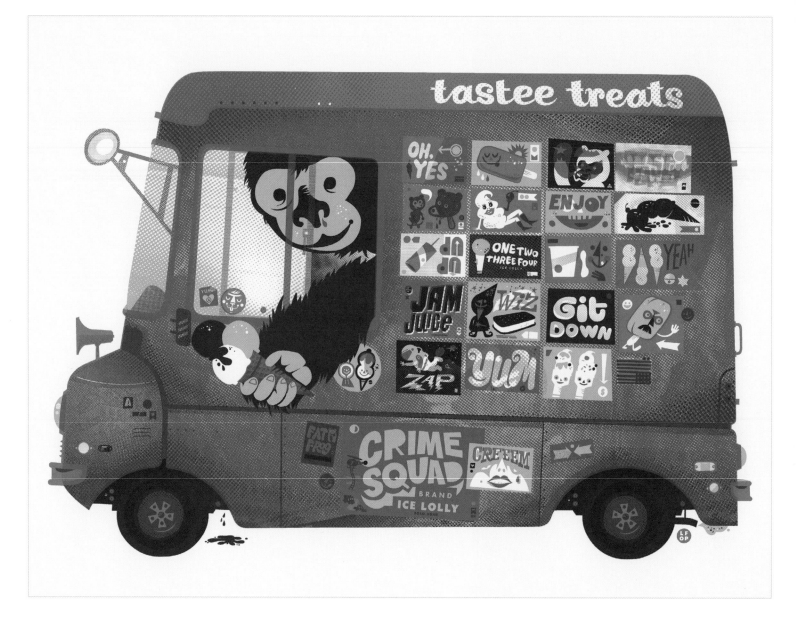

Title: *Tastee Treats 2012*

Designer: The Little Friends of Printmaking

Size: 19 x 25 inches [48.3 x 63.5 cm]

Printing Process: Screen print

Number of Inks: Three

The duo of JW and Melissa Buchanan returned to this print from 2006, following a number of requests for a reprint. They felt like the original was rougher in execution than they wanted, so they took matters into their own hands. "We don't normally rework or redesign old pieces, as you can lose the initial charm, but we felt it was needed on this one," explains JW. This also allowed for some experimentation. While retaining the halftone bitmaps prevalent in their work from that era, they "printed the darkest color first, which is more or less the opposite of how silk screen usually works, but creates all sorts of neat color shifts," he adds.

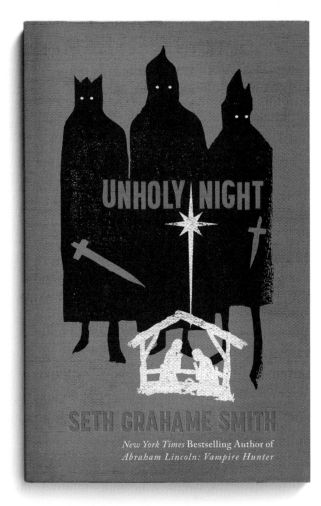

NOTE: Despite all of the magical filters that have been developed for Photoshop over the years, nothing beats a real handmade, honest-to-goodness texture. Many illustrators will make small block prints as the starting point for their work to retain that authentic and unique quality.

Title: *Unholy Night*

Designer: The Heads of State

Size: 5 x 8 inches [12.7 x 20.3 cm]

Printing Process: Block print

Number of Inks: Three

For a book cover for Seth Grahame Smith's Unholy Night, *which Dusty Summers describes as your "basic slasher nativity story," detailing the three wise men "leaving a trail of blood as they make their way to Bethlehem" To create their "seriously deranged magi," they created a woodcut and made their own prints to work from, getting that natural texture that an ink-starved pull provides and no Photoshop filter can ever truly match.*

MY PRINT SETUP: ANTHONY DIHLE, FIRE STUDIO

"Silkscreen printing is kind of like cooking," laughs Dihle. "It's as complicated as you want to make it." For several years, Dihle printed at home "on an air-hockey table in my apartment, and I washed out my screens in the bathtub." He soon moved to a small space in an old retail store. "I share it with a friend, and having a public space to work in has been great, even if it is narrow," he adds, before likening it to printing in a submarine.

Regardless of his surroundings, Dihle has always kept it simple. "The critical components for me are the table, squeegees, some washout method, screens, and exposure method." He doesn't even have an exposure table. "I use an old camera tripod with a 500-watt utility lamp tethered into its center, with the lamp facing toward the floor," he says. "I just plug it in for 21 minutes and it fully bakes the resin."

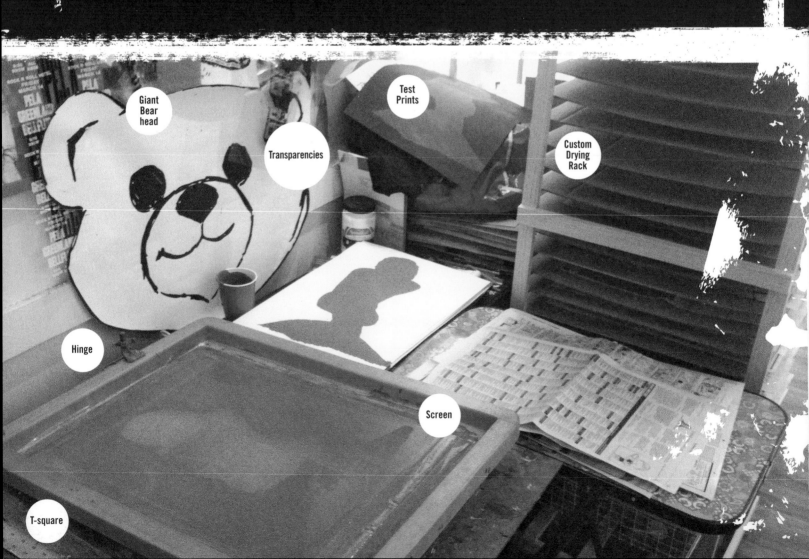

Giant Bear head

Transparencies

Test Prints

Custom Drying Rack

Hinge

Screen

T-square

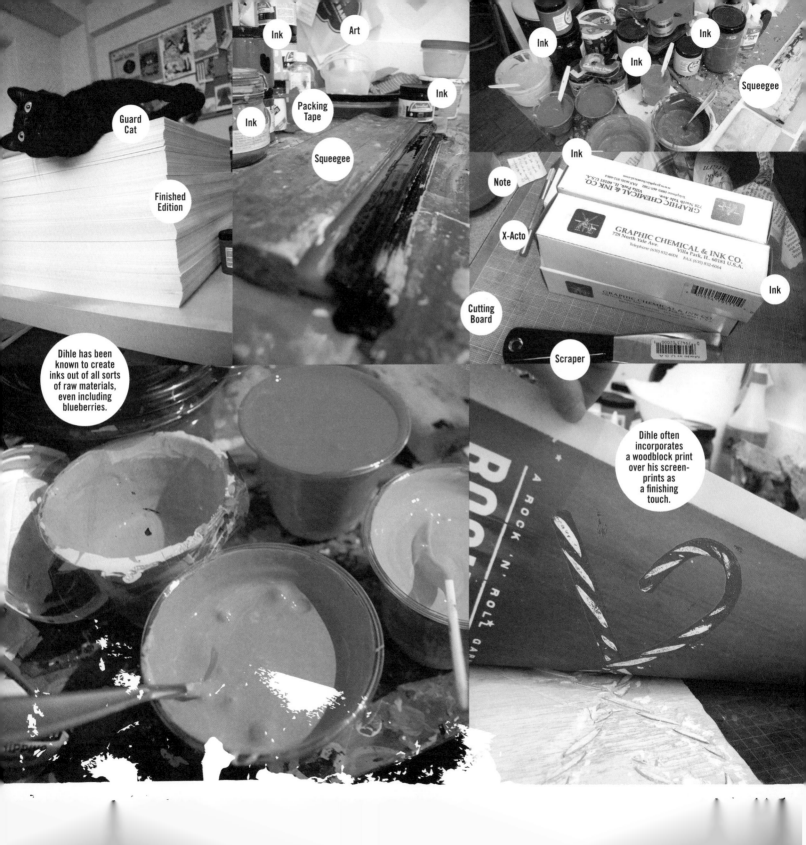

Title: *The Riverbreaks, March 3*

Designer: Anthony Dihle/Fire Studio

Size: 15 x 23 inches [38.1 x 58.4 cm]

Printing Process: Screen print and woodcut

Number of Inks: Five

NOTE: Dihle has become the master of the halftone, experimenting until he gets the results he desires. Sometimes, those results aren't even what he set out for, but he moves forward with the new and improved options as they arrive. For *The Riverbreaks* print, the sky is a photo transferred to a coarse, CMYK halftone, minus the black layer.

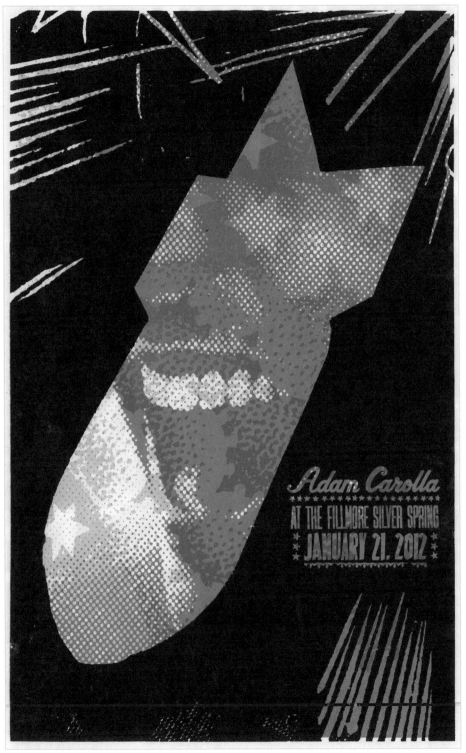

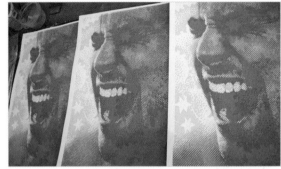

Title: *Adam Carolla at the Fillmore Silver Spring*

Designer: Anthony Dihle/Fire Studio

Size: 15 x 24 inches [38.1 x 61 cm]

Printing Process: Screen print

Number of Inks: Three

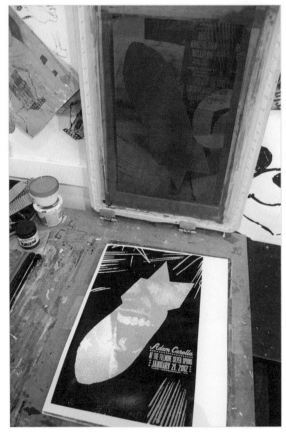

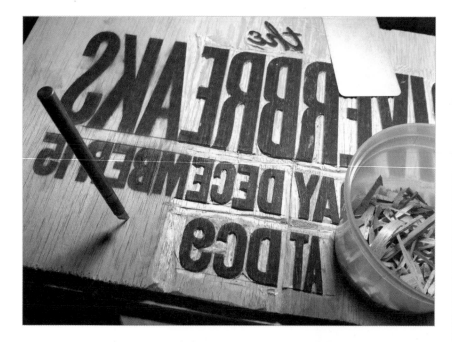

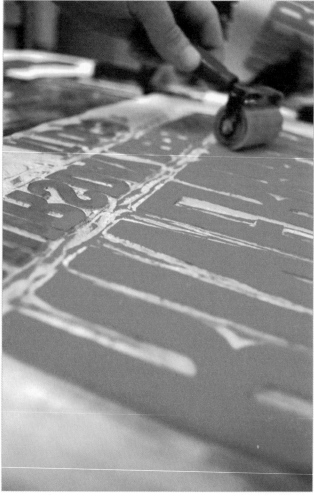

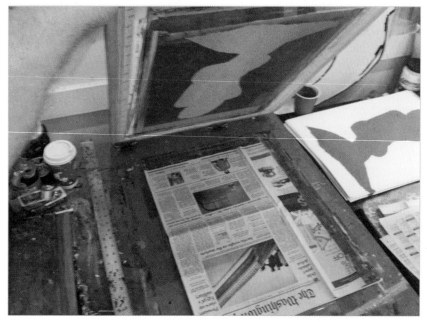

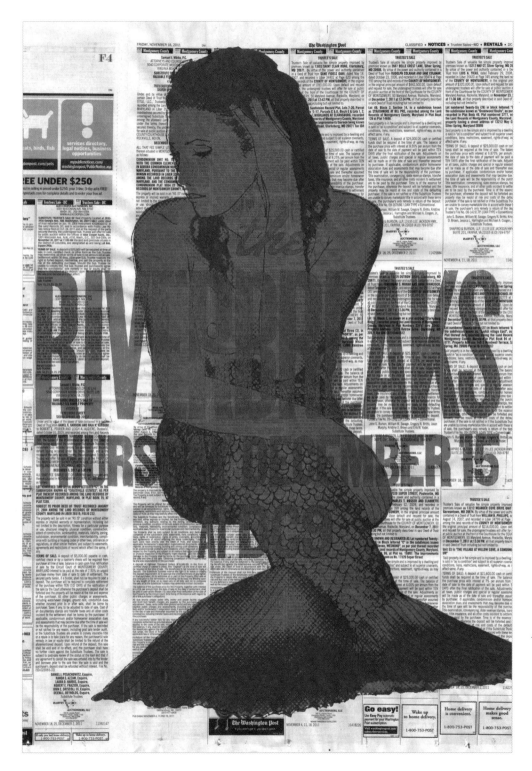

Title: *The Riverbreaks, December 15*

Designer: Anthony Dihle/Fire Studio

Size: 17 x 24 inches [43.2 x 61 cm]

Printing Process: Screen print and woodcut

Number of Inks: Four

This is what happens when a band gives me six weeks to make a poster," laughs designer Anthony Dihle. "It gets complicated." The final print actually ends up involving "three different printing methods, including four-color web (newspaper) press, three silkscreen colors, and one woodcut relief color using commercial letterpress ink." Dihle had been looking to print on newspaper for quite some time, "but getting the poster to read clearly against a high-contrast background like the front page of the Washington Post *would be tricky," he worried. Eschewing screenprinting ink, he looked for a solution that would do the trick. "Enter letterpress ink!" he says triumphantly. "The text layer is cut from ⅜ inch flat balsa wood," Dihle explains. "I transferred the image from a photocopy sheet, using a technique where wintergreen oil is dabbed onto the backwards-reading page, and the ink from the photocopy is transferred to the wood block. I then cleaned up the smudgy result with colored pencil and cut away the unlinked areas with an craft knife." Bringing in red letterpress ink, "with a small amount of white added for opacity," Dihle then "pressed the paper against the inked-up wood block with a dry ink brayer and my fingers, for good measure."*

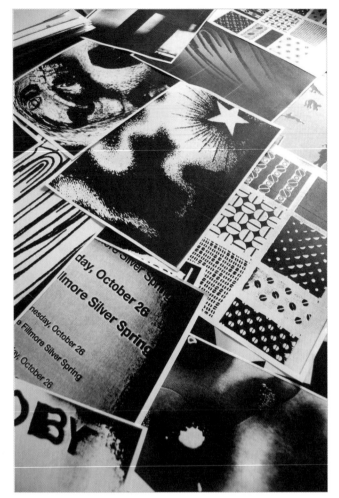

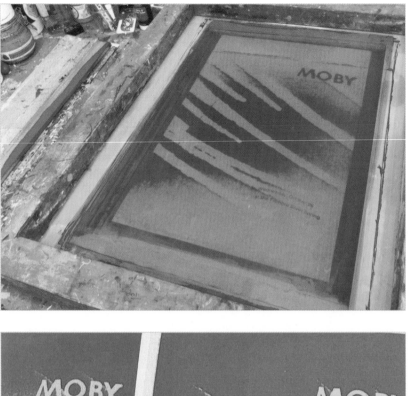

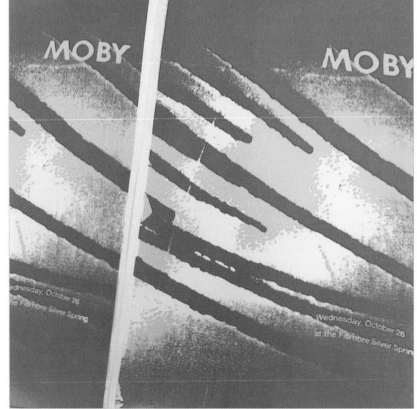

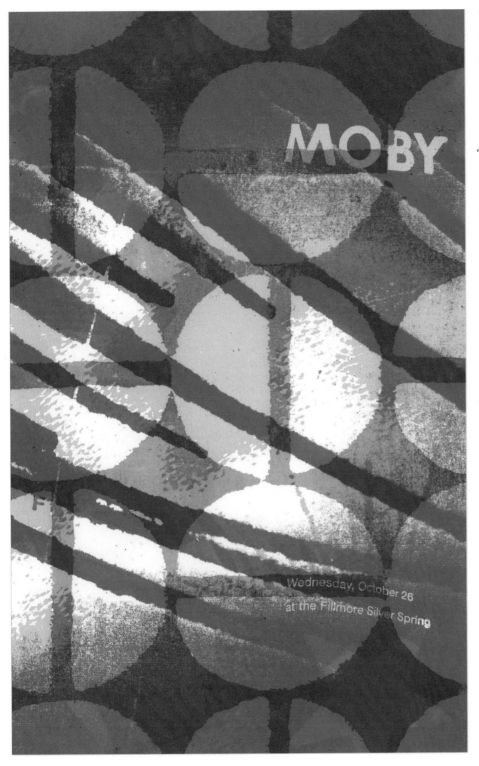

Title: *Moby at the Fillmore Silver Spring*

Designer: Anthony Dihle/Fire Studio

Size: 15 x 24 inches [38.1 x 61 cm]

Printing Process: Screen print

Number of Inks: Three

"I started by sourcing the layers from collected images and patterns in my image library," explains designer Anthony Dihle. Soon armed with "a jar of pocket change," he proceeded to make "a couple hundred copies, and then scanned them back in to make a mockup for the client." Once approved, it was then time to burn some screens. "I printed the layers as transparent as possible, going yellow then magenta and then cyan. In printing the cyan layer, I ran out of transparent base. I recovered by adding golden acrylic gel medium as a substitute," he explains. However, one fix created another problem. "The medium began to dry in the screen between prints," he says. "Eventually, I was able to resolve it by scrubbing out the screen and adding trans-extender base and retarder base to the mix. However, some screen clogging is visible to the left of 'Moby' in the horizontal blue band," forever capturing the struggle in the print itself.

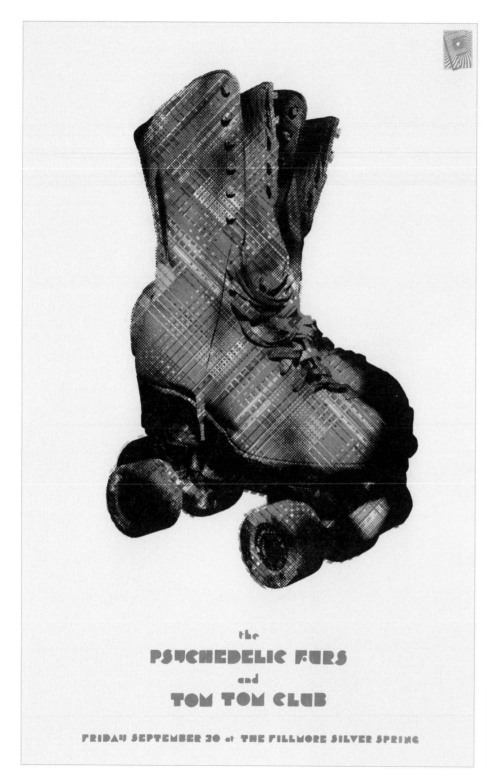

the
PSYCHEDELIC FURS
and
TOM TOM CLUB

FRIDAY SEPTEMBER 30 at **THE FILLMORE SILVER SPRING**

Title: *Psychedelic Furs and Tom Tom Club*

Designer: Anthony Dihle/Fire Studio

Size: 16 x 25 inches [40.6 x 63.5 cm]

Printing Process: Screen print

Number of Inks: Four

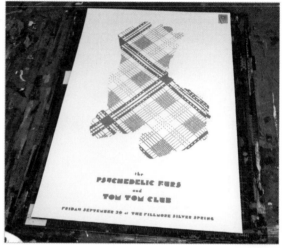

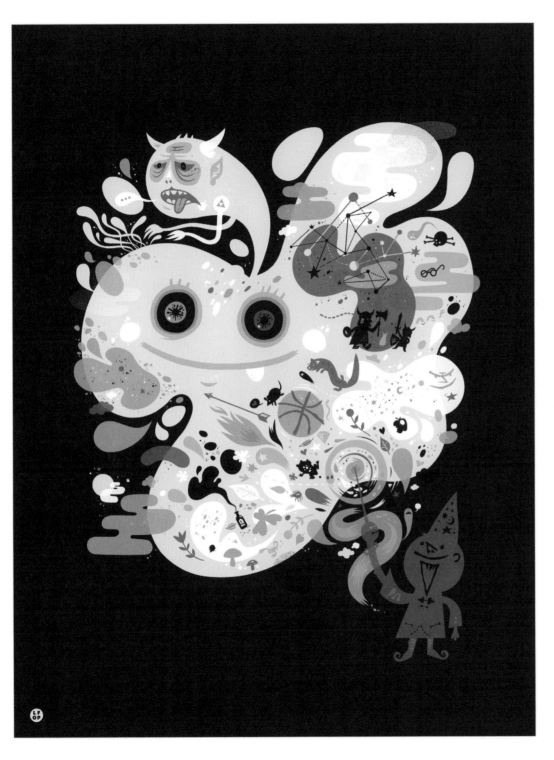

Title: *Advanced Wizardry*

Designer: The Little Friends
of Printmaking

Size: 19 x 25 inches [48.3 x 63.5 cm]

Printing Process: Screen print

Number of Inks: Six

*Working on a piece destined to hang in
an exhibition in Venice, Italy, JW and
Melissa Buchanan wanted to "make
something more detailed than usual,
given its lofty destination," explains JW.
"We decided to design a six-color print
that had very few concrete points of
registration, creating a solution to
an age-old problem for silkscreen
artists—the more colors that you print,
the more the registration between the
layers becomes a crapshoot," he laughs.
"In our experience, the stress of making
a screen print with a lot of layers comes
not from the extra work of printing, but
in the uncertainty that the layers will
still fit together nicely in the end."*

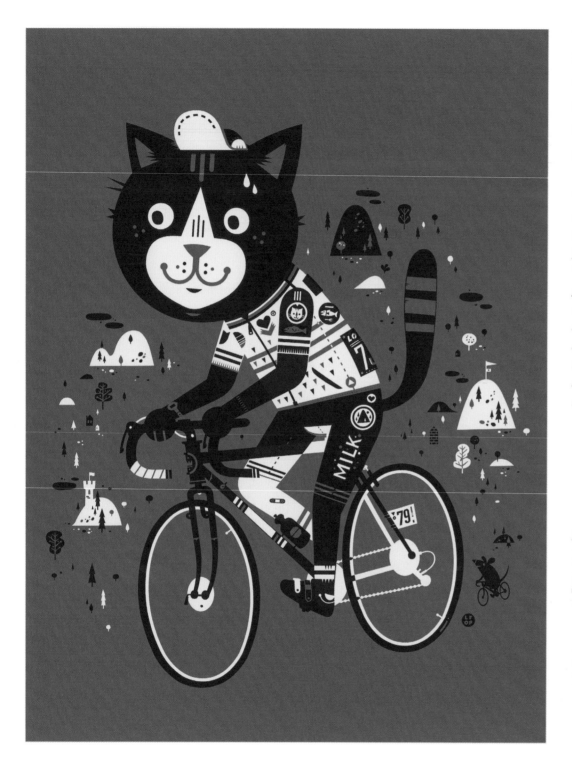

Title: *Cycle Cat*

Designer: The Little Friends of Printmaking

Size: 19 x 25 inches [48.3 x 63.5 cm]

Printing Process: Screen print

Number of Inks: Two

"Starting out as a shirt graphic, it quickly sold out, and we adapted it to an art print." The duo of JW and Melissa Buchanan found that when printing it, they were "struck by how good it looked as a large-scale print. The details that were lost on fabric were suddenly popping out when placed on paper," explains JW. Its beginnings as a shirt graphic meant that it "had butt [perfectly aligned] registration and a limited palette, giving it a leaner look than we would usually put into print."

NOTE: One of the hallmarks of a print from The Little Friends of Printmaking is the use of underprinting. Adding little nuances and details that can be seen through the ink laid on top.

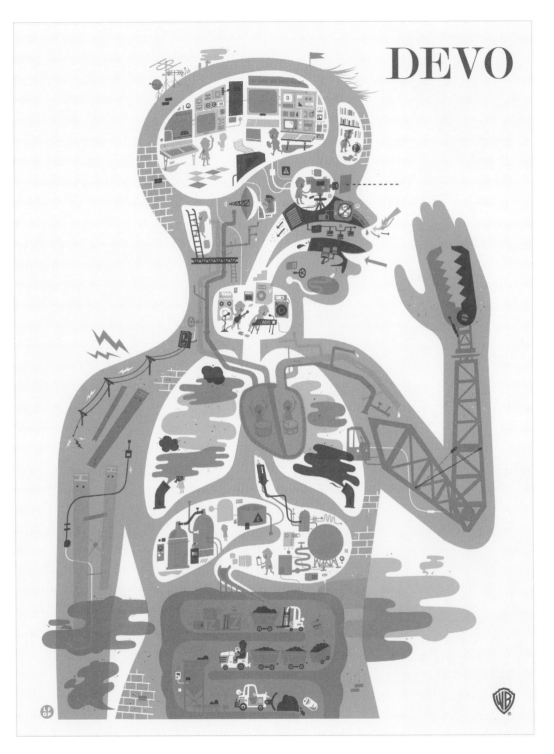

Title: *Devo Poster*

Designer: The Little Friends of Printmaking

Size: 19 x 25 inches [48.3 x 63.5 cm]

Printing Process: Screen print

Number of Inks: Four

Asked, along with a number of other prominent artists, to create a print for Warner Bros. Records honoring one of their artists on the occasion of the label's fiftieth anniversary, JW and Melissa Buchanan quickly snatched up Devo. "The idea here, visually, was to emulate the use of spot colors in children's science books and textbooks, to be daring with the lack of trapping," explains JW. "That allowed us to capture that slightly off-register vintage-styled look."

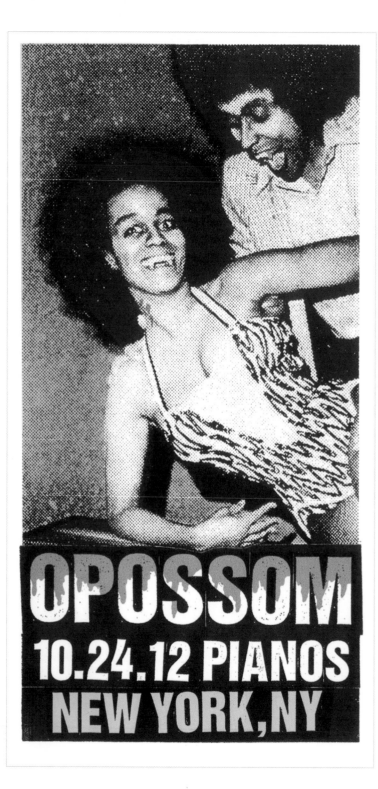

Title: *Opossom*

Designer: Print Mafia

Size: 10 x 20 inches [25.4 x 50.8 cm]

Printing Process: Screen print

Number of Inks: Three

*"We had this image for years and were hesitant to use it,"
explains designer Connie Collingsworth. "But when the
small poster job for Opossom popped up with its total
creative freedom, we simply couldn't resist going a little
old school with the design. The picture was so great, with
the facial expressions and Afros, that it just need a little
pop of color." Bringing in "the Day-Glo yellow is always
a favorite for us," she adds, "and pink made for a nice twist
on the traditional blood drips."*

NOTE: Print Mafia keeps an extensive
collection of reference material and is
always on the lookout for more. Indulging
their enjoyment in the more kitschy moments,
they seem to have a particular knack for
bringing out another layer of personality
from existing photographs once they are
in their hands. They also never forget a
killer image, as witnessed by their patience
here in waiting until just the right project
came along.

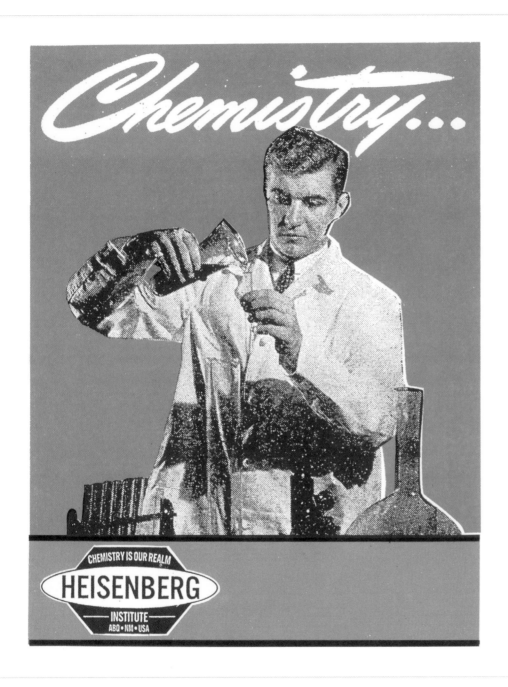

Title: *The Heisenberg Institute*

Designer: Print Mafia

Size: 16 x 20 inches [40.6 x 50.8 cm]

Printing Process: Screen print

Number of Inks: Three

Knowing that they wanted to do something inspired by the television series Breaking Bad, *designer Connie Collingsworth lamented that "the poster world is flooded with people tracing and redrawing photos of the characters from the series." She really focused on "the concept of portraying the basic premise of the show, and the reason for Walt's success: Chemistry! Walter White and Jesse Pinkman make the best meth because they make it the right way, the scientific way, not the usual street cook way." They then started brainstorming on "the idea of a fictional scientific school that could have been run by Walt if he hadn't gone bad. The '60s lab look appealed to us, and we had the perfect picture to complete our visual in an old* Popular Science *magazine." All of the elements were quickly in place.*

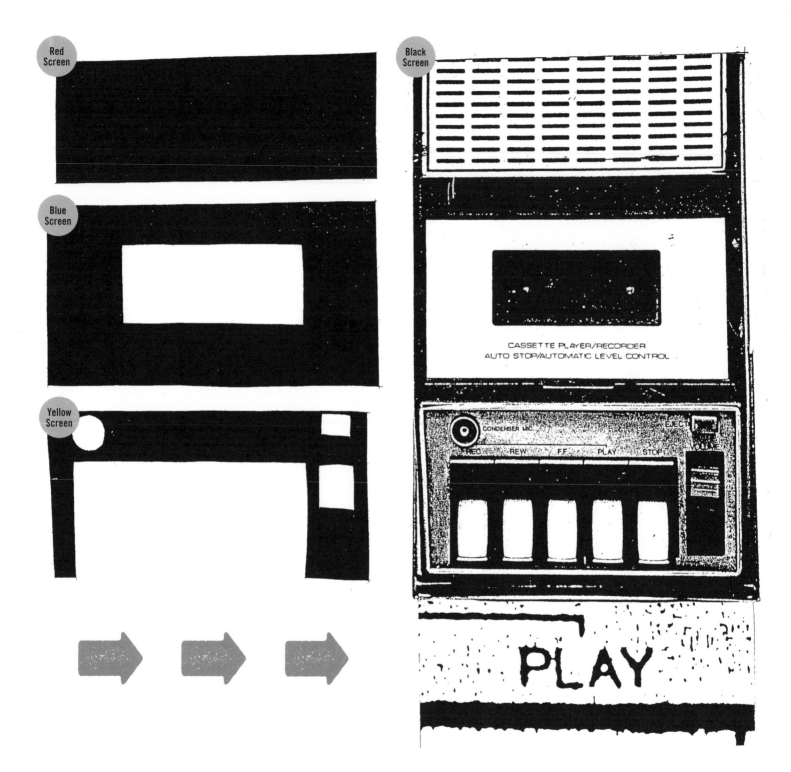

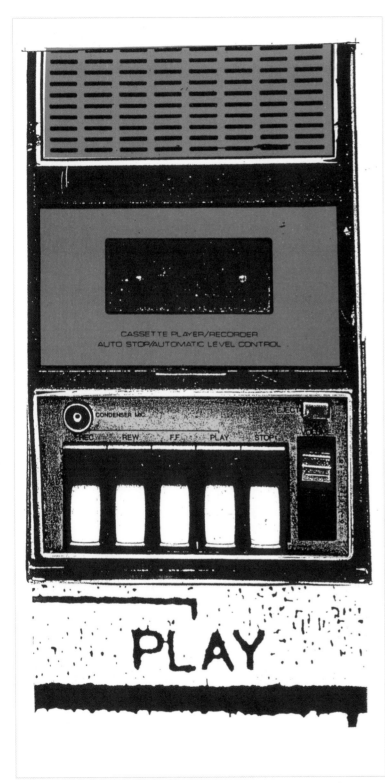

Title: *Cassette*

Designer: Print Mafia

Size: 10 x 20 inches [25.4 x 50.8 cm]]

Printing Process: Screen print

Number of Inks: Four

"We originally created this design for a T-shirt for our line at Dillard's department stores, and we have just always loved it," explains designer Connie Collingsworth. "It emerged from a photocopy of a picture we took of an actual tape player we had," she adds. "We then added the lines and PLAY wording to fill out the extra area that was available on the paper, extending the design past the original limitations on the T-shirt." She thinks about it and laughs at how often this imagery crops up. "We keep coming back to tape players due to our love for the classic mix tape," she smiles.

NOTE: Once you have all of the pieces ready to go, you can see the simple construction as the screens for the red, blue, and yellow are laid down before the black is screened on top to tie it all together.

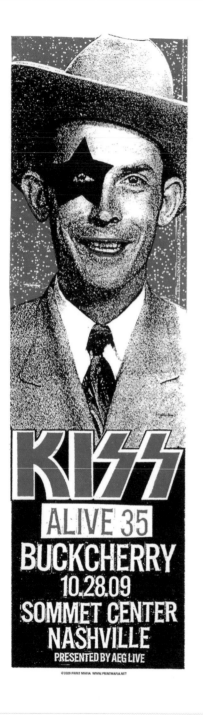

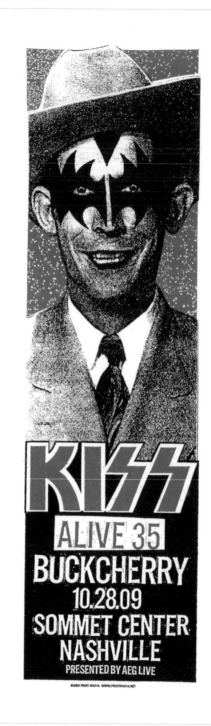

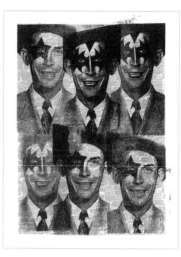

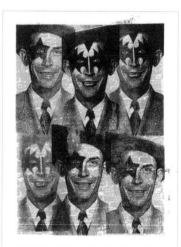

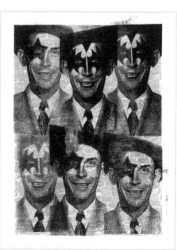

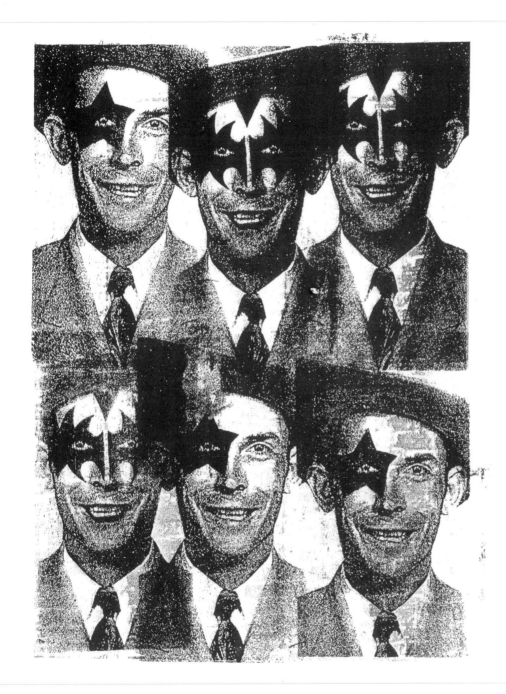

Title: *Hank KISS*

Designer: Print Mafia

Size: 16 x 20 inches [40.6 x 50.8 cm]

Printing Process: Screen print

Number of Inks: One

"This print came out of a series of other pieces," explains designer Connie Collingsworth. *"We had done the KISS show poster set for the Nashville show featuring Hank Williams sporting Gene and Paul's makeup on each individual poster. When we were printing those posters, we used the blackline art on a test print and it came out great, featuring just the black faces layered over a gold color. We loved the look and simplicity."* It then took on another life as *"the test print was scanned and then reduced, which we then printed out small so that we could make photocopy one-color flyers for inclusion as an extra in fulfilling our web orders."* Then it came full circle as *"the simple one color was so, zine-like and scruffy that we decided to make a print of it,"* she laughs.

NOTE: An image can have several lives when in the hands of Print Mafia. In fact, it can often seem like it lives on forever, as they constantly find new ways to riff on it and reinvigorate and experiment with it over several projects.

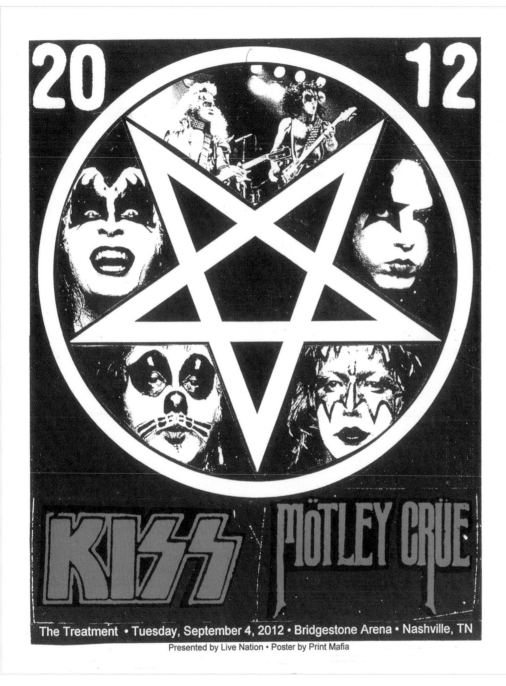

Title: *KISS/Mötley Crüe*

Designer: Print Mafia

Size: 16 x 20 inches [40.6 x 50.8 cm]

Printing Process: Screen print

Number of Inks: Two

"We have been fortunate enough to do a few posters for KISS shows over the years. KISS was such a big part of our childhoods in the '70s that we always feel the pressure to live up to their image," explains designer Connie Collingsworth. "You can't go wrong with KISS photos because they really are about the makeup, and it's hard to find a picture that isn't great of them," she adds. For this double-bill concert with Mötley Crüe, "another band we loved growing up," she adds, they went for the familiar. "The pentagram is possibly the most recognized symbol for Mötley Crüe, and the segmented shape was perfect for placing the KISS images in each section." The studio "likes to make sure as many posters as possible have an authentic connection to each of us," she explains. "So for the bands' logos, we enlarged images from ads in our own personal copies of Circus magazine. These logos were actually KISS and Mötley Crüe necklace pendants. We thought this was a nice touch over our usual cut-and-paste letter style and really made it seem more '70s / '80s metal magazine like, which is always a good thing."

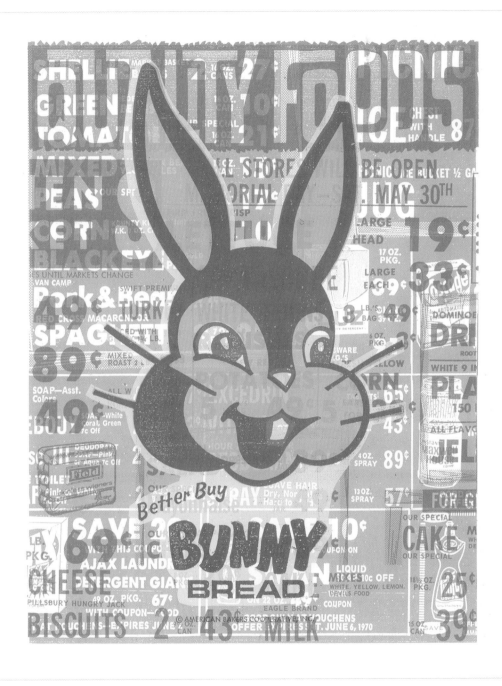

Title: *That's What I Said*

Designer: Print Mafia

Size: 16 x 20 inches [40.6 x 50.8 cm]

Printing Process: Screen print

Number of Inks: Four

We are both drawn to vintage advertising logos and characters; it is a major bond in the studio," explains designer Connie Collingsworth. "Jim is obsessed with a few in particular, including the Bunny Bread bunny." Taking that lead, they "photocopied the plastic hand puppet that would come in the bread bags, and we knew that we wanted to place it with '60s/'70s-era grocery store ads. After searching for the specific style of ad we were looking for and having no luck, I actually came across a June 6, 1970, newspaper from our hometown in a friend's desk," says Collingsworth. "I could hardly believe it; we had just what we were looking for and it added in that unique personal touch we always strive for."

NOTE: Focusing on their obsessions brings out the best in Print Mafia's work, and points to a good policy for any designer or printer in creating projects for themselves.

Title: *Famous Stereo*

Designer: Print Mafia

Size: 16 x 16 inches [40.6 x 40.6 cm]

Printing Process: Screen print

Number of Inks: Six

Some projects have a funny trajectory, as designer Connie Collingsworth explains. "The Afro image in this print was originally used in a 2004 Soul Fest show poster. We really love the texture of the image and it prints fantastic, so we decided to use it on a large wood piece for a gallery show." Setting up the base with "the wood layered with many colors and patterns and wording relating to vinyl records and soul music," they then "placed the silhouette of the figure on top of a spraypainted color block in the shape of the Afro. We cut a piece of card stock in the shape of the image to use as a stencil. When the stencil was placed over all the colors, we just fell in love with the white border and then the shock of the multi-color design in the shape of the Afro." It seemed inevitable what the next move would be. "After completion of the gallery piece, we set about the task of re-creating the layers and the stencil shape" to create a new print that captures that surprising image.

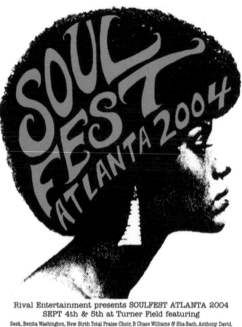

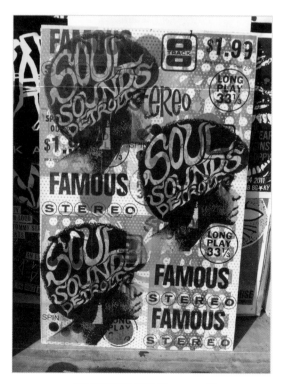

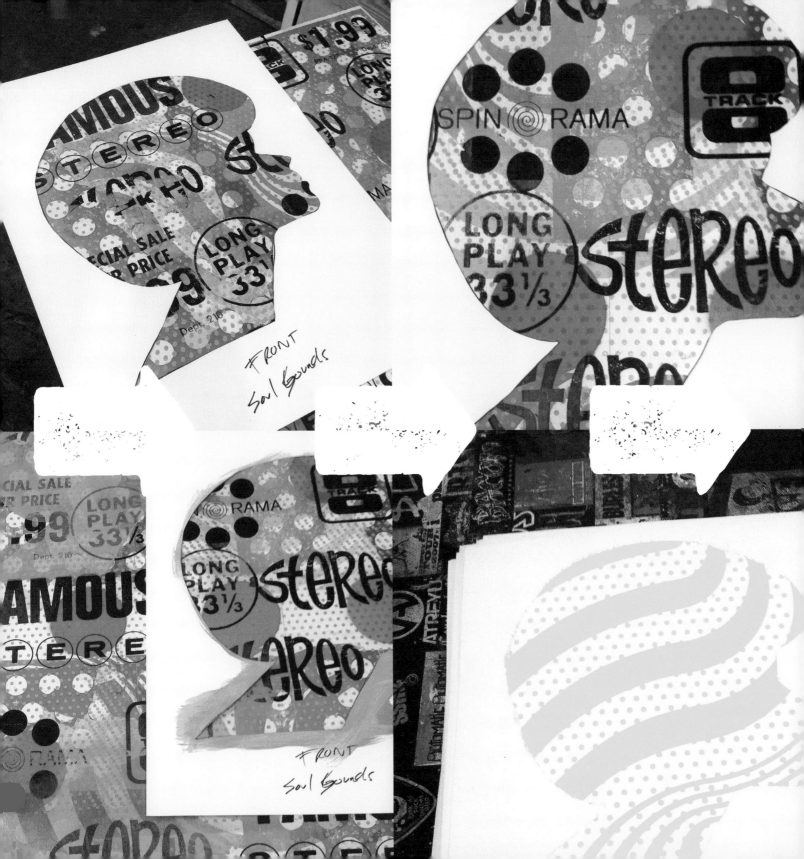

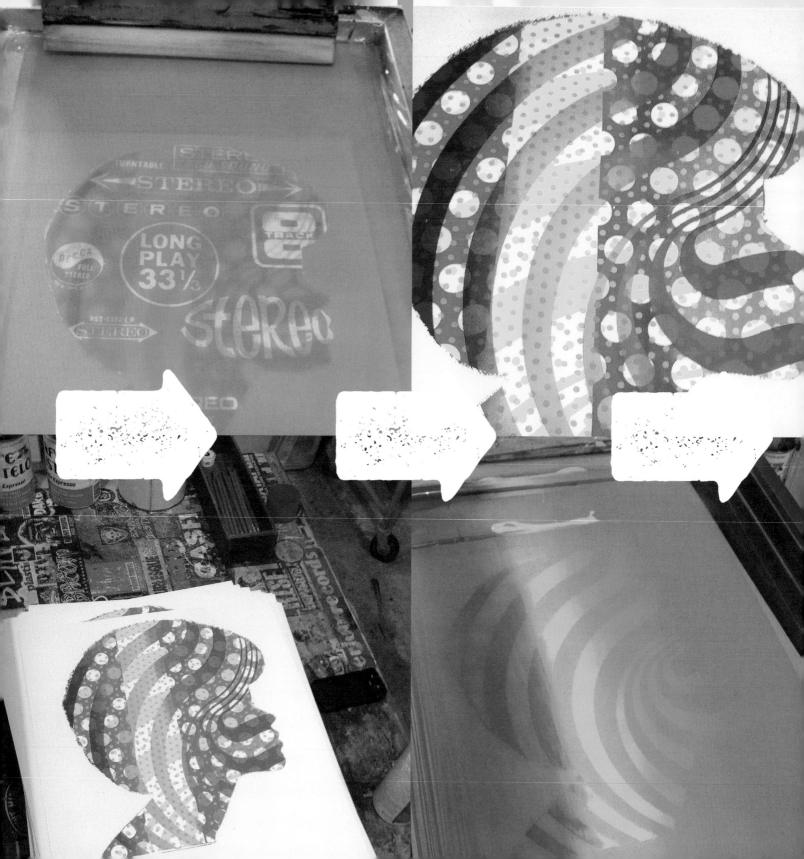

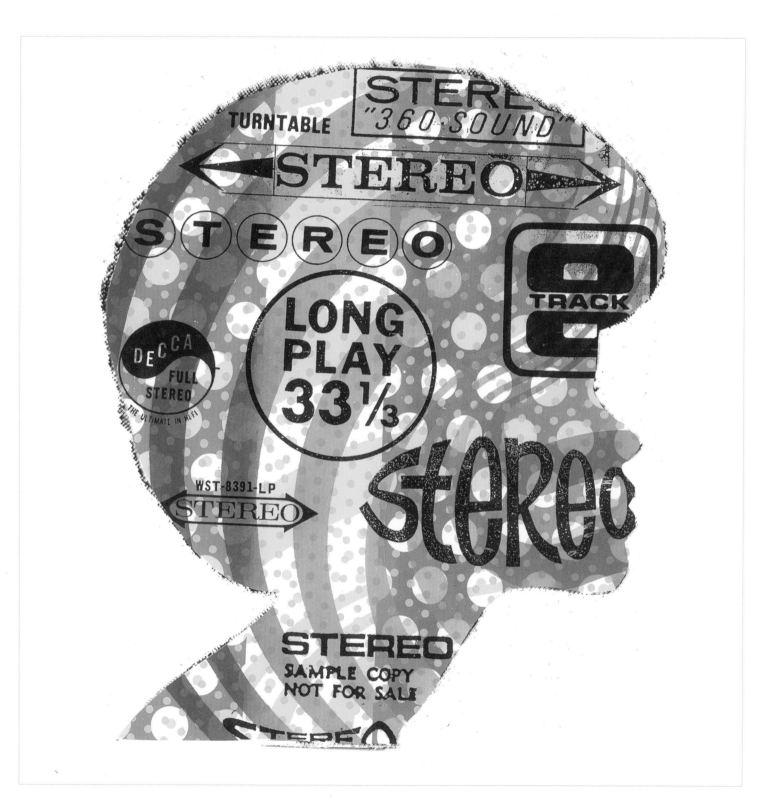

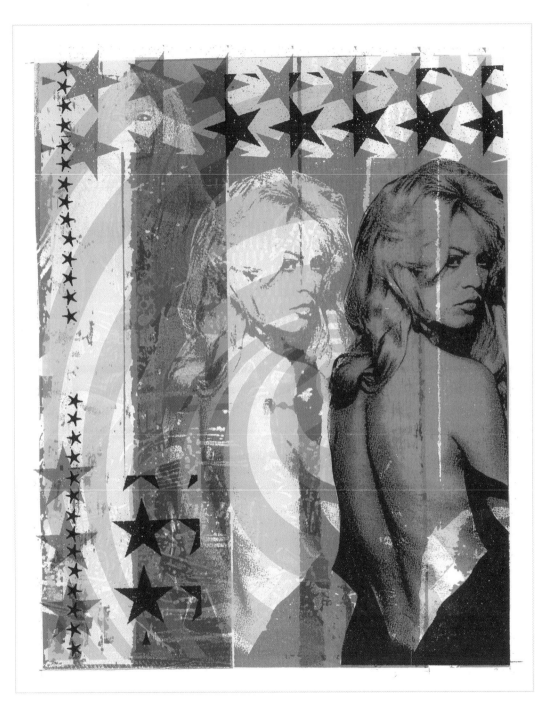

Title: *Bardot No. 2*

Designer: Print Mafia

Size: 16 x 20 inches [40.6 x 50.8 cm]

Printing Process: Screen print

Number of Inks: Three

"Two things that we always like at the studio are a Bardot picture and layering yellow, teal, and red inks," says designer Connie Collingsworth. "We added a whitewash and some stars and swirls to complete the look. Not really sure what 'the look' is," she laughs, "but we know we like it and it is a color scheme and style we that have had great success with over the years."

NOTE: Sometimes, the key to success is in your past work. Knowing which inks interact well, and which please their own tastes, ensures an amazing end product for Print Mafia on press.

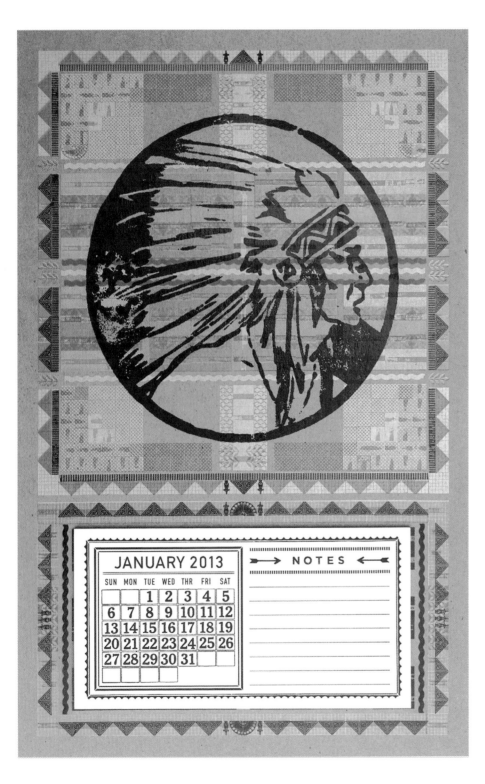

Title: *Calendar*

Designer: Brady Vest/Hammerpress

Size: 11 x 17 inches [27.9 x 43.2 cm]

Printing Process: Letterpress

Number of Inks: Three

NOTE: Hammerpress never forgets the little details that make their products stand out above the rest. This piece stands out on its own via the calendar "letterpressed by us for you" card.

Title: *Pattern*

Designer: Brady Vest/Hammerpress

Size: 8 x 9 inches [20.3 x 22.9 cm]

Printing Process: Letterpress

Number of Inks: Four

NOTE: A hallmark of Hammerpress's work is the intricate patterns and overlaying multiple patterns. The end result can be a print where you can get lost in the joys of even the tiniest corner.

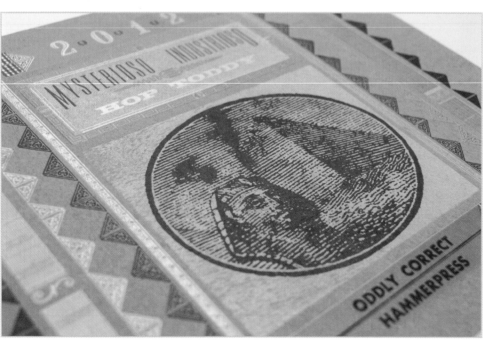

Title: *Mysterioso Industrioso*

Designer: Brady Vest/Hammerpress

Size: 8.25 x 10.75 inches [21 x 27.3 cm]

Printing Process: Letterpress

Number of Inks: Three

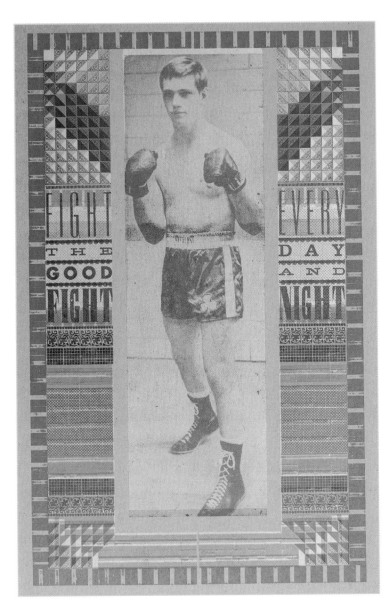

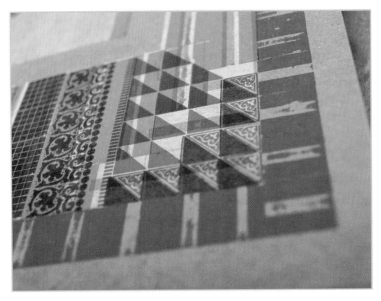

Title: *Fight the Good Fight*

Designer: Brady Vest/Hammerpress

Size: 11 x 17 inches [27.9 x 43.2 cm]

Printing Process: Letterpress

Number of Inks: Four

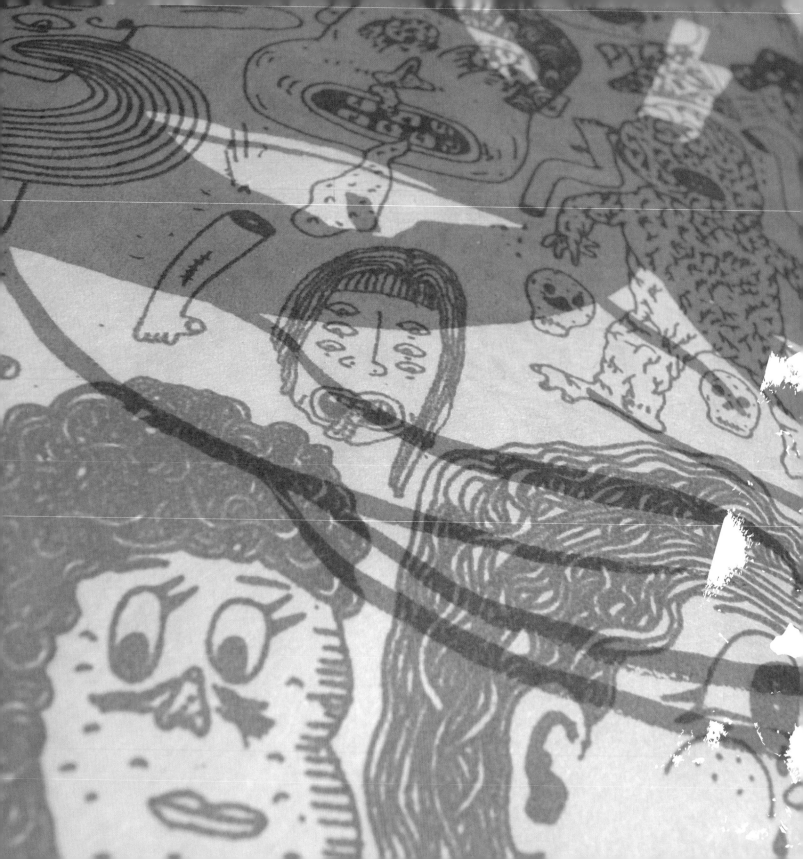

WHY DO WE PRINT?

We have gone over all of the practical reasons why we print, and the history behind that, but we haven't explored the question as to why do we print this way, and why now? Let's be honest, small press printing makes little sense when explored from many angles. Yet, here it is, an ever-expanding marketplace for designers and artists and crafters. It seems to grow daily, with practitioners both young and old jumping in with both feet. For that drive to get involved with something seemingly impractical, and messy, and … well … small—there has to be multiple forces at play. If it was the allure of making one pretty little print, then it would end at a single print, with designers frustrated by the inconsistency of the process, and printers battered and bruised by archaic methods and presses that require some sweat to get them working properly. But it doesn't end there. It grows. And those that engage in it get obsessed, and soon find it all-consuming, making as many pieces of printed matter as they can manage, and often an additional run on top of that.

That pull comes from two of our base needs when your brain tells you that you need to make things: a mechanism that allows us to receive payment for our creations, and an outlet for those voices swimming in our head that eventually reach our hands and start spilling out our thoughts in visual form. It's all about money and feelings, people. But then again, isn't it always?

close-up of a print by Seripop

BUSINESS OPPORTUNITIES

We have established that long ago, there were art prints and commercial printing, but very little bridging the gap between the two. Then the gigposter movement started to rewrite the rules, along with an overall push to do more handmade products, and suddenly little regional scenes were exposed to the world via the Internet, and the impossible seemed, well, possible!

That celebration of the handmade has now turned into a full-blown explosion. It is perfectly acceptable to give someone a small print as a birthday girl, or at a baby shower. Letterpress cards and stationery align your correspondence with your aesthetic. Etsy and Felt & Wire and events like the Renegade Craft Fair and Crafty Bastards, and the multitude of Flatstocks that occur each year, among so many others, have made the outlets to sell your wares endless.

This has set many of the first wavers off into different opportunities. The guys at Aesthetic Apparatus have designed an entire line of printed materials outside of gigposter work, from snarky store signage to cards and coasters, eventually launching their new Haute Crap online store. Strawberry Luna has become a force in the craft market with her friendly illustrations adorning her popular animal alphabet series. Frida Clements took her fanciful illustrations into art prints. Comic humorists Modern Toss created collectible (and frightfully dark and funny) little prints, even making a caricature template for events. Fine art galleries, along with pop-up versions, have opened their doors to these folks, in hopes of attracting a younger, hipper audience. Big brands have caught on as well, co-opting the grassroots appeal.

Coming into their wake is a new batch of artists from all walks of life, making their own prints and cards and products, and building devoted followings, often without the training, or experience of those who have come before them. The sudden surge of people in these markets is not without some growing pains. New people don't know the rules, and the ethics of the various scenes can be thrown into turmoil at times. In the end, everyone is just trying to make a living doing what they love.

While some letterpress shops like Hammerpress are well established in printing numerous items, from posters to cards and gift tags and stationery, the number of people working in this area was pretty slim. As designer/educator Dirk Fowler explains, "There truly seems to be three to four times the number of people that were doing it five years ago. I really do believe that this is driven by online vehicles like Etsy, and it has changed the field considerably. It seems like all you need is a small Kelsey Excelsior and a few metal letters, and you can print cards and invitations." Fowler isn't complaining, but he wryly notes, "Letterpress has suddenly become huge in the stationery and wedding invitation market, and I don't do that kind of work."

Screenprinting is even less expensive to try your hand at, and the influx of poster-makers amuses Jay Ryan as well. "In the last handful of years, I have noted a substantial increase in the number of young people who would consider this to be a viable career. I guess the older designers are to blame for giving the impression that we are able to pay for food after we have spent it all on paper and ink," he laughs, before adding a playful, "Get off my lawn, kid!"

That's not to say that the benefits don't go both ways, either. As it has opened up to a broader group, a funny thing has happened—whereas the gigposter community has long been a male stronghold, the opposite is true in the craft-fair world. "The events have become open to poster makers, and I think the work shows really well there," says designer Anthony Dihle, adding, "honestly, male craftmakers are a sought-after minority at craft events."

Seeing people coming to the table without fine art backgrounds has changed some of the rules of the game as well. "A few years ago, we were seeing a lot of silkscreen artists making prints in an open edition—unmarked prints, being printed endlessly," explains The Little Friends of Printmaking's JW Buchanan. "These people

(continued page 59)

NAME:

MODERN · TOSS

1·4·2012

Title: *Portrait Booth Body*

Designer: Modern Toss

Size: 5.9 x 7.5 inches [15 x 19 cm]

Printing Process: Screen print

Number of Inks: One

"The Modern Toss Portrait Bodies are used as a base for live portrait sessions. We have a flat-packed portable Portrait Booth that we take to events and festivals, in order for people to have their caricature done Toss style." This allows the firm to create a set edition of prints, while still having every finished piece be unique to the recipient.

NOTE: The portrait card uses an additional finishing technique via embossing their logo.

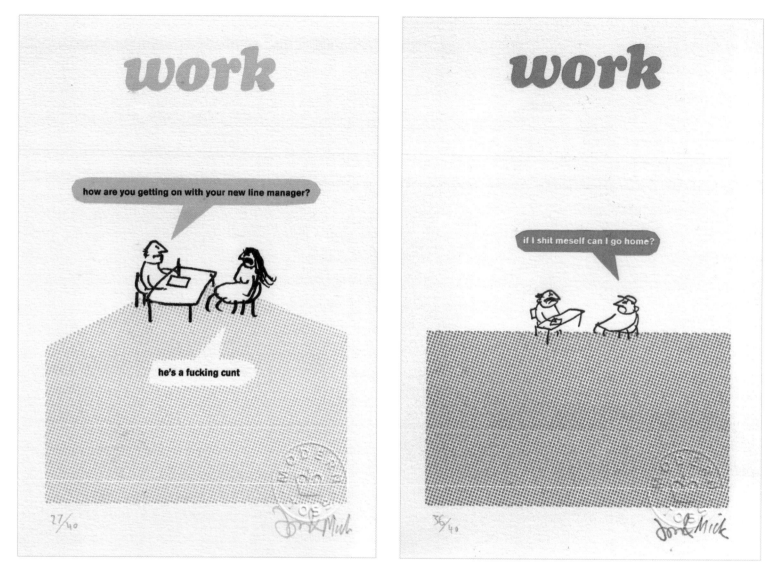

Title: *Work . . . Line Manager*

Designer: Modern Toss

Size: 6 x 8 inches [15 x 21 cm]

Printing Process: Letterpress

Number of Inks: One

Title: *Work . . . Shit Meself*

Designer: Modern Toss

Size: 6 x 8 inches [15 x 21 cm]

Printing Process: Letterpress

Number of Inks: One

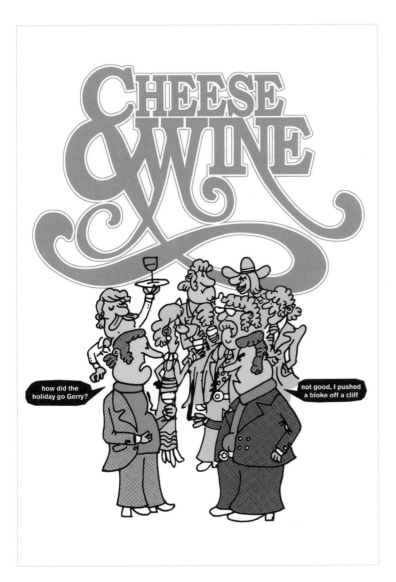

Title: *Cheese & Wine Holiday*

Designer: Modern Toss

Size: 16.5 x 23.4 inches [42 x 59.4 cm]

Printing Process: Screen print

Number of Inks: Four

NOTE: While Modern Toss uses effective little touches in the printing process, whether it is letterpress or in producing a screenprint, they never lose sight of the most important part of the process for actually selling their prints—the writing. It is not enough to just make decent prints and hope for the best in today's market. You need to have talent, but you also need to have a unique style or perspective. Modern Toss uses their biting commentary, which is delivered in short, sharp stabs to society's abdomen, to carve out a special place for themselves. In many ways, their design and (anti) illustration style serves to highlight how important the words are and demand that you acknowledge their brilliance.

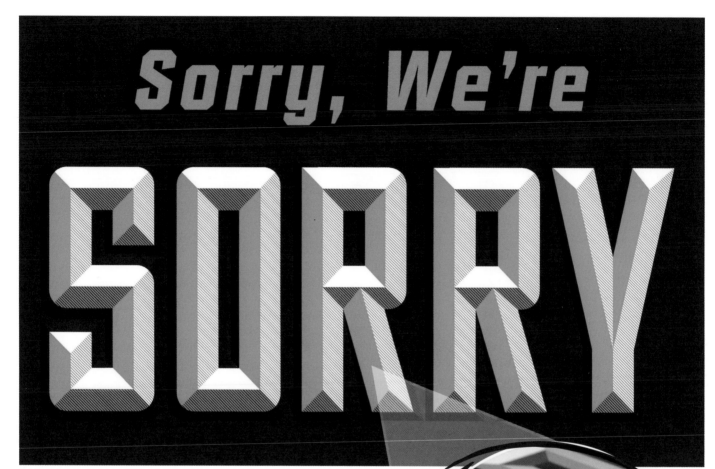

Sorry, We're SORRY

©AESTHETIC APPARATUS CORP. U.S.A.

Creating even the simplest of images using screenprinting can often turn extremely complex. The more limitations you have; like only two inks to print with, and the more you want to accomplish; like creating a false dimensionality in your flat typography—the harder you have to work to achieve it. Designers Dan Ibarra and Michael Byzewski were able to tailor a custom font Valuco from their own hands to do everything that they needed. Modernizing some old school techniques, they carefully use flat portions of orange and white to balance the lift created by the alternating orange and white stripes on some panels, and the anchor created by the shadow effect from the alternating orange and black stripes on others.

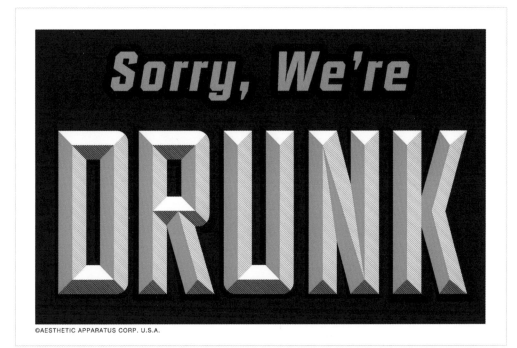

©AESTHETIC APPARATUS CORP. U.S.A.

Title: *Yes We're/Sorry We're Signs*

Designer: Aesthetic Apparatus

Size: 12 x 8 inches [30.5 x 20.3 cm]

Printing Process: Screen print

Number of Inks: Two

Finding various niches in the marketplace is the key to survival for the small printer/designer. Tapping into an existing market, with a new twist, can be one of the easiest points of entry. Using their unique sense of humor, along with their discipline to know that the signs needed to look authentic, Aesthetic Apparatus hit on an instant winner. Using the ubiquitous business signs announcing that a shop is now open or, unfortunately, closed, they created a slew of funny and engaging variations.

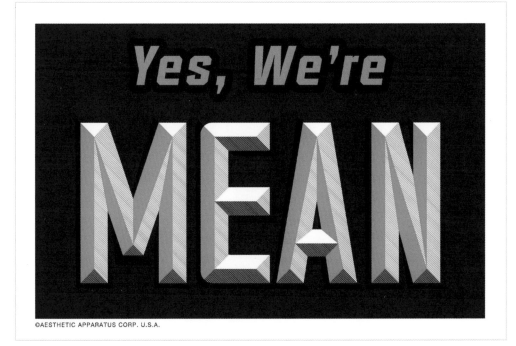

©AESTHETIC APPARATUS CORP. U.S.A.

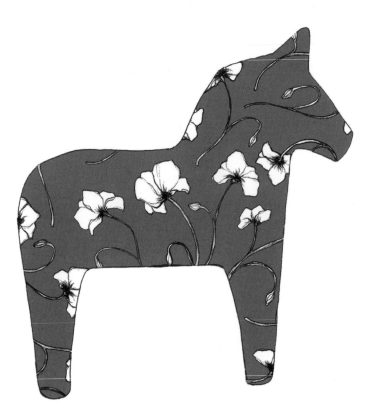

DESIGN © FRIDA CLEMENTS 2012 | PRINTED BY BROKEN PRESS

Title: *Swedish Poppy Horse*

Designer: Frida Clements

Size: 11 x 14 inches [27.9 x 35.6 cm]

Printing Process: Screen print

Number of Inks: Two

Taking note of the competitive market in gigposters and limited edition prints, designer Frida Clements realized that she had to accentuate the portions of her work that truly set her apart. Here, she combines her unique illustration style with her Swedish heritage to create something that could only come from her hands.

NOTE: Clements also made additional editions using different base colors.

didn't have the strict methodology drilled into their heads, and their audience was accepting them uncritically." Seeing that the market had opened past the tiny circle of collectors that had kept it going, "that really opened our eyes," he admits. "We realized we could be making multiple editions of our popular prints, which is something we never would have considered earlier. But the audience is telling you what they want, and sometimes you have to be smart enough to listen."

EMOTIONAL CONNECTION

Creatives create. Sure, they have to eat and pay rent and find one or two articles of clothing to cover their body before they go outdoors, but they are driven to make things, in a way that only fellow creatives can appreciate. They can't turn it off, and everyone finds a different catalyst for each project that they feel compelled to take on. It could be a unique personal experience, like interacting with a somber landmark in a foreign country, as is the case in the usually playful Jesse LeDoux's stark *Permanent Shadow*. Or, it could be the bittersweet feeling he experienced in leaving Japan to return to the U.S. that he expressed in *Sayonara Gohan*.

Having this outlet to express themselves is vital for designers and artists, but they must also focus those feelings into something that connects with the viewer, and reaches deep inside to tap their own emotional well, and compels them to take a printed piece home with them. Forming that bond between the person behind the art and the consumer, with paper and ink holding them together. That is one of the true joys of these methods of printing, be it silk screen or letterpress, as they allow for an economy that would normally be unobtainable, so that anyone off the street that feels connected to a piece could actually own one of the limited-edition prints. It is a win/win in the purest sense.

There is also a release available in pulling prints. "I love the ritual of it all. The very act of printing," explains Denny Schmickle. "It also requires dedicated time," he adds. "I can't walk off and do something else, because the ink will dry in the mesh and screw up the works. It's meditative and relaxing when it's working right." He also taps into its low-art appeal, adding a voice to what so many probably don't even realize is a core reason why they do this. "I also print because I have a chip on my shoulder. I had a very blue-collar upbringing, and I learned to respect manual labor and hard work. Screen printing is a very lunch-pail, blue-collar kind of printing." With its history as strictly an option born from economic needs, he literally hits the nail on the head.

For many, it is a calling. Fowler explains the feeling he had when he visited the iconic Hatch Show Print and saw letterpress for the first time. "I knew instantly, after seeing the process, that it was what I was meant to do. I love the tactile quality and the fact that you can see and feel the printing. Quite simply, I was in love."

Sonnenzimmer's Nick Butcher sums up a lot of the appeal, on both ends, when he says, "Screen printing is accessible, cost-wise, to get into, but the results can be extremely high in quality. The same can't be said for any other print medium." Surveying his studio, he adds, "You know what my favorite thing about the final result is? That we've built it from scratch, right here in our little studio and print shop."

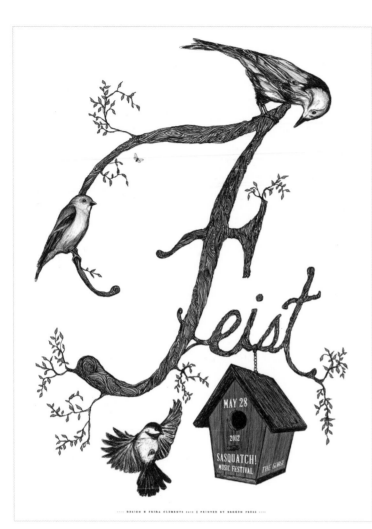

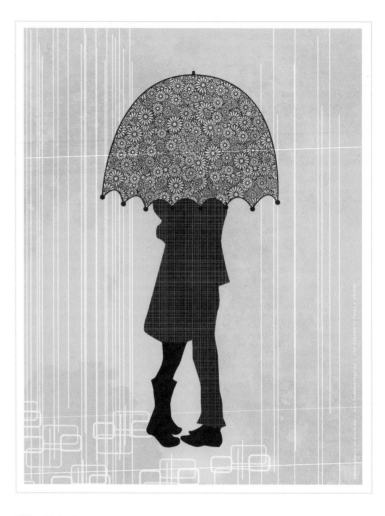

Title: *Feist*

Designer: Frida Clements

Size: 18 x 24 inches [45.7 x 61 cm]

Printing Process: Screen print

Number of Inks: Three

Title: *Raindrops*

Designer: Frida Clements

Size: 18 x 24 inches [45.7 x 61 cm]

Printing Process: Screen print

Number of Inks: Two

NOTE: Clements adds her unique illustration to some of her trademark birds, but also literally branches out and creates a unique typographic solution. One of the keys to her success is always pushing her pieces, whether trying a new approach to type or maximizing the business potential of an image by making it an artprint.

"THE MOMENT I STARTED TO UNDERSTAND HOW SCREEN PRINTING WORKS, FROM A DESIGN PERSPECTIVE, WAS WHEN POSTER DESIGNER RICHIE GOODTIMES EXPLAINED THE VALUE OF DESIGNING IN CHANNELS, RATHER THAN LAYERS, IN PHOTOSHOP. CHANNELS MORE ACCURATELY REPRESENT SEPARATIONS, AND WHEN I FINALLY FIGURED THAT STUFF OUT, WITH THE HELPING HANDS OF THE GENEROUS DESIGNERS AND PRINTERS WHO FREQUENT GIGPOSTERS.COM, IT ALL STARTED TO REALLY CLICK FOR ME."

THE COOLEST THING I HAVE EVER SEEN

Denny Schmickle's Wallpaper Series

Denny Schmickle worries. He worries a lot. He worries enough that you could fill a gallery's walls from head to toe with his worries. He is concerned about the minuscule chance that his kids will contract the West Nile virus from the even-smaller mosquito buzzing about them in the backyard. He has dreams where all of his teeth fall out, so he adds his anxiety over bedbugs to the visual mix. He makes a self-portrait, cobbling together the things he loves, yet he can't resist balancing them with the things he hates, and leaves a gun dangling perilously close to his son. He overanalyzes every aspect of what makes it possible for us to breathe and walk and talk. He also manages to do all of this with an easygoing nature and trusting smile, so who are we to question if he wants to pour all of these thoughts into flowing patterns on massive rolls of wallpaper and cover the room with his thoughts?

Once he had this direction, Schmickle admits that "designing the patterns was a challenge. I wanted them to be decorative from a distance and yet personal and perhaps autobiographical up close. This way they functioned as an object of design, as well as personal and expressive art." Some of his concerns quickly became simply ones of functionality. "One of my main objectives in designing the patterns was to hide the seams," he laughs. "In researching decorative patterns, I found that a checkerboard-like pattern with a simple repeating grid was uninspiring and bland. However, an image that repeated with no clear boundaries was like a bacteria that grows and spreads. That is exactly what I wanted in these patterns."

Printing these in his small studio meant that Schmickle had to completely reimagine his work process. "Typically, I make posters or prints, with which I can adjust and move around as necessary," he explains. "When printing from a roll, all of the ... The

roll had to be made square to the table, and square to the screen frames, and square to the image burned into the mesh. This was never much of a worry before, as I could reposition a piece of paper any which way. With roll-based printing, I had to actually pay attention to what I was doing," he adds with a smile.

"As I began printing, I placed a line of tape across the print surface, where the bottom edge of the roll would lie. Then, with each pattern, I could make registration marks where the image landed on the tape. Using that, I would then measure out two more repetitions and make more marks. I had learned in my research that it is necessary to print every other print to prevent smearing. Therefore, I would print #1, advance the paper two spots, and print #3 then #5 and so on until I had printed the 35 feet or so that I needed for this installation. Then I would make sure that the images were dry and roll up the Tyvek and do it all over again, lining up the images to print the even sections." Schmickle made the decision to print on Tyvek "because it holds the paint like paper would, and it installs and (more importantly) uninstalls easily. I can just peel the rolls right off the wall without ripping and tearing."

All of the preplanning meant that "the installation went like a normal wallpaper hanging, with the exception of putting up a base layer of Masonite as to avoid putting glue directly onto the gallery walls," he explains. Ever the worrywart, Schmickle "wasn't sure what it would be like to get the walls back to normal after the show, so I glued onto the Masonite as a precaution. Then, I cut lengths of Tyvek appropriate to my particular installation, used a paint roller to apply a generous coat of run-of-the-mill wallpaper glue, making especially sure to get the edges, and then tried to hang them as straight as possible."

He then stood back and let all of his anxieties blend into a beautiful and engrossing pattern, becoming prettier and more soothing with every step he took away from it.

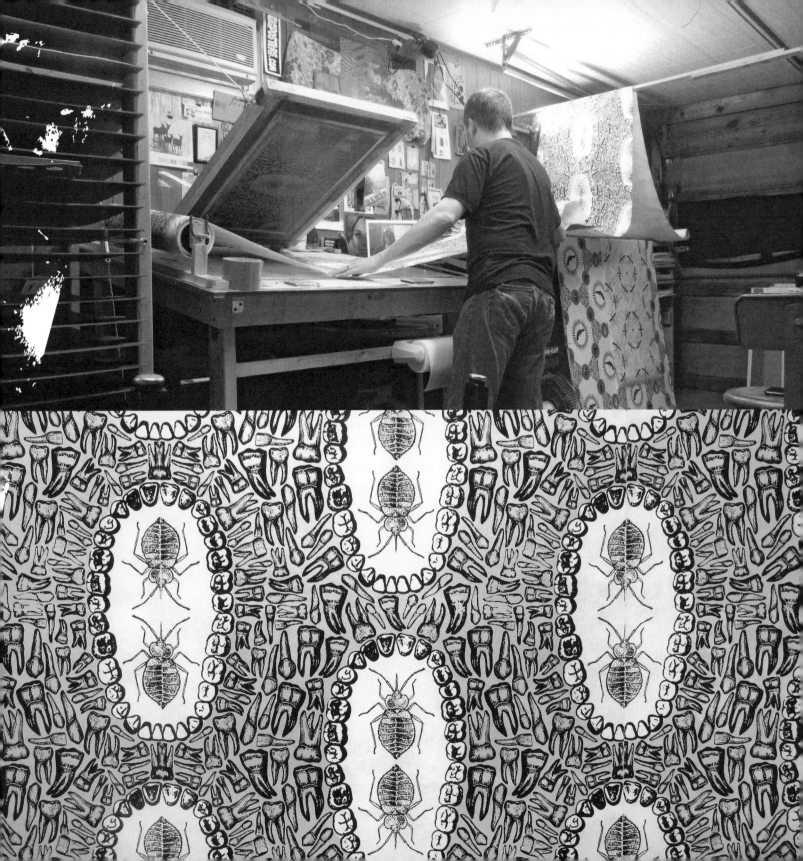

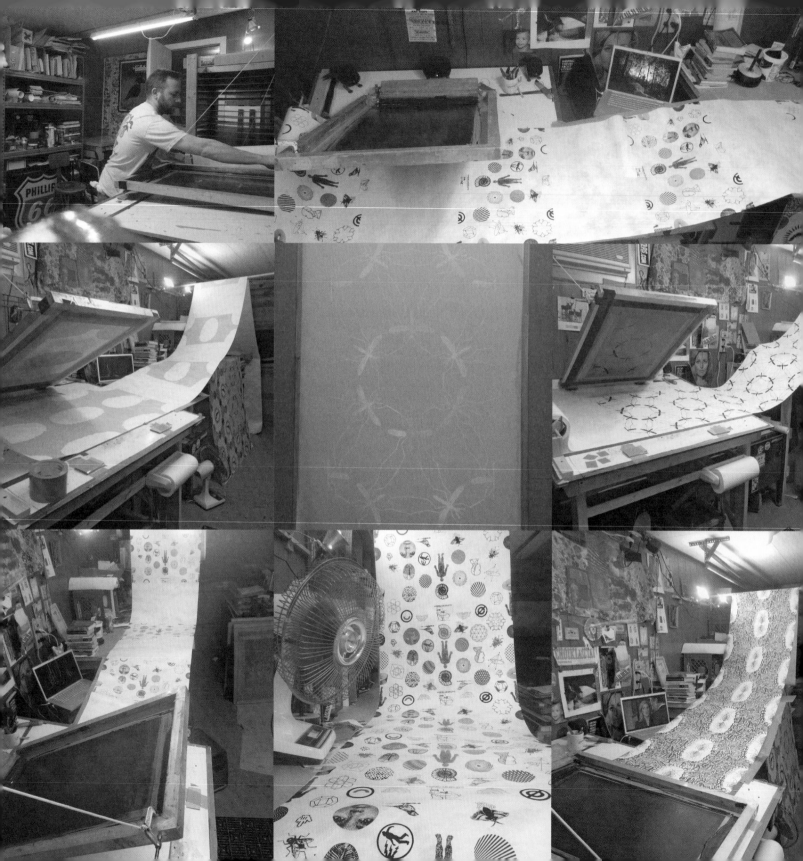

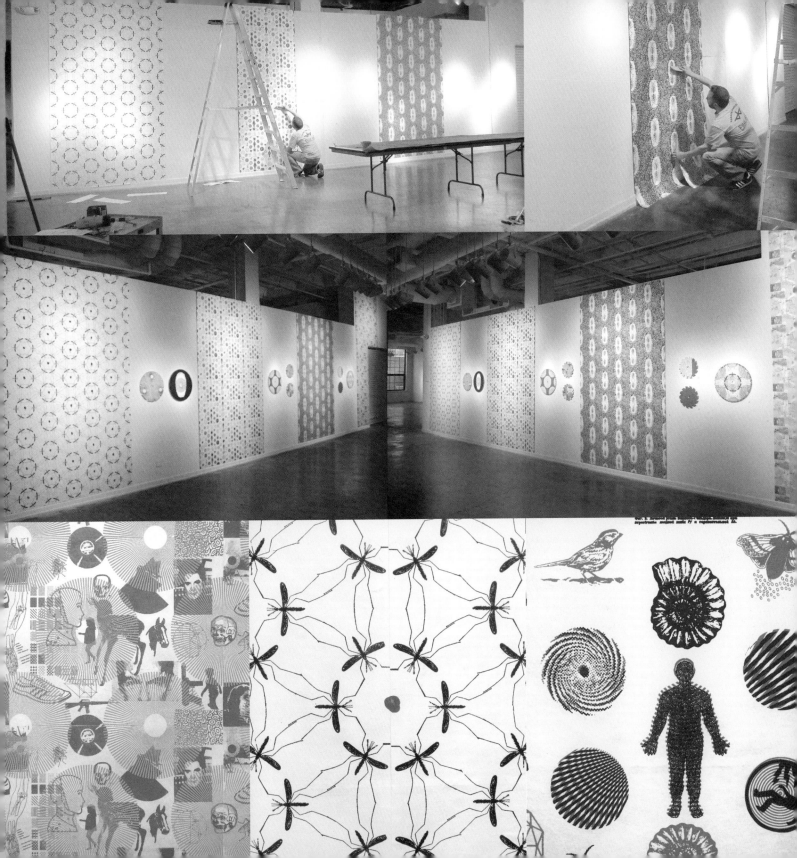

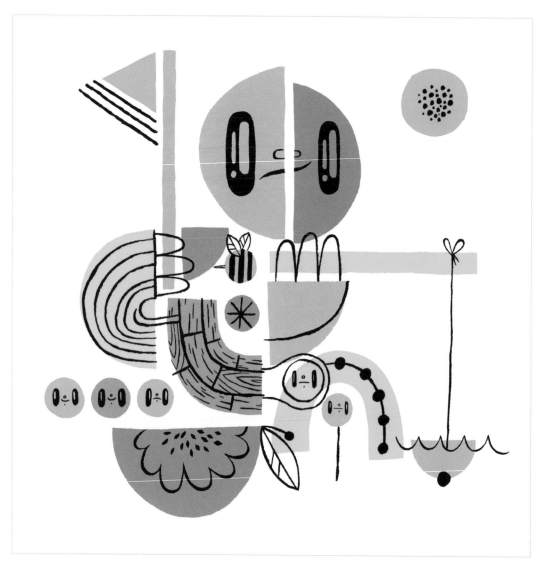

Title: *Sayonara Gohan*

Designer: Jesse LeDoux

Size: 18 x 18 inches [45.7 x 45.7 cm]

Printing Process: Screen print

Number of Inks: Four

"This print was in response to having just moved back to the U.S. after living in Tokyo for a little over a year. Sayonara gohan means 'goodbye rice' in Japanese. On one hand, it was nice to be back to a place where I had a little space to once again spread out (my apartment in Tokyo was 350 square feet [46.5 sq. meters] and be able to fully articulate what I wanted to say (my Japanese vocabulary consists of yes, no, please, thank you, sorry, hello, good-bye, toilet, beer, and whiskey—which the last three happen to be toilay, beeru, and wisukee, respectively). On the other hand, my time in Japan was amazing, and to say that I miss it is a drastic understatement. It's a magical place. I think about it every day."

NOTE: LeDoux uses the overprint of the final screen of black to tie in all of the elements and add his own unique illustration style to what would otherwise be simple shapes.

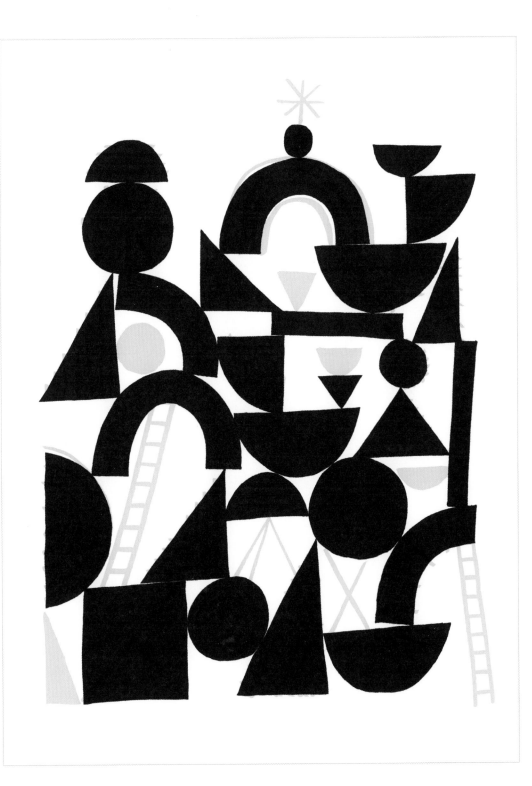

Title: *Permanent Shadow*

Designer: Jesse LeDoux

Size: 16 x 20 inches [40.6 x 50.8 cm]

Printing Process: Screen print

Number of Inks: Two

"There is a portion of a bank's stone steps on display at the Hiroshima Peace Memorial Museum. On the steps lies a circular, discolored area of what is now known as a 'permanent shadow.' A person sat in that spot on August 6, 1945, waiting for the bank to open as the atomic bomb dropped. The discoloration is all that was left of him. It made me think of how fragile life can be and how every action we take affects those around us. This print is a reminder to me to always try to be the best person I can, even if my actions go unnoticed."

NOTE: LeDoux creates a startling effect by printing a layer of white down first, followed by the black shapes, making for a subtle varnish like effect.

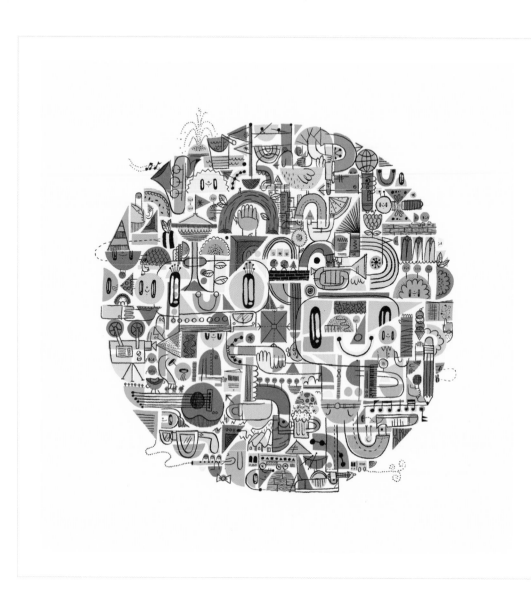

Title: *Bumbershoot*

Designer: Jesse LeDoux

Size: 18 x 18 inches [45.7 x 45.7 cm]

Printing Process: Screen print

Number of Inks: Seven

"As I put the finishing touches on Bumbershoot's 2011 campaign (advertisements, merchandise, brochures, pamphlets, posters), the organizers and I agreed that we should make a commemorative screen print. Since the various elements for the festival were all printed with four-color process (except the merchandise, of course), I was tasked with the challenge of re-creating my carte blanche color palette using as few colors as possible. I was able to distill about sixteen visible colors into seven printed. Some elements overprint, while others knock out. Some overprint the overprint. And even others overprint the knockout. To add extra visual depth, most of the colors have a little metallic mixed into the ink, which makes the print shimmer under the right light."

NOTE: The addition of the metallic base allows for a very special visual experience that can only be enjoyed by those that actually own one of the prints.

THE MOST CHALLENGING PIECE I EVER PRINTED

Sonnenzimmer

Sonnenzimmer's Nadine Nakanishi says, "The *Insound* poster series created technical issues because we had decided to go with a diffusion dither to do the four-color process, instead of using halftones. We really underestimated the dot gain in relation to the viscosity of the inks."

Butcher agrees that this was the most challenging project they've ever done. "It was insane in terms of scale as well: Ten posters at ten to twelve colors each, that, when placed together, form a larger image. We had limited experience with four-color process screen printing before this anyway," he says. "We definitely learned a lot, with juggling the ink consistency to decrease dot loss, to using the right resolution of dither to avoid moiré patterns, to selecting the proper mesh count for our screens."

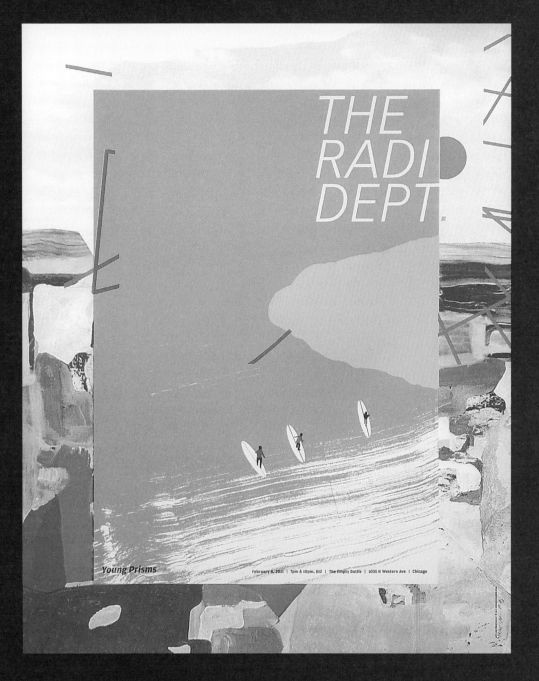

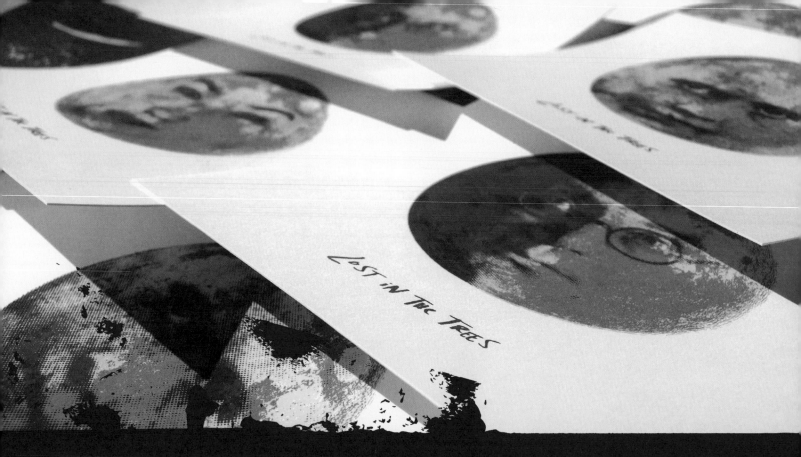

Lost in the Trees

I WANT MORE COLOR
(AND I DON'T WANT TO PAY FOR IT)

Bad People Good Things

Many designers start off doing whatever they feel like they need to do to get an amazing solution, and then figuring out after the fact how they can afford to screenprint it, paring away until they reach an acceptable number of colors to bring their creation to life. I always like to approach a problem with as much information as possible on hand, including budget, and then I see what walls have been erected against my creative instincts, so I can figure out ways to climb over them (or dig a tunnel under them.) Oftentimes, knowing that a client can afford only two, or three colors, or a certain size, will directly

I find that limitations tend to bring out the best in me, and my work, maximizing my abilities, and I strive to do the same with my printers. This is a great example, created for Lost in the Trees. They knew that they wanted an unusual size, and a fairly large print run, so I went to work on the math. Figuring out two vital things—that they could afford three colors, and that we would be leaving some of the sheet on the cutting room floor, I was determined to circumvent both.

The second part was sorted out when I came upon the idea of printing a card set on the side of the sheet, leaving us with a big square poster for the fans to enjoy. The color issue was a little more complicated. Experimenting with colors, while simultaneously working on the design, I arrived at three that worked well together, and also had the ability to create additional colors through overprinting. I know I was going to be putting the fine

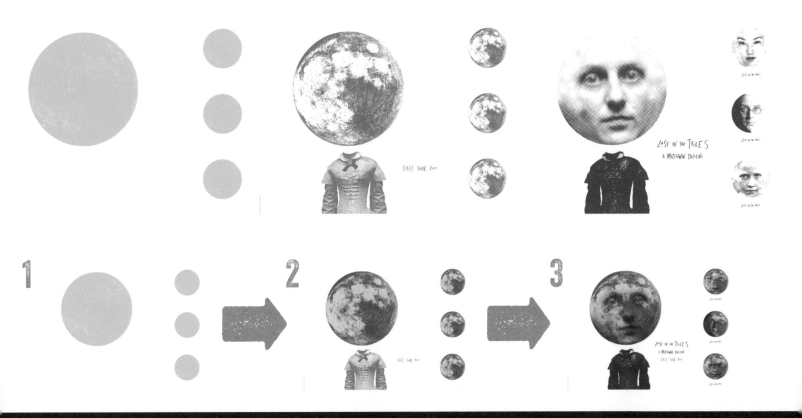

folks at Grand Palace Silkscreen, who would be printing the job for me, through their paces, but they relish the challenge almost as much as I do. It is the tie that bonds us. It also allows me to make decisions like this, knowing that they have the abilities to see my vision through, and even enhance it along the way.

One of the tricks I have discovered over the years, is to have one light color, as well as two medium colors, when looking to build five colors from three inks. The tendency is to have a dark color in the mix, but that dominates things, and limits the potential in overprinting, whereas two mediums can print on top of one another to form a dark, and still create additional colors with the light.

For this project, I knew the colors that would work well with the client and their audience, and through trial and error I was able to arrive at a trio that would be versatile on press.

STEP ONE PMS 116 forms the yellow base with the moon image. This is one of my favorite yellows to work with, because it's bright and warm. This art is vector-based. You generally print the lightest color first.

STEP TWO PMS process cyan then goes down. This is also vector-based, and I will use it to create the contrast and definition in the moon shape, as well as underprinting the body/dress to create all of the subtle details there.

STEP THREE PMS 512 then finishes it off, adding in the color on the body/dress and the faces on the moons. This screen is a mix of vector for the body and halftone images to add another texture and feel for the faces.

Now, you see yellow and light blue and purple on the ink-mixing table, yet two of the main colors in the piece aren't even present.

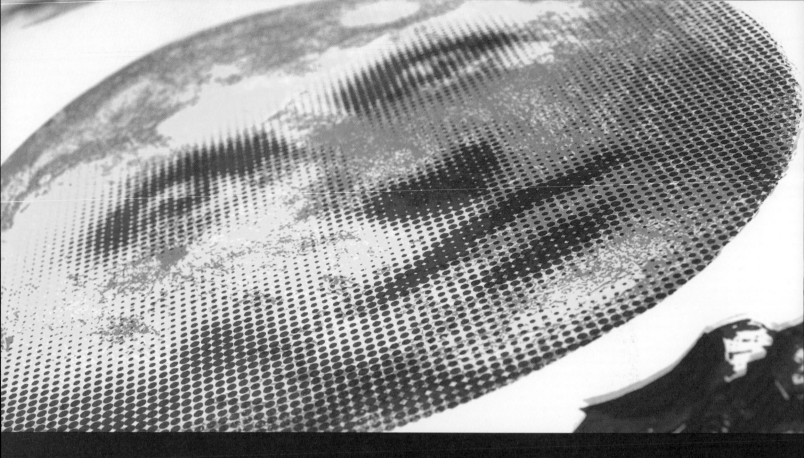

What gives? There is a ton of red and green all over this thing, surely those are ink colors, too. Well, here is where the magic of stretching the economics of your piece comes in.

The green is formed using the yellow as a base for the cyan. This requires that your printer work with the opacity of the ink so that the overprint has the desired effect, but the trade-off is less worrying about registration and trapping. If I had done the green as a straight ink, there would have been tons of trapping to sort out, and an extra screen, ink etc, to pay for, so I was careful to use the yellow as an almost flat shape, making a solid base to run the cyan over. The cyan plays the reverse role in the body, as it creates a darker and more vibrant purple to bring out the details. The purple then plays nice with the yellow to make the gorgeous deep red that you see in the faces.

When all three overlap, they create a dark brownish color that serves to make shadows on the moon and add depth and contrast to the overall image.

To get the final product I was hoping for, the viewer actually sees two colors that don't really exist, but are made on the page during the printing. They dominate the proceedings, with the three raw colors making only a cameo appearance. Yet, none of it is possible without that specific team of inks coming together in the special ways that they have.

Three colors = five colors.

That's the kind of math I could do all day.

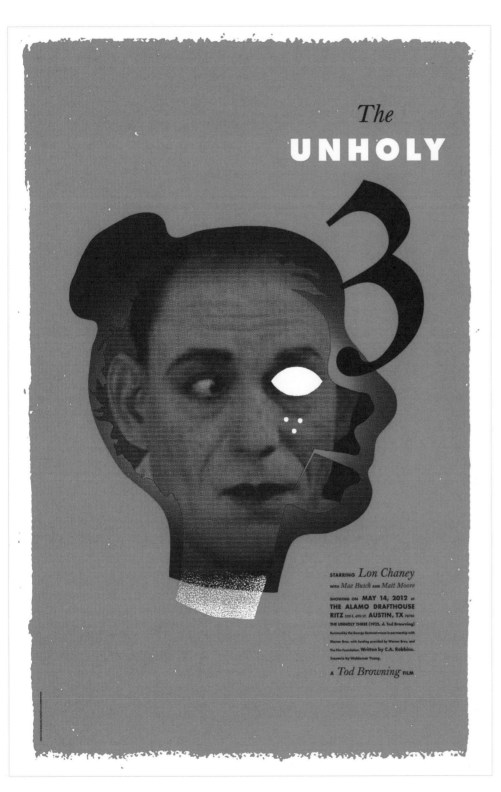

Title: *The Unholy Three*

Designer: Jeff Kleinsmith

Size: 18 x 24 inches [45.7 x 61 cm]

Printing Process: Screen print

Number of Inks: Three

"This was created for a screening of the Todd Browning classic. I was pretty excited because this is also the last silent film that Lon Chaney made."

NOTE: Kleinsmith makes the most of his available inks but also defers to what is best for the final product, bringing in a flat gray here rather than try to stretch the black via aby further, as it is already working hard on creating the face.

THE HENLEY COLLEGE LIBRARY

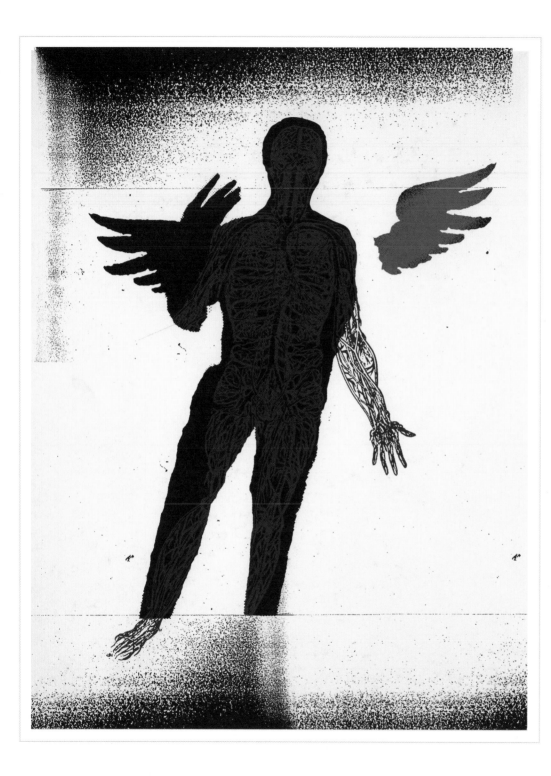

Title: *Nirvana Exhibit*

Designer: Jeff Kleinsmith

Size: 18 x 24 inches [45.7 x 61 cm]

Printing Process: Screen print

Number of Inks: Four

"Commissioned by the Experience Music Project to coincide with their exhibit entitled Nirvana: Taking Punk to the Masses, a handful of poster artists were asked to contribute a screen print that was inspired in some way by the band and their music."

NOTE: One of the printing techniques that is so vital to these prints is the overprinting, building out additional colors and creating interesting effects. It also makes you question and investigate how different parts came about, giving the viewer an added joy.

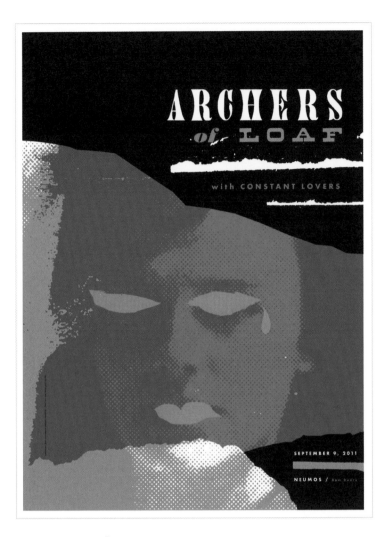

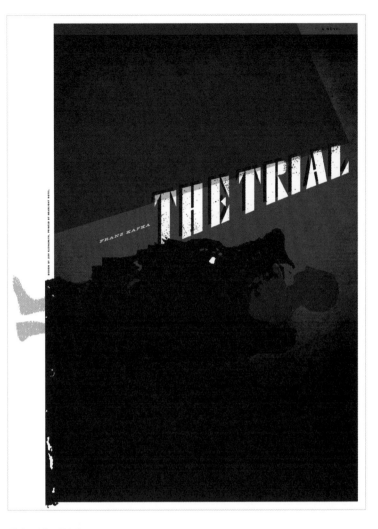

Title: *Archers of Loaf*

Designer: Jeff Kleinsmith

Size: 18 x 24 inches [45.7 x 61 cm]

Printing Process: Screen print

Number of Inks: Four

"Unlike most posters that I do, this one came together pretty easily."

Title: *The Trial*

Designer: Jeff Kleinsmith

Size: 18 x 24 inches [45.7 x 61 cm]

Printing Process: Screen print

Number of Inks: Three

"This print was inspired by The Trial *by Franz Kafka, for the Required Reading exhibit at Gallery 1988 in Melrose, California."*

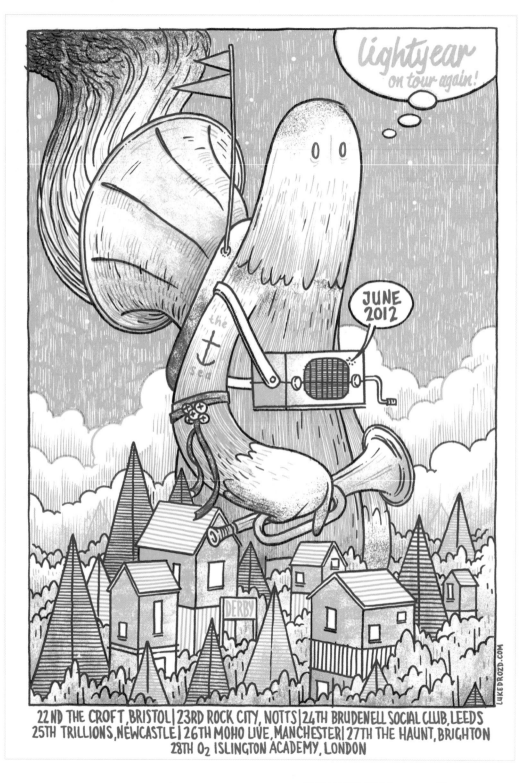

Title: *Lightyear*

Designer: Luke Drozd

Size: 16.5 x 23.4 inches [42 x 59.5 cm]

Printing Process: Screen print

Number of Inks: Three

NOTE: Every pass of color is informed by Drozd's unique linework and illustration style. This adds to the collectible nature of his work for his fans.

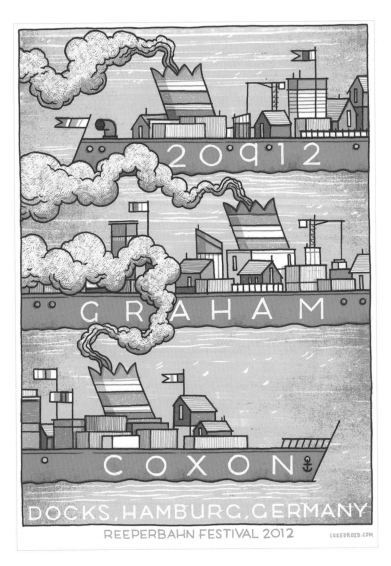

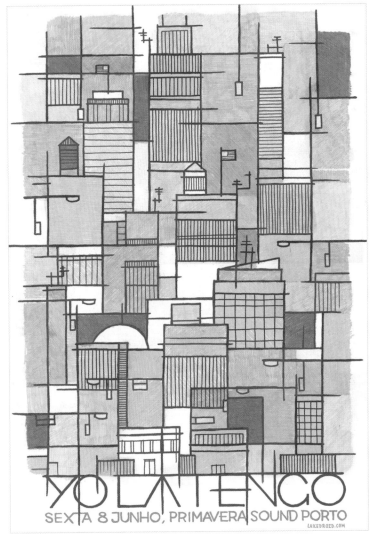

Title: *Graham Coxon*

Designer: Luke Drozd

Size: 16.5 x 23.4 inches [42 x 59.5 cm]

Printing Process: Screen print

Number of Inks: Three

Title: *Yo La Tengo*

Designer: Luke Drozd

Size: 16.5 x 23.4 inches [42 x 59.5 cm]

Printing Process: Screen print

Number of Inks: Three

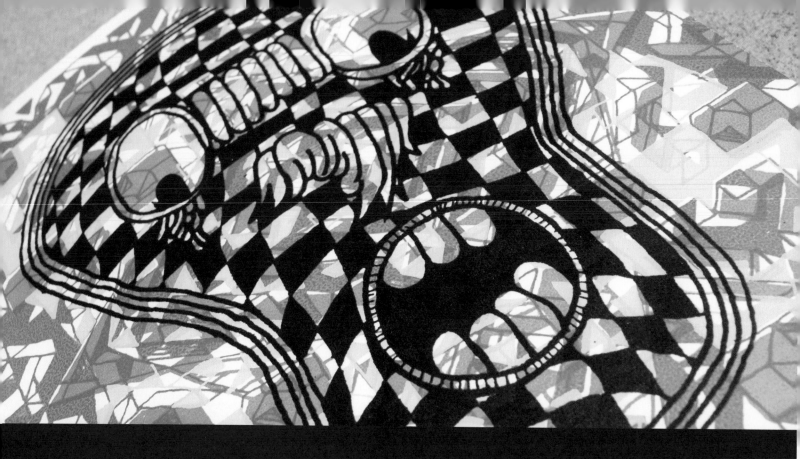

THE COOLEST THING I HAVE EVER SEEN

Seripop's "Monster Guarded"

Perfectly combining the burning desire to just get out there and visually realize what is going on in their heads and their hands—with the tactile rewards in laying down ink on paper—Montreal's Seripop has challenged both the design and art world with their barrage of work and unique outlook on imagery and typography. Chloe Lum and Yannick Desranleau have created some of my favorite work of all time, forever altering how I view screenprinting, and design in general.

In creating a collection of art prints, they sought to tie them all together in a self-sufficient book, forming their own little art

the freedom to fully exploit their mix of detailed and loose illustrations, while going bonkers with the number of inks, and layering them on with varying degrees of opacity, for thin transparent ghostly applications in some areas, and thick muddy forms in others. The interplay of under- and overprinting is simply incredible. At every turn, there is a fascinating indication of what their hands create, whether via their drawings, or the way in which they mix and pull the ink across the page.

Making the most of their materials, the piece uses house paint for ink (as is the case with most of their work) and various papers. Incorporating different weights and sizes for impact, the book has fold out portions that occur in unexpected fashions, and one has to sit back in amazement that two little staples somehow managed to contain all of that energy and brilliance.

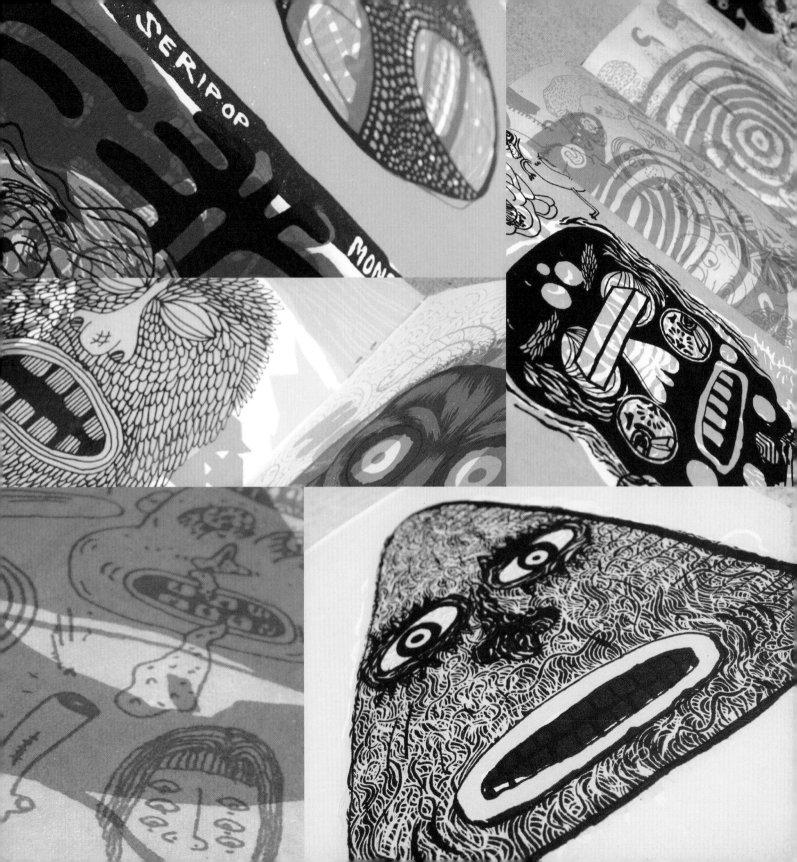

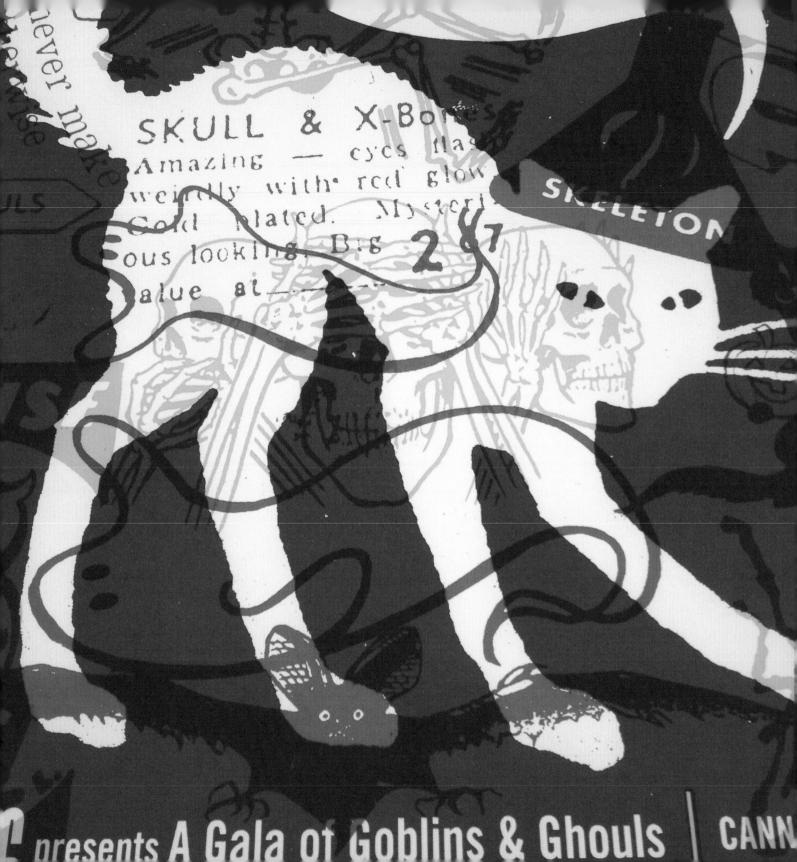

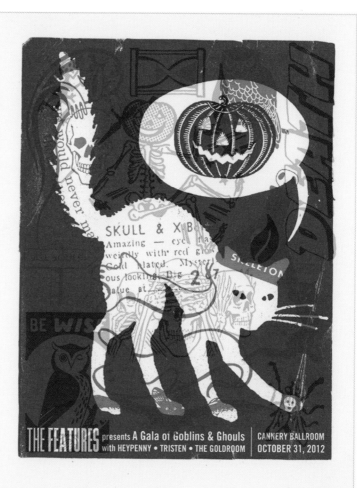

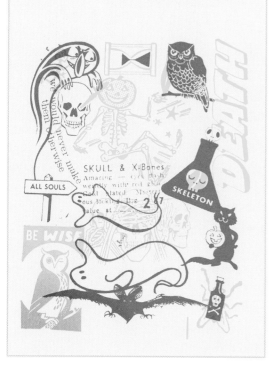

Title: *The Features*

Designer: Andrew Vastagh

Size: 18 x 24 inches [45.7 x 61 cm]

Printing Process: Screen print

Number of Inks: Three

NOTE: Seemingly random bits of art, related only in their connection to Halloween, go down as the first yellow pass, and then the second magenta pass, find themselves suddenly all coming together with the overprinting of the final blue screen. This creates incredible interactions, where a bat peeks out through a paw and a skull bottle and fly are held in hand, and a toxic beaker serves to cap the cat in dramatic fashion.

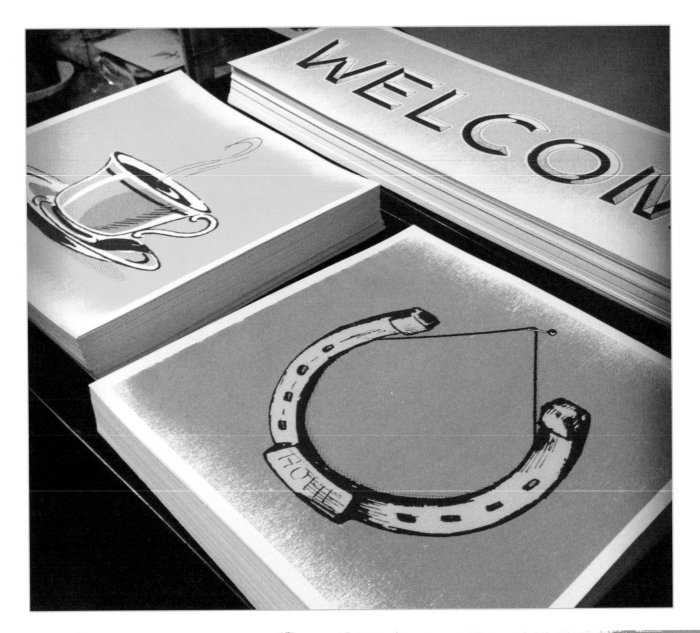

Title: *Welcome*

Designer: Andrew Vastagh

Size: Various

Printing Process: Screen print

Number of Inks: Three

NOTE: BOSS Construction's Andrew Vastagh has a keen eye not only for new business opportunities in creating art prints around a welcome sign, a lucky horseshoe and a comforting cup of coffee, but also for maximizing his resources. Using three inks and one sheet, he produces three new prints for sale, while taking on the cost of printing only one.

THE MOST CHALLENGING PIECE I EVER PRINTED

Jesse LeDoux

"I did a print for Seattle's Woodland Park Zoo as part of a print series to raise awareness (and funds) for certain endangered animals. I chose the Red-crowned Crane. Comprised of red, black, and four varying shades of earthy tan/gray inks, the six-color print became a true challenge when it came time to create the separations. I wanted the print to have a delicate subtlety to match its feathered subject. This meant the gray inks had to overprint and/or knock out of each other to achieve upwards of ten visual colors. It felt like computer programming, except for paper: A + B - C - D = a colder dark gray, and C + A + B - D = a medium creamy gray. It took a detailed diagram (and a couple of days) in order to get it right to convey to the printer. Most other artists in the series opted to do a giclee print. I'm willing to bet that they slept better."

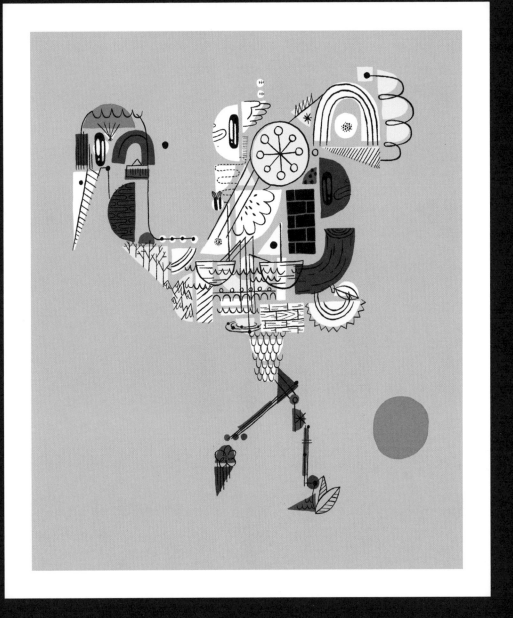

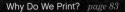

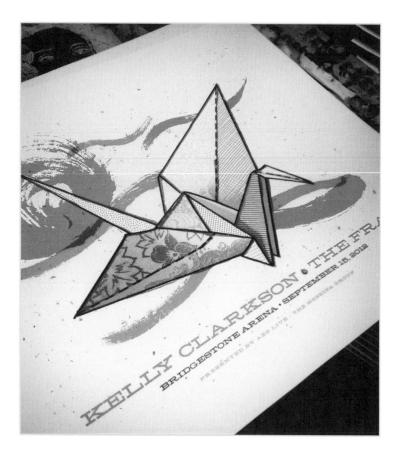

Title: *Kelly Clarkson*

Designer: Andrew Vastagh

Size: 18 x 24 inches [45.7 x 61 cm]

Printing Process: Screen print

Number of Inks: Three

Title: *Eric Church*

Designer: Andrew Vastagh

Size: 18 x 24 inches [45.7 x 61 cm]

Printing Process: Screen print

Number of Inks: Three

NOTE: Vastagh is the master of building depth and interest with added textures, while keeping them from overwhelming the images. It might be a brushstroke, or a little photocopier grit, or a heavy halftone pattern, but it always serves to accent the piece for the better.

Title: *Andrew Bird*

Designer: Andrew Vastagh

Size: 18 x 24 inches [45.7 x 61 cm]

Printing Process: Screen print

Number of Inks: Three

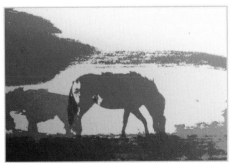

MY PRINT SETUP: DIRK FOWLER, F2 DESIGN

To convert his former sunroom, Dirk Fowler added two letterpress proof presses, a wire storage rack, a few drawers of type/ad cuts, and an area for mixing ink. "My studio is small, but I keep most everything within arms' reach, making it amazingly efficient," he explains. "I also use unconventional methods for letterpress, like cutting and gluing gasket rubber and other substances to an MDF base that is almost type high. I am always finding and collecting new things and wondering if I can use them for printing. I use wood type and metal monotype, ink, brayers, putty knives, lock-up furniture, craft knives, among other things to get the job done."

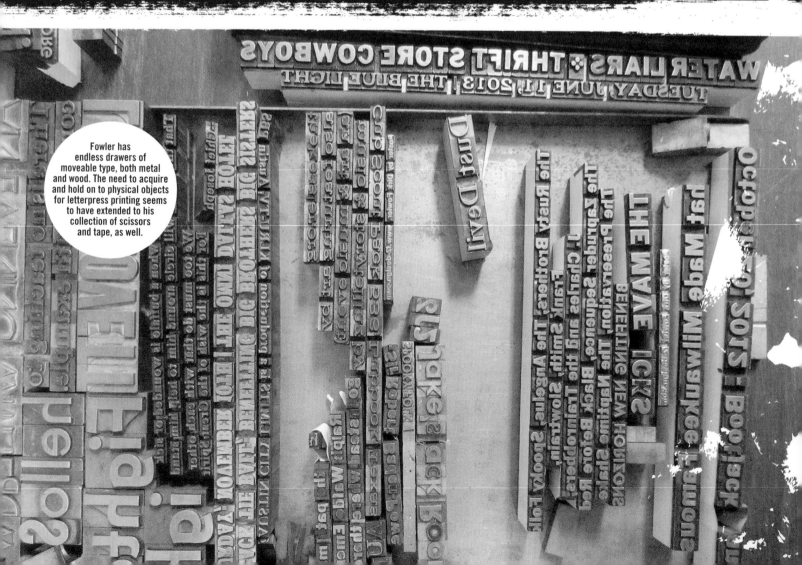

Fowler has endless drawers of moveable type, both metal and wood. The need to acquire and hold on to physical objects for letterpress printing seems to have extended to his collection of scissors and tape, as well.

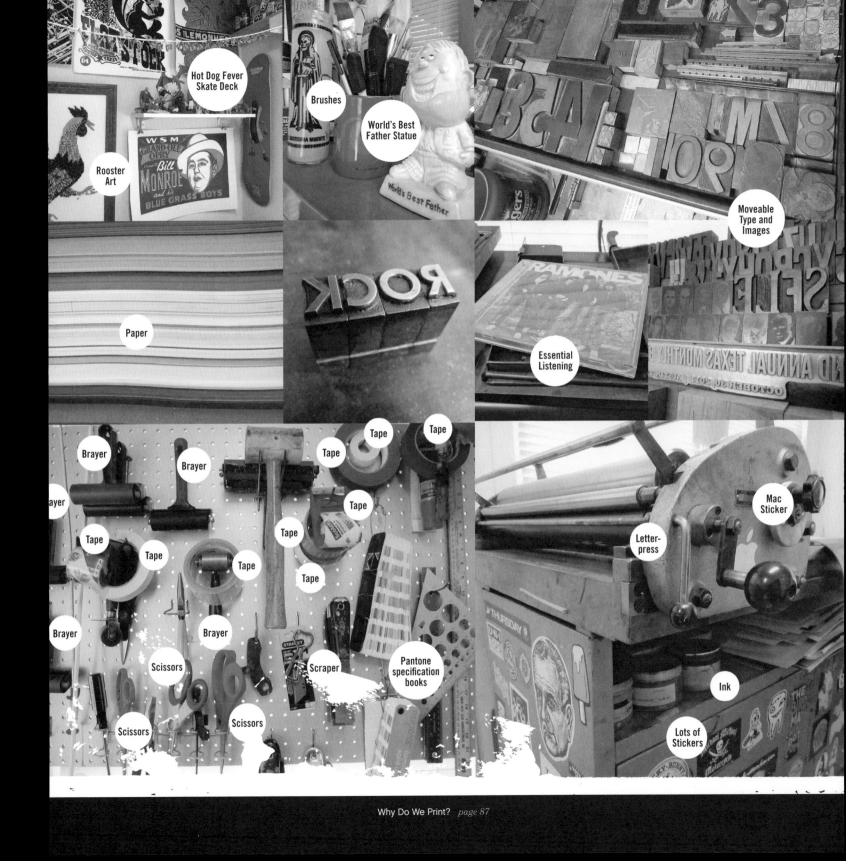

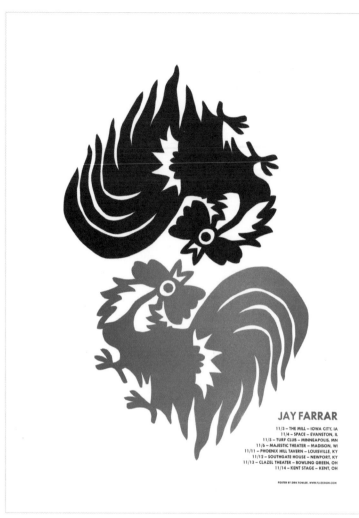

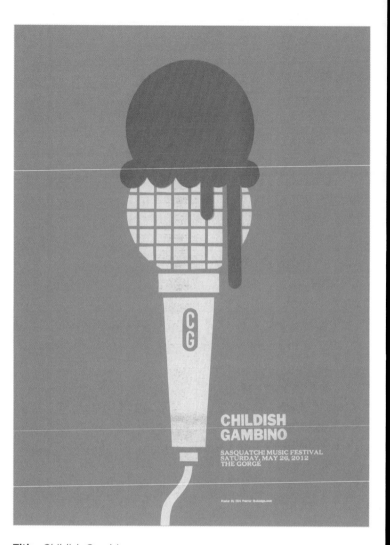

Title: *Jay Farrar*

Designer: Dirk Fowler

Size: 18 x 24 inches [45.7 x 61 cm]

Printing Process: Letterpress

Number of Inks: Two

"I like simple things," explains designer Dirk Fowler. "I hand cut all of my own printing plates and, when possible, I like to bring this simplicity into the production process itself. In this case, I cut only one image of the rooster, printed it in red, then turned the same plate upside down and printed it in black." He smiles and adds that "sometimes, my printing process seems to be more like assembling a puzzle than making art."

Title: *Childish Gambino*

Designer: Dirk Fowler

Size: 18 x 24 inches [45.7 x 61 cm]

Printing Process: Letterpress

Number of Inks: Two

Going all metallic, with metallic inks atop copper metallic paper stock, "I really liked the contrast of the blinged-out metallics with an ice cream cone," laughs designer Dirk Fowler. "I felt that the subtle humor fit the artist and his brand of rap perfectly."

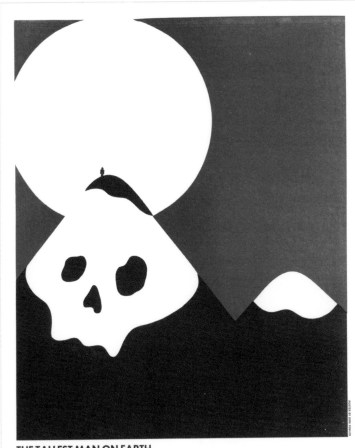

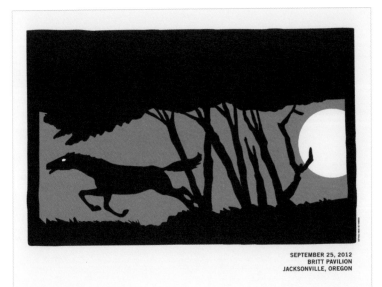

Title: *Wilco—Jacksonville*

Designer: Dirk Fowler

Size: 18 x 24 inches [45.7 x 61 cm]

Printing Process: Letterpress

Number of Inks: Two

Title: *The Tallest Man on Earth*

Designer: Dirk Fowler

Size: 18 x 24 inches [45.7 x 61 cm]

Printing Process: Letterpress

Number of Inks: Two

Oftentimes, small-press printing is about embracing the inconsistencies. "It is really difficult to get good, consistent coverage on large areas of solid color," admits designer Dirk Fowler. "Luckily, the random textures in the blue and black parts of the poster work really well aesthetically for an artist like The Tallest Man on Earth and highlight the unique nature of each individual print."

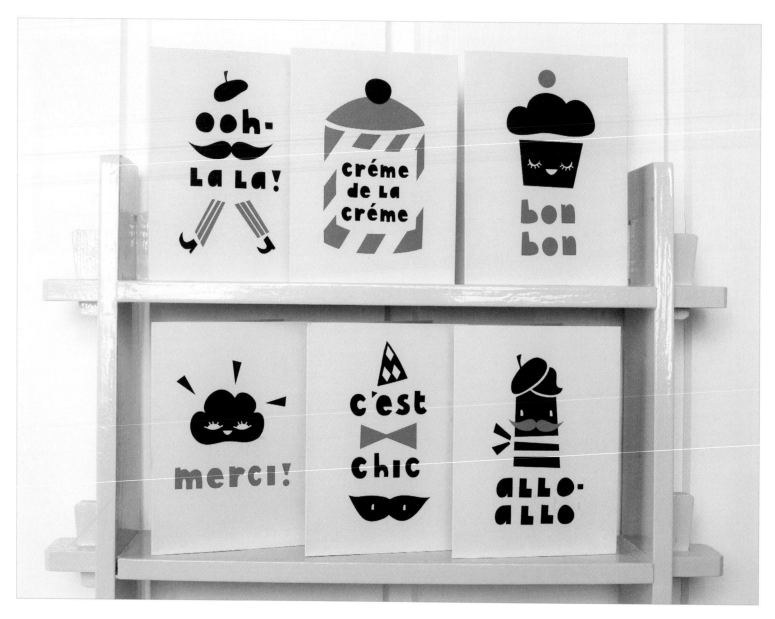

Title: *Paris Collection*

Designer: Darling Clementine

Size: 9 x 11.4 inches [22.9 x 29 cm]

Printing Process: Screen print

Number of Inks: Two

NOTE: Darling Clementine always projects a fun personality, even when keeping their illustrations to a graphic minimum.

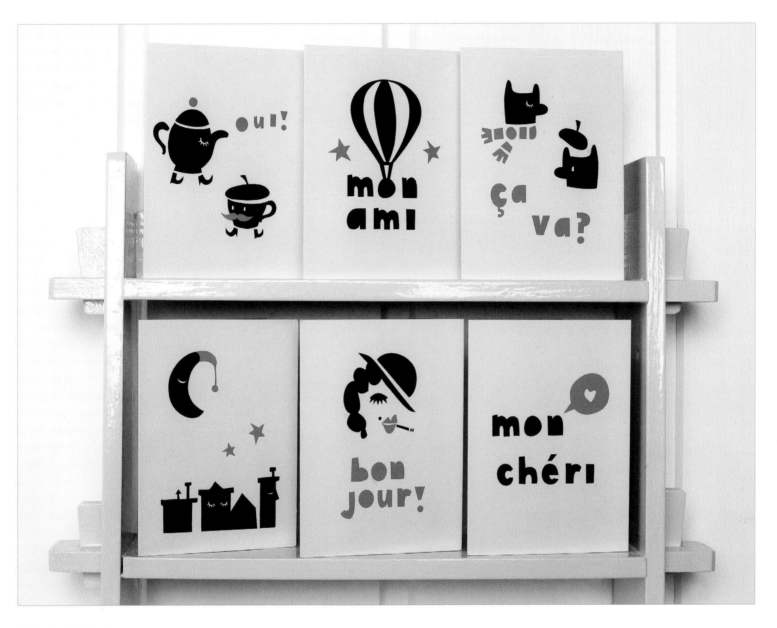

Title: *Paris Collection*

Designer: Darling Clementine

Size: 9 x 11.4 inches [22.9 x 29 cm]

Printing Process: Screen print

Number of Inks: Two

CUTTING EDGE TO CUDDLY KITTENS

Now that we have gone over how these amazing pieces make it onto press, it is time to talk about all of the incredible work out there. Some designers and artists have found their footing in exploring the fringes and pushing the boundaries, while others have found a comfortable spot where their style finds wide acceptance and offers a warm glow to the recipients. The push and pull is in finding where their strengths lie, as well as the simple task of appealing to an audience that seeks out and purchases their work.

close-up of a print by Jay Ryan/The Bird Machine Inc.

INNOVATIVE BLEEDING-EDGE WORK

Some people started at this point and just never looked back. Their brains seem to operate on a different plane than the rest of ours. It takes a moment to wrap your head around the work in front of you, unhinged and wildly creative, and in the best instances, you may never fully do so. I can't recall a time when Seripop or Sonnenzimmer's work didn't fall into this category. Not only do they push at the boundaries, they knock right through them, set up new boundaries, and then obliterate those.

Perhaps the designer that personifies this the most for me is Zeloot. Elusive as she is, shadowed in the Netherlands by her mysterious moniker, her work references illustrations from the 1960s as if viewed from another planet, and quite possibly on serious psychedelic drugs. The actual person creating these pieces is nothing like the scenario described, but her ability to bring such a unique vision, from pen to ink to paper, most certainly is. Intersecting figures and flowing lines forever challenge your ability to tell where they start and where they end. It's not just in her groundbreaking imagery. Her use of the ink itself is innovative. Many of the pieces in this book make the most of two or three inks, yet Zeloot uses them to create multiple colors in ways that no one else even approaches. Every single piece that I hold in my hands reveals another decision that I couldn't see anyone else making, and it always betters the final product.

Others stun by reinventing icons and images that you thought you knew so well. Jason Kernevich and Dusty Summers, the dynamic duo that makes up The Heads of State, did so when they created a gallery series around the Civil War. Located in Philadelphia, the studio could have been excused had they decided to simply mine the tried-and-true sepia-toned feel of the past. Instead, they took the symbols and words from the nation's strife, stripped them down to simple forms, and used bold and bright colors, along with a layered approach, to create something breathtakingly modern.

Typography comes under assault via experimental hands once all the shackles of traditional design work are removed. What better place to push the readability of a word, or all of the words for that matter, than something of which there are only fifty in the world and that commemorates an event rather than promotes it beforehand. Some people, like Zwolf in Berlin, seem to create a new font and visualization of the alphabet for every project. Zeloot matches her wild imagery with similar adventures via her letterforms. Chances are being taken wherever appropriate, and often in areas where the distinction is not so clear.

Bold and courageous imagery dominates the work of certain designers, while texture seems to creep over the corners and overtake others. The key is the ability to fully immerse themselves into the process of experimentation and discovery, often making mistakes along the way and showing us the growing pains and eventual victories that are the result. The subsequent work can be a fascinating reveal into their process. You can study Sonnenzimmer prints for days, watching as each layer slowly peels away to showcase a new set of intersections as you try to make sense of how all of this beautiful ink ended up here in this crazy fashion. Or it can emerge like a fever dream, an apparition trying to pull you across the visual divide and into another world entirely, like Jeff Kleinsmith's haunting, broken specter in his Nirvana print for the Experience Music Project.

No matter how it comes to the forefront, once you have laid eyes on it, it is unforgettable.

FOLKSY ART

Just as there is a knowing warmth and comfort in owning a piece that has been produced by hand, the same is true for creating work that scratches that same itch. Emanating from equal parts familiarity and creativity, these objects are meant for the home—something to bring a smile to your face when you enter the kitchen every morning, add a personal touch to a room, and just bathe everything with a soothing glow or tender smile.

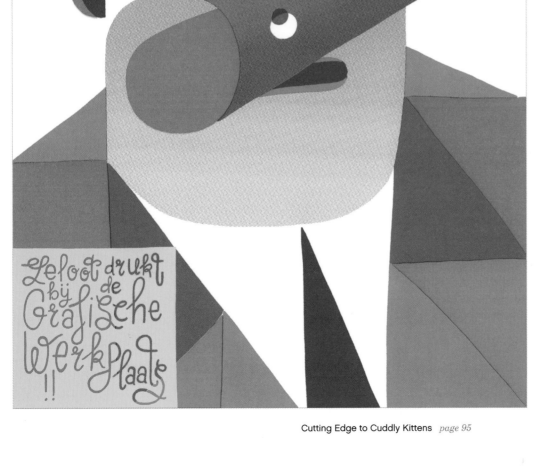

Title: *Zeloot drukt by de Grafische Werk Plaats*

Designer: Zeloot

Size: 16.5 x 23.6 inches [42 x 60 cm]

Printing Process: Screen print

Number of Inks: Three

NOTE: Combining a love of '60s graphics from the likes of the Push Pin Group, with her own madcap sensibility, Zeloot pushes her prints in every way, whether through the illustration style or typography or the application of ink with tricky blends and overlays.

Andrew Vastagh of BOSS Construction harks back to the Bluegrass State's dining experience with his clever series of welcome/coffee cup/horseshoe. Frida Clements also draws from horses, but this time through her Swedish roots, combining in her whimsical drawings of flowers; her art prints always exude an underlying warmth. Perfectly summing up the appeal of her work, and that of all small-press printers, she adds that "these are tactile and dynamic forms of art, but it isn't so highbrow as to feel exclusive. It's old school and new school at the same time." The Norwegian duo of Ingrid Reithaug and Tonje Holand, the charm factory that make up Darling Clementine, take up that torch by bringing a graphic application, and occasional pop-art flourish, to this marketplace. Frisky foxes and dancing girls cavort with Parisian journeys and peacocks and sunrises, providing irresistible smiles to the viewer.

Kansas City's letterpress powerhouse, Hammerpress, creates line after line of products that always hit the bull's-eye where this is concerned. Never losing sight of their masterful printing, they also delight in saying something as simple as "gracias" in a new way. They have also brilliantly opened up a new market of Mother's Day cards that balance out the sugar with a little more spice than Hallmark provides. My mom loved hers this past year!

Aesthetic Apparatus goes right for our stomach with their new line of prints, highlighted by a bright color palette and simple graphics. Few things are as comforting as a big stack of pancakes or a deviled egg (or a pint of beer for that matter). They add in some retro flare for their take on old shopping flyers promoting both "Meat" and "Veggies." By the time they peel back their undying love for the state of Minnesota, via the most charming bicycle-riding state that anyone has ever witnessed, it is enough to melt all of the snow in the Twin Cities.

CUTE AND CUDDLY FOR THE KIDDIES (YOUNG AND OLD)

Some of the same folks that dominate the edgy side of the printing game also have a soft spot. Whether brought on by having children, or a sweet tooth, or just a general need to appeal to a fun audience, they showcase an ability to change up their game and brighten up a new nursery in a flash. Then there is Jay Ryan from The Bird Machine. Jay trots out drawings of sailboat-riding bunnies, monkeys all dressed up and late for a date on their bicycle, and a garage filled to the brim with dogs, butts facing outward.

Sure, his bears may occasionally sharpen the blade on an axe, but he also has a gorilla and a turtle in what appears to be a serious and thoughtful discussion. The amazing part about Jay's work is that he employs the same loose and fun style, and proliferation of animals, no matter who the client might be. Heavy sludge-metal band? Bring on the squirrels! He doesn't discriminate. Every client needs some of the levity, humor, and style that Jay brings to the table, and he delivers it to them time and time again.

Because such a glut of art in the marketplace is aimed at children, truly talented people can easily shine by virtue of their style and craft. It can be a rewarding pursuit on all levels. Some find that their style of illustration leans toward this avenue, or their forms of inspiration have always been the greats of past children's books and animations. It may simply make business sense. More importantly, it can leave the designer or artist filled with happiness, as they impart a little sunshine down onto the page.

Bringing his delightfully graphic illustration style into play, it is inevitable that Tad Carpenter's fun, yet sophisticated, characters will appeal to all ages. His Alphabet print serves as a great learning device, as well as a wonderful and engaging visual, and he takes that same approach with the adult audience that adores his prints on wood to hang in their homes. His sense of humor comes across in his Sad Santa cards and ornaments, but it is really in his Monster Mix Up print series that it all comes together. A collection of split halves, with the option to change up tops and bottoms and create your own unique monster, it is a tried-and-true trick. Carpenter brings a quirky feel and playful color palette to life in his creatures. Living

(continued page 99)

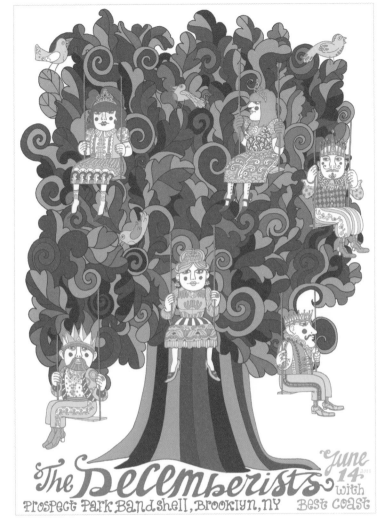

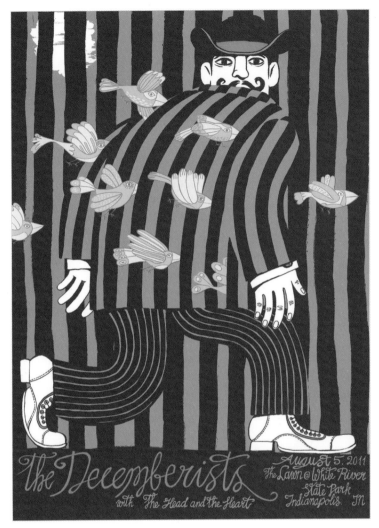

Title: *The Decemberists, Brooklyn*

Designer: Zeloot

Size: 17.7 x 23.6 inches [45 x 60 cm]

Printing Process: Screen print

Number of Inks: Four

Title: *The Decemberists, Indianapolis*

Designer: Zeloot

Size: 17.7 x 23.6 inches [45 x 60 cm]

Printing Process: Screen print

Number of Inks: Four

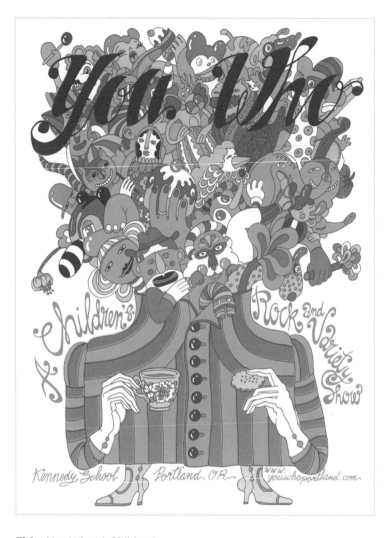

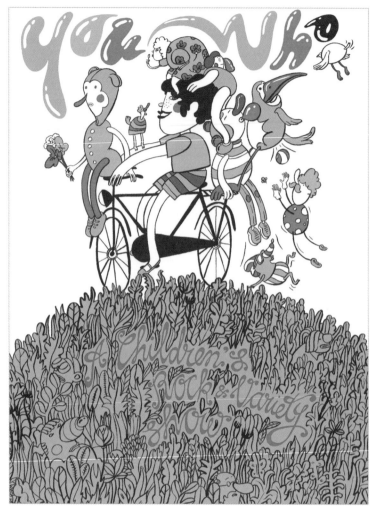

Title: *You Who: A Children's Rock Variety Show*

Designer: Zeloot

Size: 17.7 x 23.6 inches [45 x 60 cm]

Printing Process: Screen print

Number of Inks: Three

Title: *You Who: A Children's Rock Variety Show*

Designer: Zeloot

Size: 17.7 x 23.6 inches [45 x 60 cm]

Printing Process: Screen print

Number of Inks: Three

in a world that is half retro morning cereal box and half modern animation, he widens eyes at every level. Seeing the entire series before them, families can argue for days about the best combination for the perfect monster.

Greg Pizzoli has seemingly been training to illustrate a celebrated children's book his whole life. He will get the chance soon enough with the release of his nervous-crocodile tale, "The Watermelon Seed." In the lead-up to its completion he was a busy bee, producing everything from zines (truly the perfect training ground) to fun-filled prints. Pizzoli's characters always seem to hark back to a simpler time, one that resides in our brains from when life was really just about getting a toy train to work or finding something sweet to sink our teeth into. One thing that seems to run through all of his work is a love of reading—just look at all of the books his animals have buried their noses into! As I said, the man has been training for this moment his whole life.

One of the hardest things to master when you are illustrating for a younger audience is a quality of line. Once someone has arrived at a point of comfort, you often see them ride it out until the very end. If a lot of your work is done by hand, it may come naturally, but even then, you see a beefed-up version of that natural stroke in the work of Jay Ryan and Greg Pizzoli, always

making sure that their figures read immediately and consistently. Scotty Reifsnyder's work amazes me in his broad spectrum of line work and in his balance of large forms held up by little more than white space. His mix of illustration work, design, patterns, color, and balance is wildly sophisticated, yet he applies it to fun and whimsical scenarios. It becomes even more amazing when applied to animated characters that we already know like the back of our hands. His prints detailing moments from *Peter Pan* and *The Incredibles* are filled with delightful textures and a mix of positive and negative space, making the viewer enjoy these modern and past classics in a new light.

Reifsnyder's work taps into the easy connection we feel with the past—a time when we felt that things were cheery and fun and every day was filled with promise. This kind of day can only be captured by a mouse driving a train—à la Greg Pizzoli's hardworking lil' critter. It is a place where adults can see scenarios filled with peril (the pirates are coming!) and laugh it off, knowing that no matter what today holds, everything will turn out fine. Who is afraid of monsters when we can just take off their legs and give them a different pair? Certainly not us! We know that we will tuck our kids into bed, kiss them good night, look over the prints that we have filled their room with, smile, and turn off the lights.

MY PRINT SETUP: GREG PIZZOLI

Sharing his studio with another screen printer "means that our studio has to meet both of our needs," explains Greg Pizzoli. "At the core, our process is essentially the same, but her work is often installation based and it's huge—she'll print yardage of repeat patterns or use ten screens to print a life-size drawing of a piano—and piece them all together on one 8 foot [45.7 x 61cm] sheet of paper. My work is aimed at a more commercial market, and in terms of technique, I usually max out at 18 x 24 inches. My typical print size is 8 x 10 [20 x 25cm], so they can be easily framed. While using "the same process and the same equipment, we do so to very different ends," he explains. "We have built, or had everything in our studio custom built

for us to fit our needs. Everything, except our drying rack, is custom: our print tables were made by an industrial designer to fit directly onto our flat files, so that we have built-in storage under our print area. Our exposure unit can expose screens up to 40 x 50 inches [1 x 1.2 meters] and will burn screens using photocopy paper (with no veggie oil needed!) We built a light-tight box with a Velcro front, so that we can store screens while the emulsion dries, and we had a carpenter make us a shelf to hold all of our squeegees. Not having any one of those things would make printing either impossible, or a lot less fun, and we also have a window and plants. Both are important for a studio."

Plants

Books

Books

Books

Plants

Giant Framed
Print of an
Alligator Eating
a Watermelon

Plants

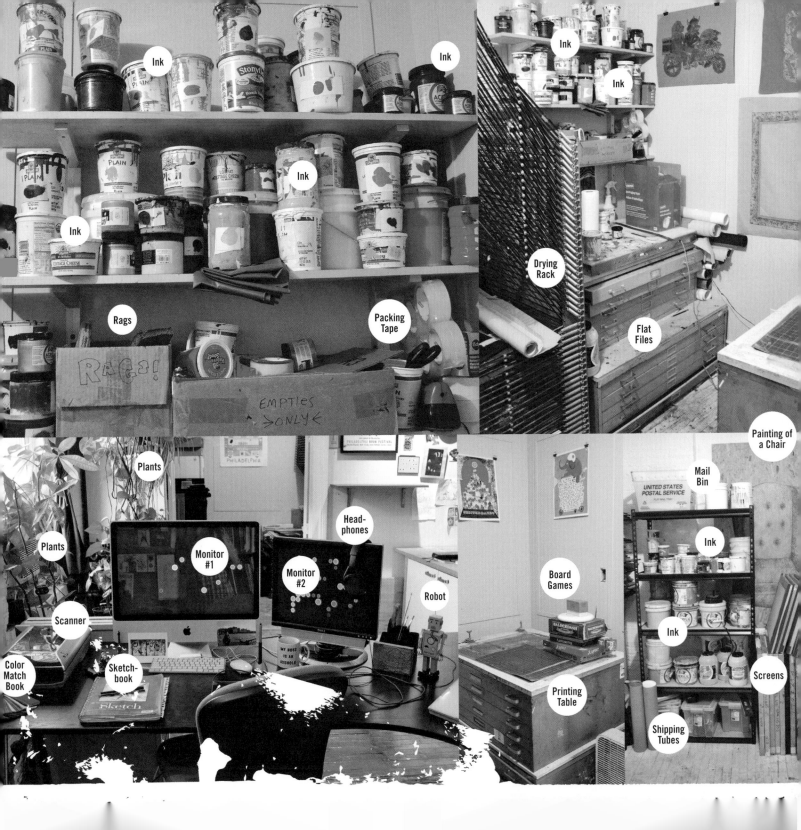

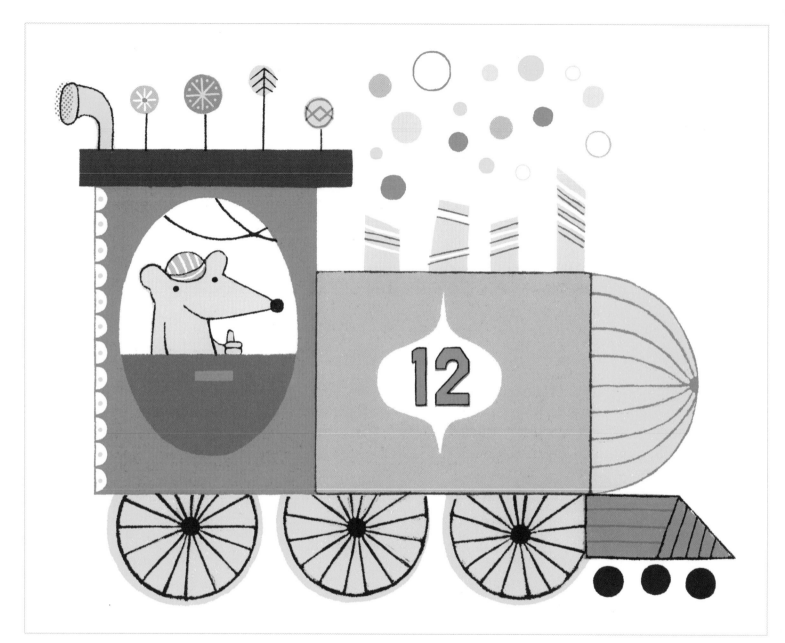

Title: *Number 12*

Designer: Greg Pizzoli

Size: 8 x 10 inches [20.3 x 25.4 cm]

Printing Process: Screen print

Number of Inks: Five

NOTE: Pizzoli harkens back to a classic storybook style, putting his own spin on it, along with his master printmaking skills.

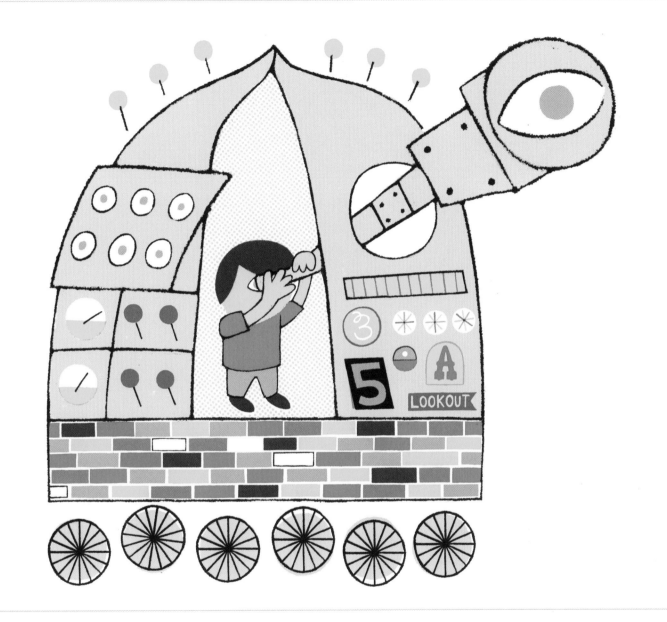

Title: *Lookout*

Designer: Greg Pizzoli

Size: 8 x 10 inches [20.3 x 25.4 cm]

Printing Process: Screen print

Number of Inks: Five

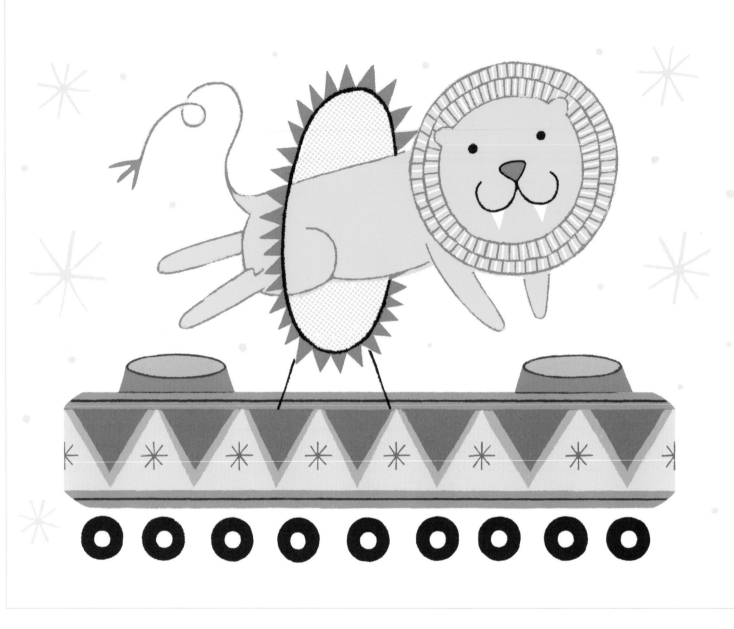

Title: *Lion Car*

Designer: Greg Pizzoli

Size: 8 x 10 inches [20.3 x 25.4 cm]

Printing Process: Screen print

Number of Inks: Five

NOTE: One of the most interesting things to watch for is when Pizzoli uses black to add final definition, and when he holds it back.

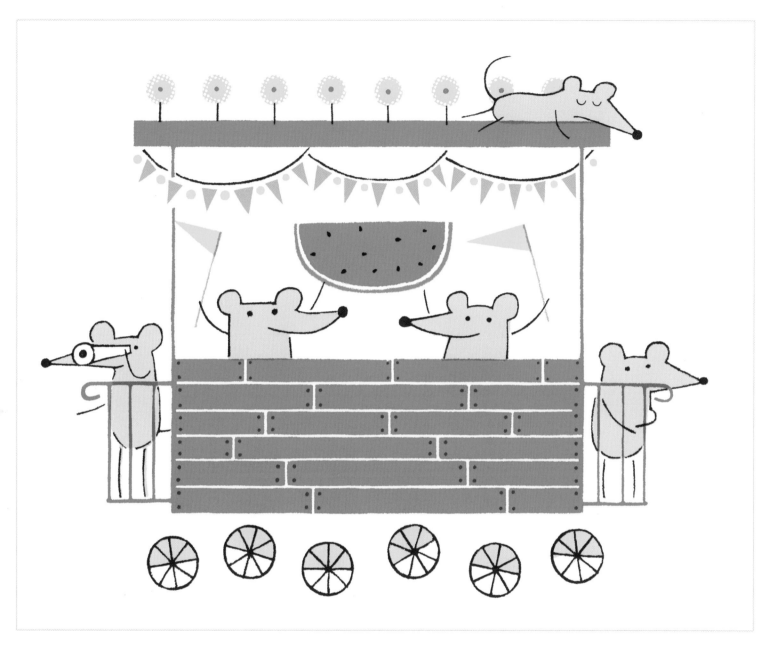

Title: *Melon Caboose*

Designer: Greg Pizzoli

Size: 8 x 10 inches [20.3 x 25.4 cm]

Printing Process: Screen print

Number of Inks: Five

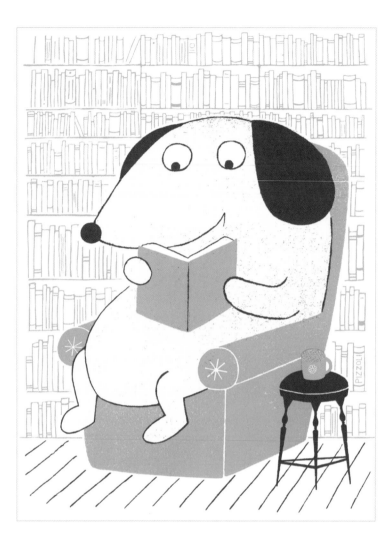

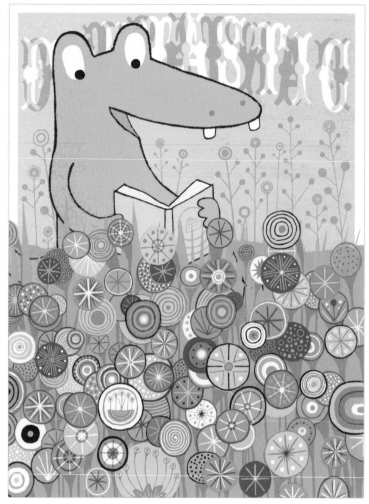

Title: *Read 'Em and Sleep*

Designer: Greg Pizzoli

Size: 18 x 24 inches [45.7 x 61 cm]

Printing Process: Screen print

Number of Inks: Four

Title: *Summer Deeds*

Designer: Greg Pizzoli

Size: 18 x 24 inches [45.7 x 61 cm]

Printing Process: Screen print

Number of Inks: Twelve

"Sumer Deeds has a lot of ink on it," explains designer/illustrator Greg Pizzoli, *"and those first few background layers were tough—it's difficult to print that large, and with that much open area, by hand. It was a lot of fun to print that many colors, though, and the twelve layers create many more colors because of the overlaying transparent inks—it's quickly become one of my favorite prints I've ever made."*

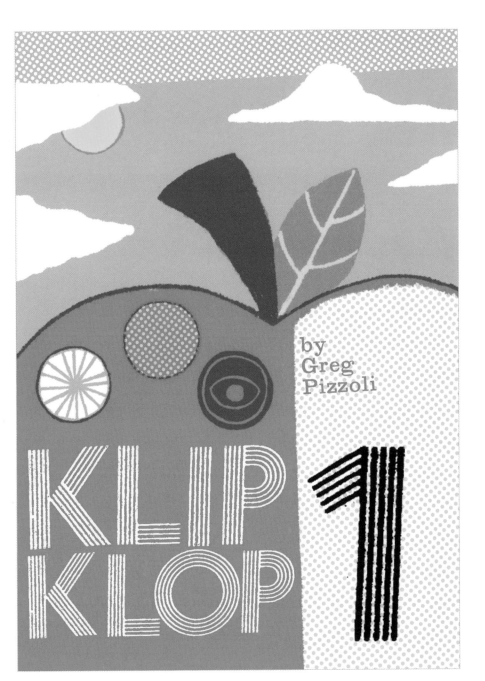

Title: *Klip Klop #1*

Designer: Greg Pizzoli

Size: 4 x 6 inches [10.2 x 15.2 cm]

Printing Process: Screen print

Number of Inks: Twenty-two (total for zine)

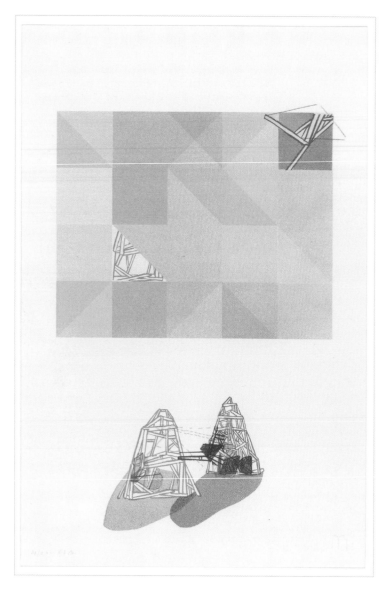

Support Your Local Printer
Freedom to print and disseminate information starts today in Bridgeport, in Chicago – and is made possible by your neighborhood print shop.

Title: *Chopstick Mountain/Jason Noble Benefit*

Designer: Sonnenzimmer: Nick Butcher and

Nadine Nakanishi

Size: 12.5 x 19 inches [31.8 x 48.3 cm]

Printing Process: Screen print

Number of Inks: Seven

Title: *Support Your Local Printer*

Designer: Sonnenzimmer:

Nadine Nakanishi

Size: 18 x 24 inches [45.7 x 61 cm]

Printing Process: Screen print

Number of Inks: Four

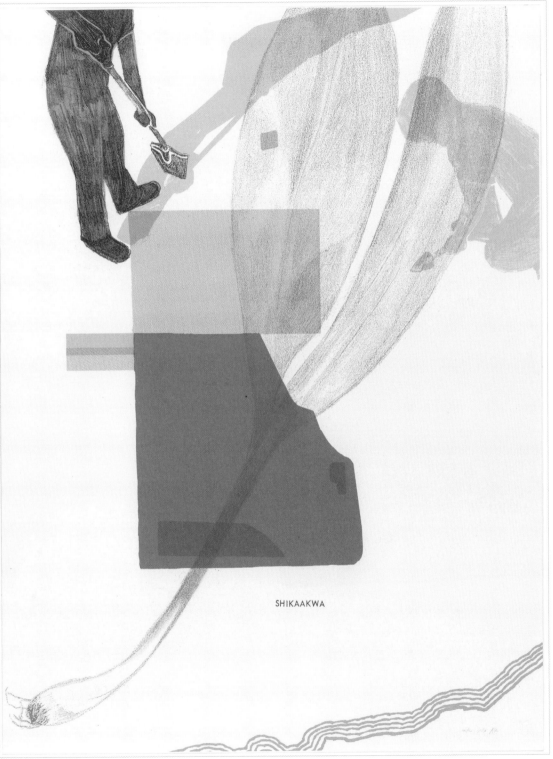

SHIKAAKWA

Title: *Shikaakwa*

Designer: Sonnenzimmer:

Nick Butcher and Nadine Nakanishi

Size: 18 x 24 inches [45.7 x 61 cm]

Printing Process: Screen print

Number of Inks: Six

NOTE: No one pushes the boundaries of art and design on the screen-printed page quite like Sonnenzimmer. Their work often feels like a painting, yet it does things that can happen only in the screenprinting process with over– and underprints.

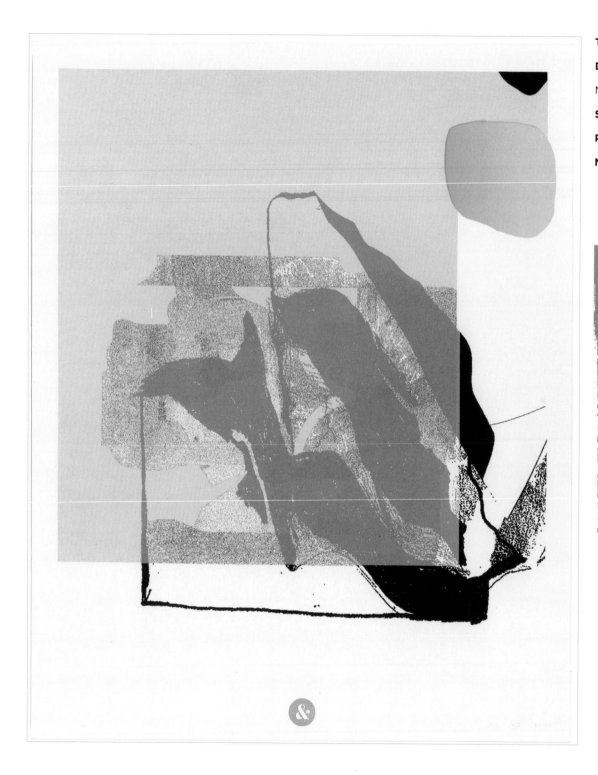

Title: *Longman and Eagle*

Designer: Sonnenzimmer:

Nick Butcher and Nadine Nakanishi

Size: 16 x 20 inches [40.6 x 50.8 cm]

Printing Process: Screen print

Number of Inks: Eight

NOTE: This is a great example of what makes Sonnenzimmer so amazing, as they go through the trouble of using seven inks and then more or less totally alter the effects of that by covering them with a semi-transparent eighth color. But the only way to get the final look was to have invested all of the time and effort and cost into the first seven passes.

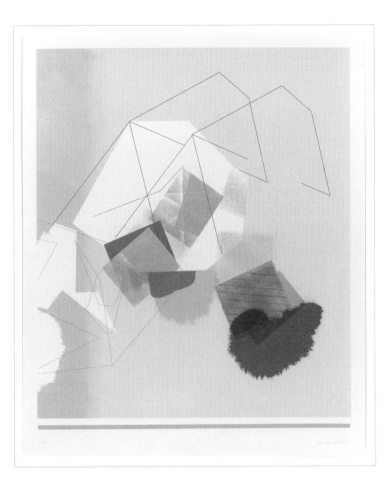

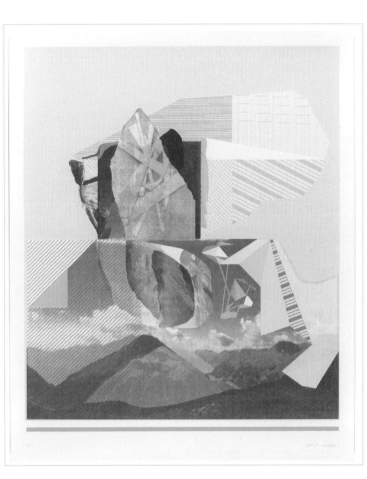

Title: *Laub*

Designer: Sonnenzimmer:

Nick Butcher and Nadine Nakanishi

Size: 20 x 24 inches [50.8 x 61 cm]

Printing Process: Screen print

Number of Inks: Ten

Title: *Il Fuorn*

Designer: Sonnenzimmer:

Nick Butcher and Nadine Nakanishi

Size: 20 x 24 inches [50.8 x 61 cm]

Printing Process: Screen print

Number of Inks: Nine

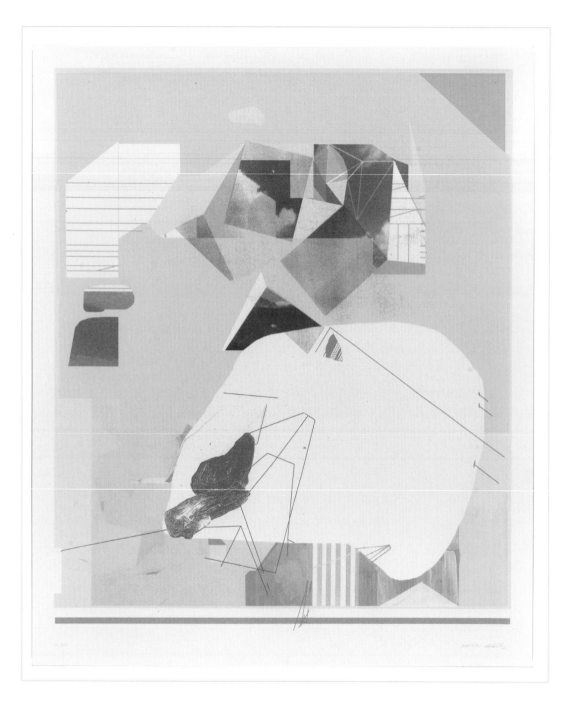

Title: *Schall*

Designer: Sonnenzimmer:

Nick Butcher and Nadine Nakanishi

Size: 20 x 24 inches [50.8 x 61 cm]

Printing Process: Screen print

Number of Inks: Ten

NOTE: Through collaboration with other artists and designers, Sonnenzimmer continues to push their own limits.

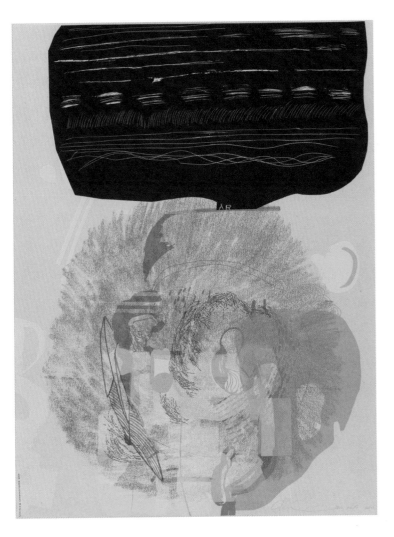

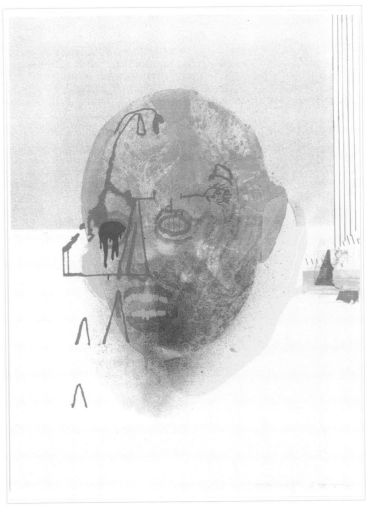

Title: *Seripop and Sonnenzimmer*

Designer: Seripop and
Sonnenzimmer

Size: 19 x 25 inches [48.3 x 63.5 cm]

Printing Process: Screen print

Number of Inks: Seven

Title: *Rachel Niffenegger
and Sonnenzimmer*

Designer: Rachel Niffenegger
and Sonnenzimmer

Size: 19 x 25 inches [48.3 x 63.5 cm]

Printing Process: Screen print

Number of Inks: Nine

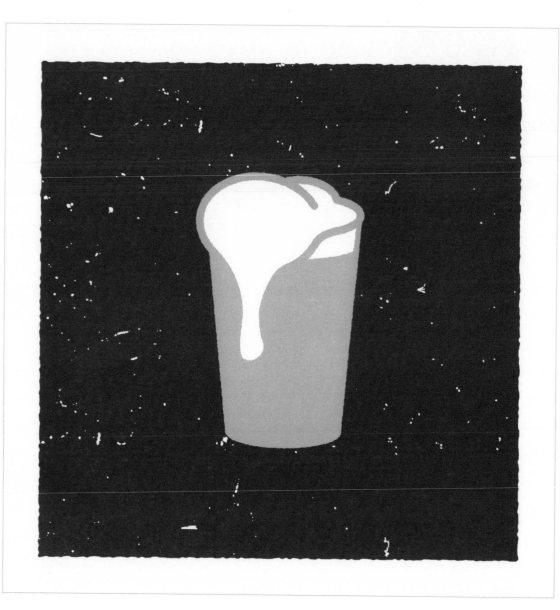

Title: *Food Icon Mini Prints*

Designer: Aesthetic Apparatus

Size: 6.5 x 6.5 inches [16.5 x 16.5 cm]

Printing Process: Screen print

Number of Inks: Four

NOTE: Known for their wild and sometimes dark imagery, Aesthetic Apparatus has come full circle and broadened its offerings, including this delightful set of graphic food prints. Clear and simple, yet stylish and engaging.

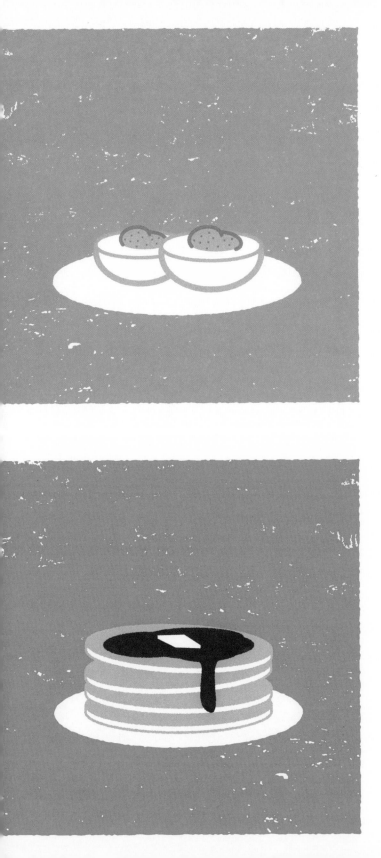

"THEY'VE BEEN WITH US SINCE THE VERY BEGINNING," EXPLAINS IBARRA, "AND THEY ARE A MAINSTAY OF OUR PRINT STUDIO: RAGS IN A BOX®. DISPOSABLE PAPER TOWELS THICK ENOUGH TO MOP UP YOUR THICKEST INK SPILLS AND STRONG ENOUGH TO RINSE AND USE AGAIN AND AGAIN FOR A FEW RUNS BEFORE NEEDING TO BE REPLACED." THINKING ON THE QUESTION A LITTLE LONGER, HE ADDS, "WE WERE ALSO GOING TO SAY 'A SENSE OF HUMOR' BUT, COME ON, A SENSE OF HUMOR IS NOT A TOOL, IT'S A COPING MECHANISM."

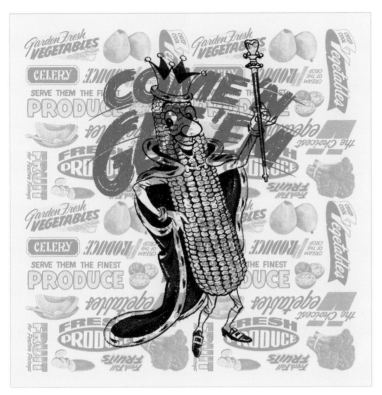

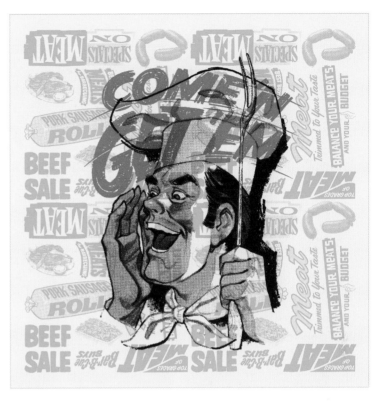

Title: *AA KITCHEN—VEGGIES!*

Designer: Aesthetic Apparatus

Size: 12.5 x 12.5 inches [31.8 x 31.8 cm]

Printing Process: Screen print

Number of Inks: Three

Title: *AA KITCHEN—MEAT!*

Designer: Aesthetic Apparatus

Size: 12.5 x 12.5 inches [31.8 x 31.8 cm]

Printing Process: Screen print

Number of Inks: Three

NOTE: Drawing typography from old newspaper circular styles and playing up a food-specific color palette with fun main imagery, Aesthetic Apparatus has created a unique entry into the wall art market for kitchen's across the globe.

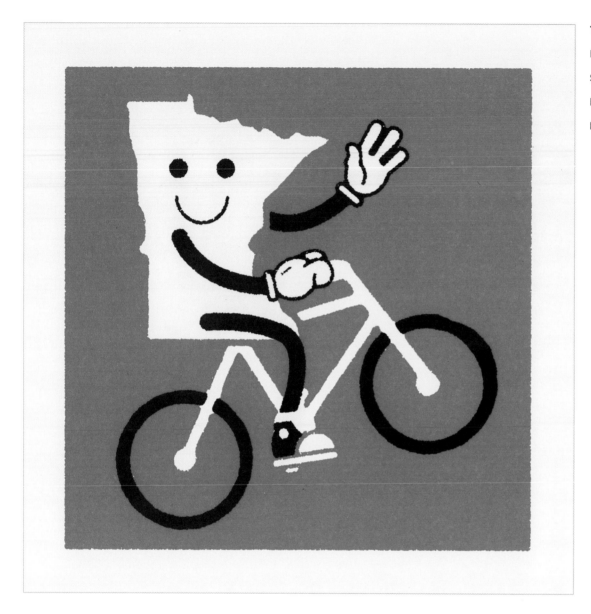

Title: *Minnesota Loves Bikes*

Designer: Aesthetic Apparatus

Size: 12.5 x 12.5 inches [31.8 x 31.8 cm]

Printing Process: Screen print

Number of Inks: Two

NOTE: By tapping into what you know best—your local surroundings—you can open up new markets for your work and your business, as is the case with Aesthetic Apparatus's Minnesota-specific prints.

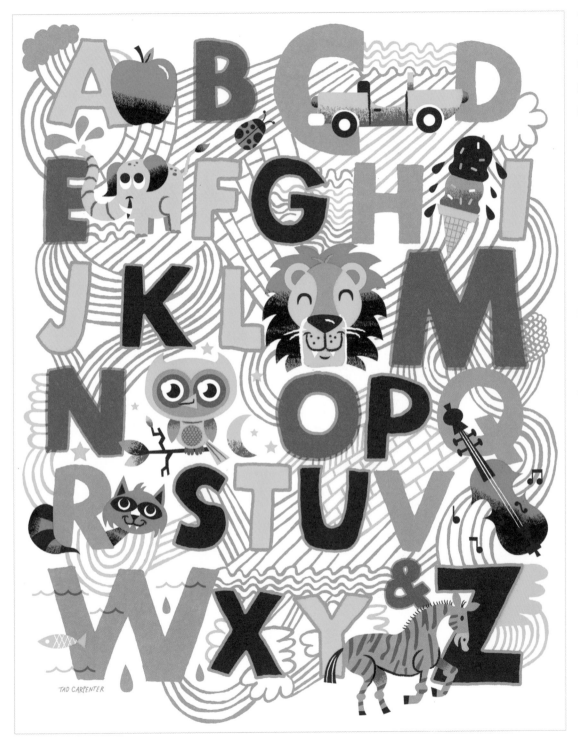

Title: *Alphabet Poster*

Designer: Tad Carpenter

Size: 24 x 36 inches [61 x 91.4 cm]

Printing Process: Screen print

Number of Inks: Four

NOTE: Many have tried their hand at doing kid-friendly animal alphabets, but Tad Carpenter's may very well be the best. Besides the added bits of texture and playful use of varying sizes, he ties everything together with the background line art, adding dynamic energy to what could have been simply a fun print.

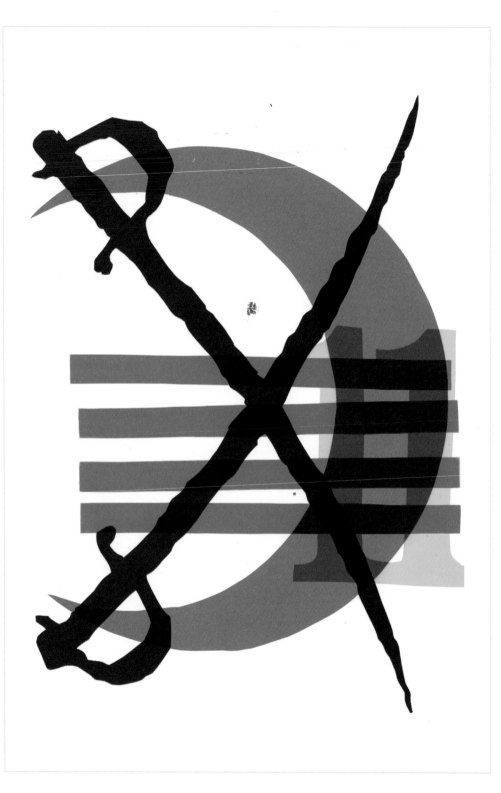

Title: *Civil War*

Designer: The Heads of State

Size: 20 x 30 inches [50.8 x 76.2 cm]

Printing Process: Screen print

Number of Inks: Five

Created for an exhibition at Art in the Age celebrating the 150th anniversary of the Civil War, titled "An Imperfect Union."

NOTE: Using a bold and layered approach, the Heads of State duo make simple and roughened icons and cut shapes into something a thousand times more powerful.

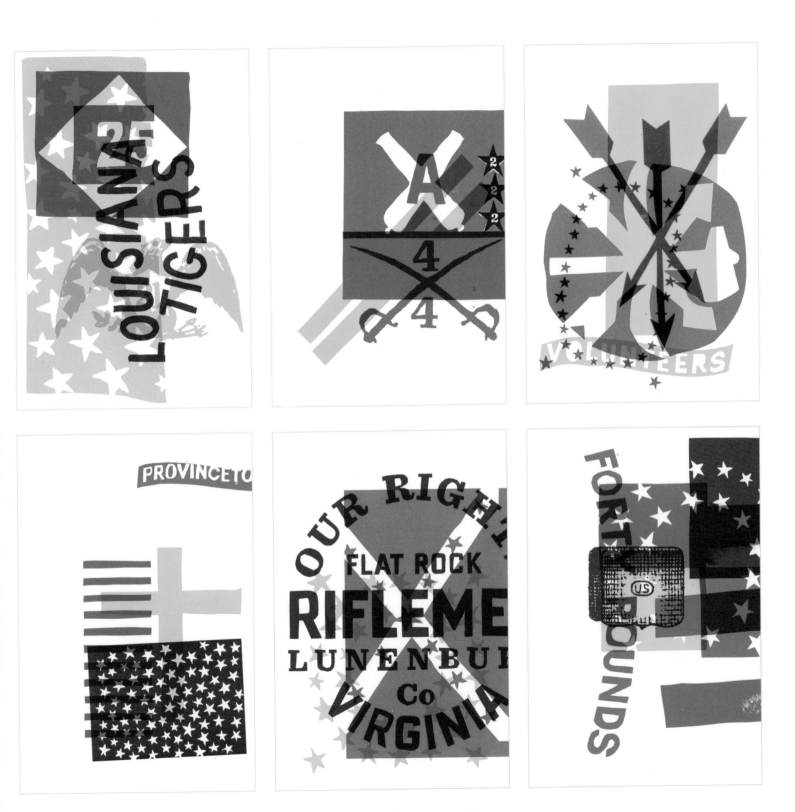

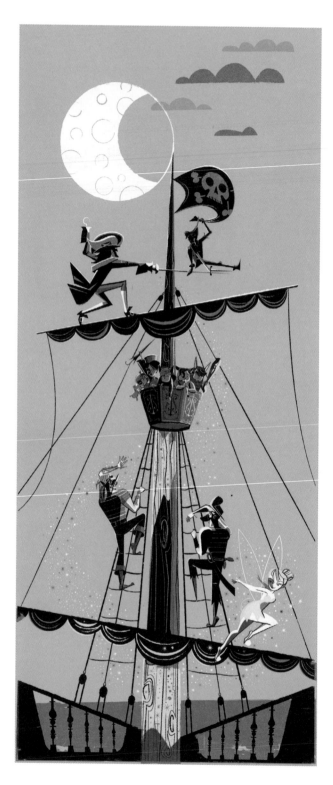

Title: *"Night Duely" Peter Pan for Disney!*

Designer: Scotty Reifsnyder

Size: 15 x 36 inches [38.1 x 91.4 cm]

Printing Process: Screen print

Number of Inks: Four

Title: *"Here Kitty, Kitty," The Incredibles for Disney/Pixar*

Designer: Scotty Reifsnyder

Size: 30 x 13 inches [76.2 x 33 cm]

Printing Process: Screen print

Number of Inks: Four

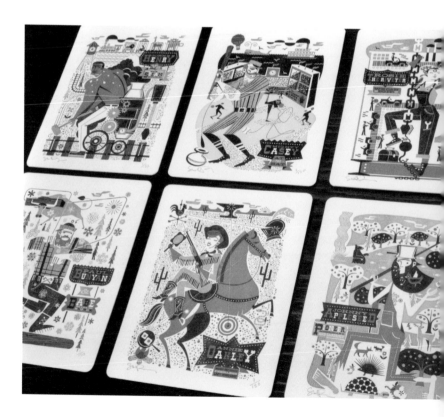

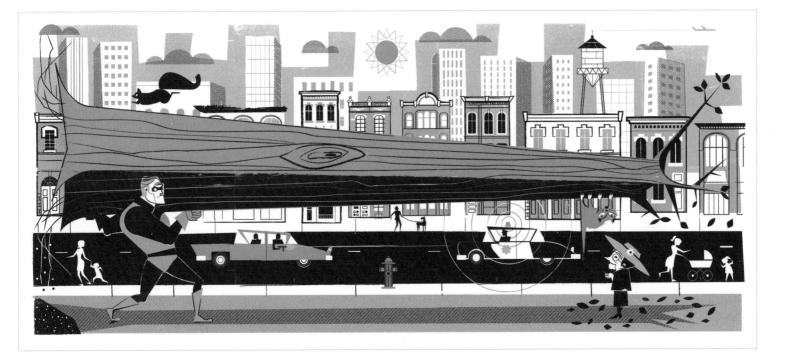

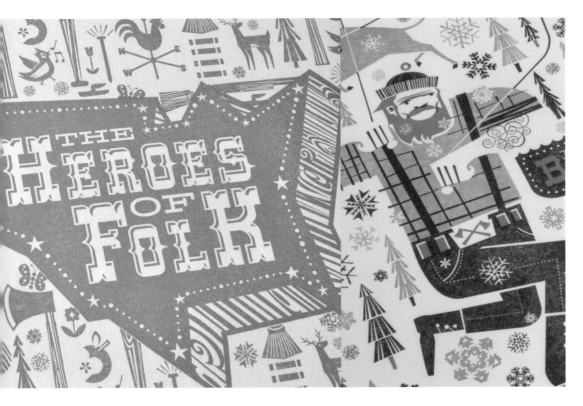

Title: *The Heroes of Folk*

Designer: Scotty Reifsnyder

Size: 6 x 8 inches [15.2 x 20.3 cm]

Printing Process: Letterpress

Number of Inks: Three

NOTE: Reifsnyder's fun and sophisticated line work applies equally well to letterpress or screen printing.

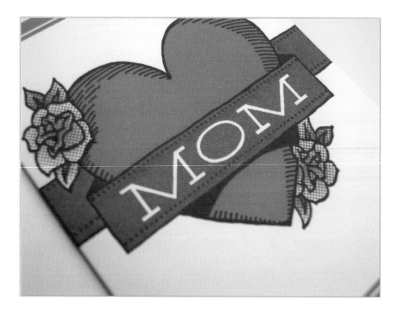

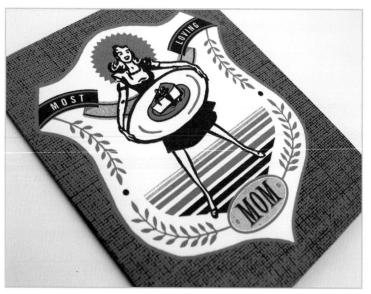

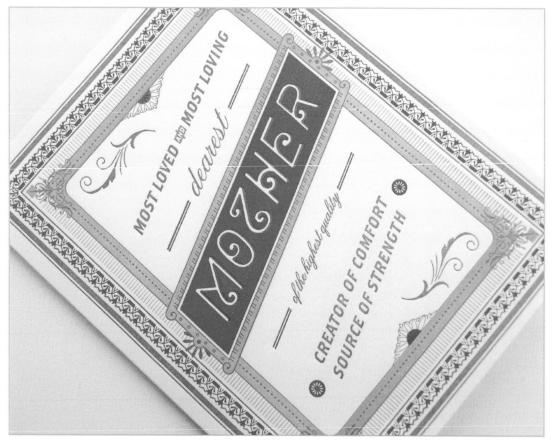

Title: *Mom Card Series*

Designer: Brady Vest/Hammerpress

Size: Various

Printing Process: Letterpress

Number of Inks: Various

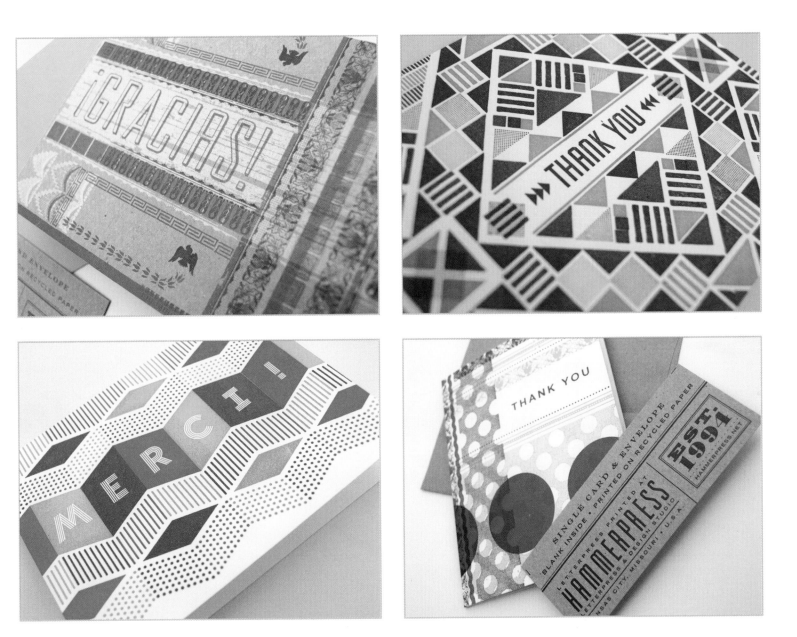

Title: *Thank You Card Series*

Designer: Brady Vest/Hammerpress

Size: Various

Printing Process: Letterpress

Number of Inks: Various

NOTE: Finding an underserved market can inspire you creatively and give your business a serious boost, as was the case with Mother's Day cards and diverse thank you notes for Hammerpress.

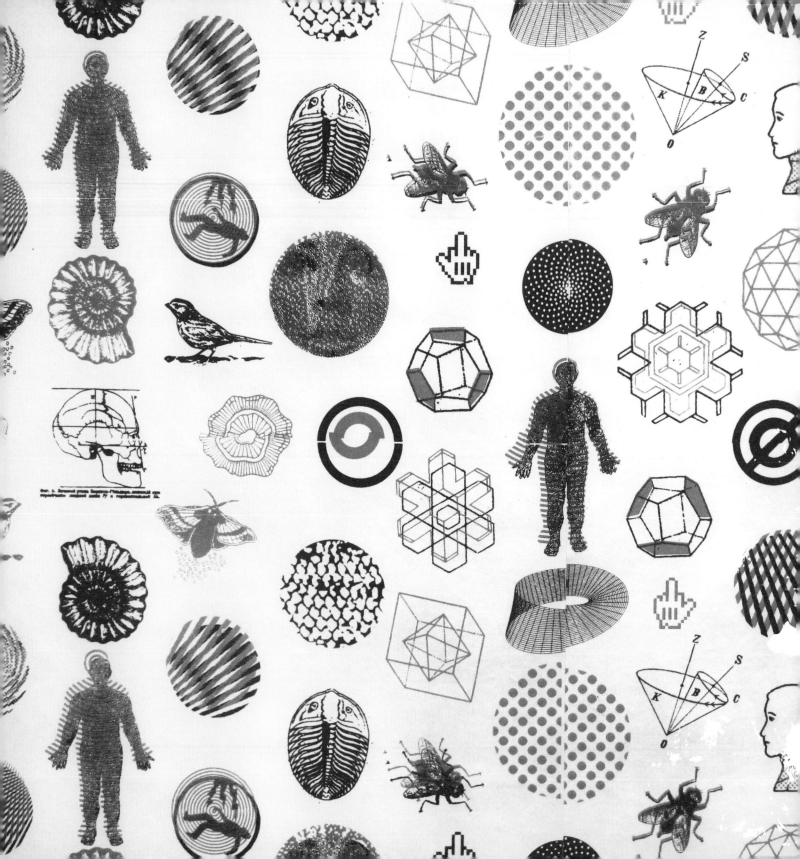

LEARN SOMETHING NEW EVERY DAY

Small-press printing is beautiful for one main reason: because it is never the same. Every pull or pass has a tiny quirk to it, an imperfection or shift, a smudge of ink, or a spot where the color is starved or saturated. It may be tiny, or it may be glaring, but it is imperfect, and that is where its beauty lies. In the same way that it is everchanging, even from one sheet to the next, it draws the kind of person that thrives in that constantly shifting environment.

close-up of a print by Denny Schmickle

THE NOVICE PRINTER

One of the more gratifying aspects of reporting on the explosion of poster design and the return to handmade final products has been the surge of people, both young and old, telling me that they are going to give it a try. Some go out and buy a full setup for screen printing in the garage or basement (hopefully with a proper area for cleaning screens and storing chemicals!). Others find a letterpress, and if they are really lucky, have enough strong and sturdy hands to move it from the place where it has probably been standing firm for decades. Even more enroll in a class or join a printmaking community where they can rent time at a space equipped with all that they need, all the better if instructors are also at hand.

If anyone asks—and they often do—I highly recommend taking the path where you can join classes and rent some time at a community space. Printing is often a pretty solitary experience. The beginner is usually doing so outside of business hours, late at night, or hidden away at odd times on the weekend. The side effect of that is there is no one to ask for help when things go wrong. No one can watch you execute something that you are about to try to pull off, and no one will accelerate your own process by imparting some of their years of experience.

A few solid books are out there to help you on your way, even more to get you started. The online forums can be a wealth of information, and when things go horribly wrong, the fine folks that frequent the gigposters.com forum will gladly help you out after a few jokes at your expense (it's worth the jab, both for not taking yourself and your situation too seriously, and for the advice that follows). The point is that nothing beats asking the person next to you who has already done this hundreds of times before (or even messed up the same thing yesterday).

Don't get hung up on having the exact materials in the most sophisticated manner either. The very core of this type of printing is that at its base level you could carve a wood block, rub in some ink, mash it onto some paper, and have a final product. "My first exposure unit was a clamp light attached to a broom and held above my screens by balancing it between two chairs," laughs Greg Pizzoli. "I made my photocopy positives clear by soaking them with vegetable oil—it wasn't fun, but it worked," he explains. "You don't need fancy stuff, as long as it works."

A few things trip up beginners consistently, and having taught at the university level for quite some time, along with his own experiences, Pizzoli is quick to spot them. "I see students really struggle with color mixing and the registration on press of multiple colors." Luckily, he is quick to add that "both come much more easily with a lot of practice." The key is to practice often, don't take yourself too seriously, and learn as much as you possibly can with each pull or pass.

OLD HANDS STILL CHALLENGING THEMSELVES

Creatives are born to create, and as they progress and become more confident in the act of producing the final pieces, they can't help but keep creating. As a process with built-in stops and starts, the act of printing can bring about the best in a restless mind. "One of the things that I enjoy most about screen printing," explains Jay Ryan, "is that I can treat it as part of the design process." Once the first screen is down and the ink is rolling, he will "take advantage of being able to change direction midproject and change the plans for subsequent colors." Going a step further, he will often "draw in newly imagined details as each layer of ink goes down on the paper," playing the process out as an ever-evolving symphony, never sure which note will follow the last.

The musical metaphor extends further beyond jazzy improvisation or the jammy endless explorations on a single hook that not only inhabit the music of Phish and Dave Matthews Band, but also the incredible gig-poster series for them by the likes of Methane Studios and Nate Duval; it also extends into a slash-and-burn punk rock reinvention. Designers unafraid to do new things, such as Zach Hobbs throwing himself into wild and constant

(continued page 132)

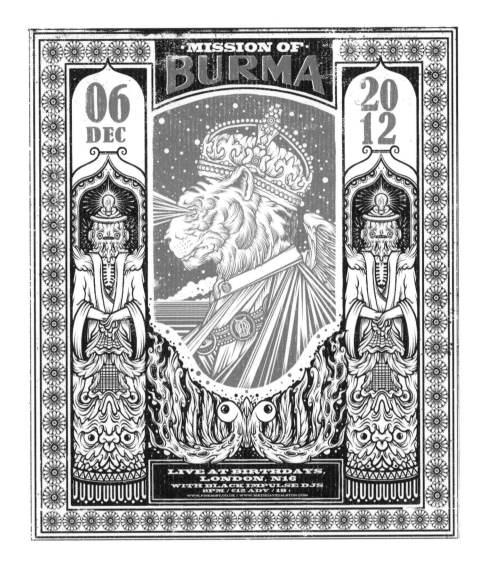

Title: *Mission of Burma*

Designer: Drew Millward

Size: 18 x 21 inches [45.7 x 53.3 cm]

Printing Process: Screen print

Number of Inks: Two

NOTE: Millward stepped outside of his comfort zone for this poster, using his illustration style but wrapping it around the Burmese stamp styles he had researched, creating something true to his output, but a standout piece that stretches the range and sophistication of his portfolio.

"THERE ARE TECHNICAL THINGS THAT CAN BE MADDENING AND DIFFICULT, SUCH AS REGISTRATION AND PRINTING SMALL DETAILS, AND HONESTLY, THINGS GENERALLY GO SIDEWAYS, BUT THAT'S ALL PART OF THE FUN. SOMETIMES, IT CAN LEAD TO INTERESTING RESULTS THAT GIVE YOU BRILLIANT NEW IDEAS. AS LONG AS YOU KEEP A BIG BUCKET AND SPONGE ON HAND TO MAKE SURE YOU CAN WASH OUT YOUR SCREEN WHEN IT ALL GOES HORRIBLY WRONG, YOU WILL BE FINE."

—Andy Smith, Andy Smith Illustration

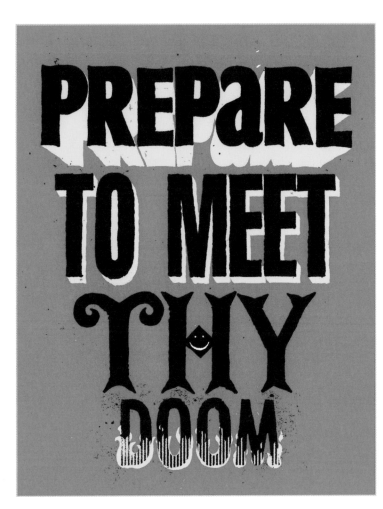

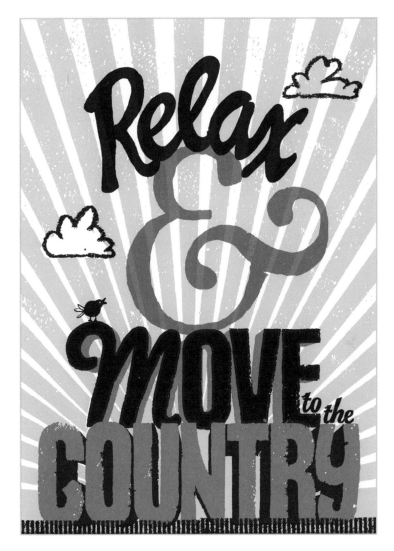

Title: *Prepare to Meet Thy Doom*

Designer: Andy Smith

Size: 5.12 x 6.89 inches [13 x 17.5 cm]

Printing Process: Screen print

Number of Inks: Three

Title: *Relax & Move to the Country*

Designer: Andy Smith

Size: 19.68 x 27.56 inches [50 x 70 cm]

Printing Process: Screen print

Number of Inks: Three

collages, leave my jaw permanently glued to the floor. Sometimes, it is the equivalent of not yet mastering your equipment, so you write the kind of tunes that live to be played sloppily. "I always worked in studios where the equipment has been on the blink in one way or another," explains Andy Smith. "[They had] wobbly print tables or worn-out screens, so you adapt to those challenges." Keeping the scope of his jobs down to a manageable range of colors, Smith also found ease once his images and type became nice and bold, yet the equipment remained a problem. "I actually started adding in texture to my work as an experiment, as I couldn't always get my prints to screen cleanly. So I thought to myself that adding in a few rougher 'mistake' areas would mean that no one would notice the imperfections that weren't necessarily expected." He laughs and then shrugs and adds, "I suppose I have tried to turn the disadvantage of screen printing into a benefit for myself, and the viewer."

As we have found, once the brain has finely tuned the creative process, it can apply it in a myriad of ways, and the dividing line between those that are truly inspired, versus more static talents, becomes wider with age.

Challenging themselves in style, process, application, and occasionally even in the venue in which they trade their wares, names that have long topped our list of designers and artists have produced incredible work. Methane produces a poster for Dave Matthews seemingly every week, and each one is amazing, while also completely on target to their audience. The level of work spread across that many pieces, essentially always solving the same problem, albeit in a different way, is staggering. Jesse LeDoux has taken his fun illustration style and brought it down to simple shapes, forming patterns and interactions that suddenly make the final product much more serious in tone, without losing his unique touch. Jeff Kleinsmith has evolved from his punk rock flyer beginnings into a bracingly smart kind of post-rock designer.

They never stop moving forward. Quite simply, they can't.

THE DECODER RING ART PRINT SERIES

There wasn't much that Geoff Peveto hadn't done in the screen printing poster world. As president of the American Poster Institute, he oversees the ever-growing series of Flatstock events and generally serves as a voice of reason, albeit liberally seasoned with passion. His design firm, The Decoder Ring Design Concern, has led the charge in producing incredible gig posters, as well as jaw-dropping design for a wealth of clients. The man knows his way around the print shop and has been known to mix a vat of barbecue sauce into his inks, among other things. His easy-going nature belies a racing mind and restless creative drive. Even with all of this on his plate, he yearned to push things further.

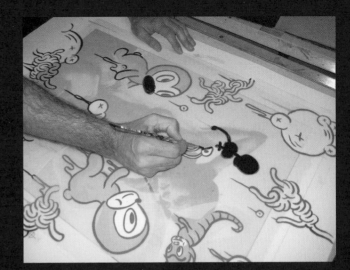

Arriving at an idea that would test his printing abilities, while also inspiring him creatively, and allowing him to throw back a beer or two with some of his favorite artists, he came up with the Decoder Ring Artist Series. Inviting an artist to come to their shop, stay a week, and create a unique piece of art while Peveto manned the press proved enticing, especially with a seemingly endless number of inks and screens available. I am sure he was having second thoughts as he pulled the sixth screen, just building up the off-white texture on a background that would be more or less obscured by the images to follow, but a little beer can smooth over such misgivings, and no one could argue with the results.

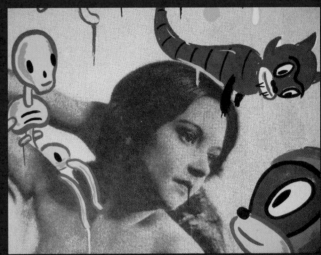

The series has reached its eleventh edition and has included designers, painters, illustrators, animators, and motorcycle-riding madmen to gentle-soul bird-watchers. To follow are a few of the recent additions to the series, with screen-by-screen breakdowns of the art and a behind-the-scenes look at their creation.

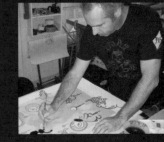

Title: *Celeste*

Designer: Gary Baseman

Size: 22 x 30 inches [56 x 76.2 cm]

Printing Process: Screen print

Number of Inks: Twenty-four

Gary Baseman's quirky illustration style has brightened everything from Saturday morning television to highbrow art galleries, making him an icon in the creative world. His simple figures always seem more complex upon closer inspection, revealing a mischievous nature that runs through all of his work. He also has a passion for archival photography: the weirder the better. It's an itch that he doesn't get to scratch in his work nearly enough, so it was little surprise that he took this opportunity to build everything around this found image of "Celeste" with the truthful, yet odd, statement "offered for study because of the superb development of the upper torso" burned onto the photo.

It is fascinating to watch this print unfold in a two-step process. After creating a multilayered rich and deep print of the photo, Baseman sets about figuring what to do with it, sketching over top of the image again and again until he settles on the right mix of inhabitants to swirl about this figure, bringing her into their madcap world.

He uses the screen printing process much in the same way a painter would lay down layers of underpainting to create depth, giving the final a richness far beyond what would be expected, and tightly mimicking his own paintings. Working in this fashion means that they have to create a new base for this second wave of images, actually printing on top of the image of the photograph, as if they had discovered it as a source all over again.

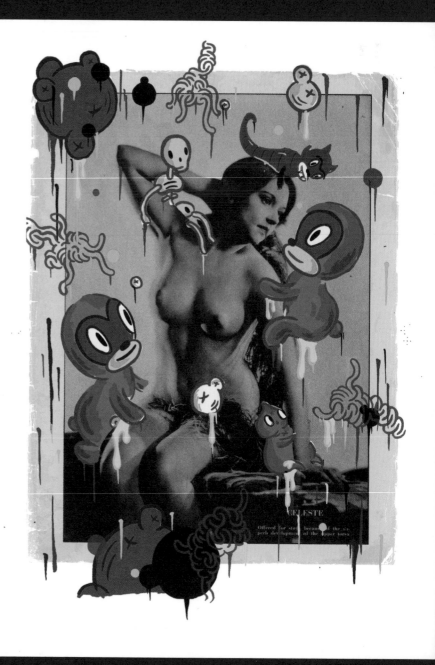

Title: *Taiga*

Designer: Diana Sudyka

Size: 22 x 30 inches [56 x 76.2 cm]

Printing Process: Screen print

Number of Inks: Twenty

Diana Sudyka is a very respected illustrator with a wonderful mix of tiny detail and expressive strokes. She also happens to be a master printer, so she knows a thing or two about what can be attempted on press. Much of her work is colored by her passionate love of animals and nature, and what she created for this series is no different. Using her inked illustration, along with a steady hand cutting rubylith, a rich and layered image emerges, with tiny surprises peeking out among deep and rich colors, and a golden bear that is quite literally printed in gold.

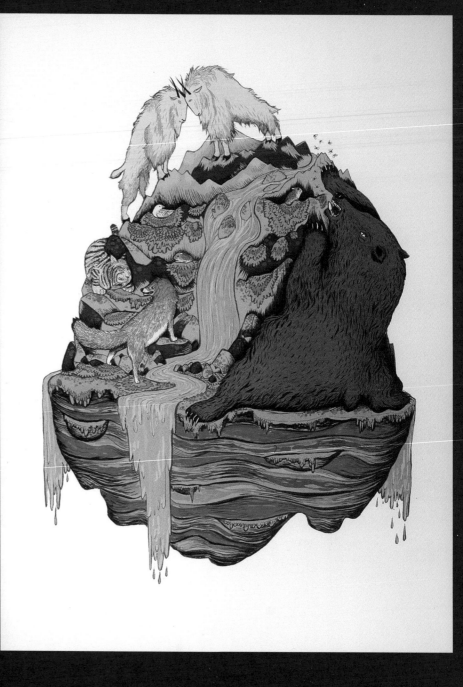

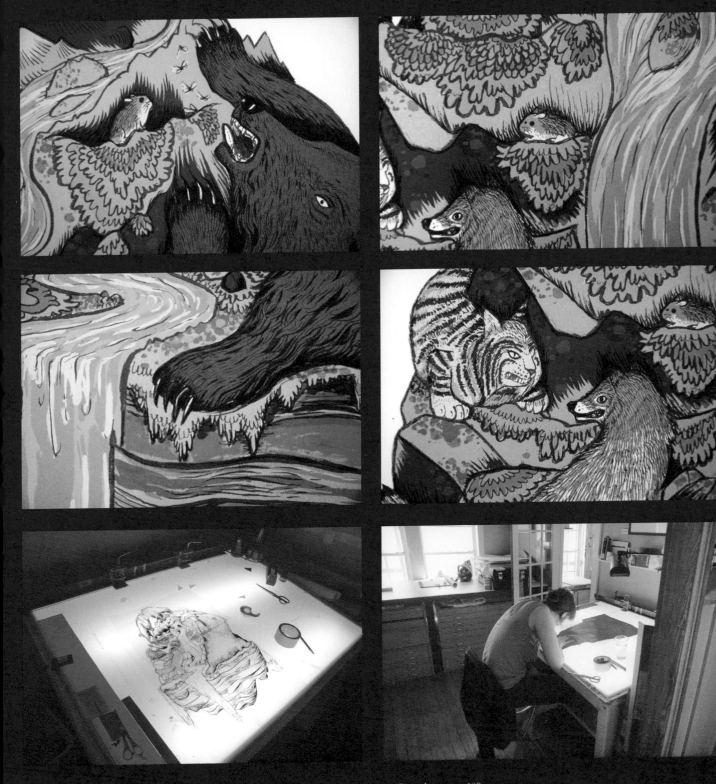

Title: *Discovered*

Designer: Michael Sieben

Size: 22 x 30 inches [56 x 76.2 cm]

Printing Process: Screen print

Number of Inks: Twenty

Peveto was very familiar with artist Michael Sieben, as he is also based in Austin. Admiring his work for Bueno Skateboards, as well as his writing for Thrasher Magazine, *Peveto couldn't wait to see what Sieben would create in the studio. Building on the layers of detail evident in his paintings, Sieben drafts one of his creatures to inhabit the page, with every detail serving to create more questions than answers for the viewer. The printing process involved layers of varnish and even mixing wax and coffee into the inks.*

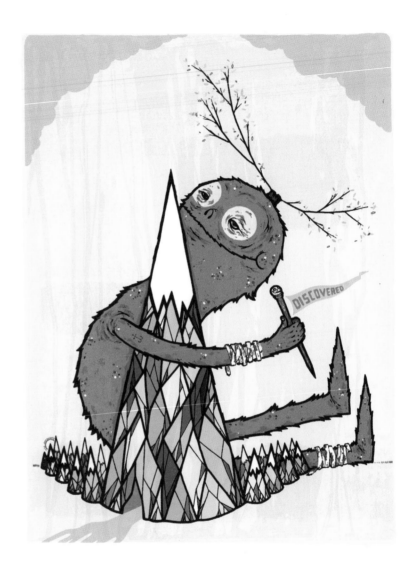

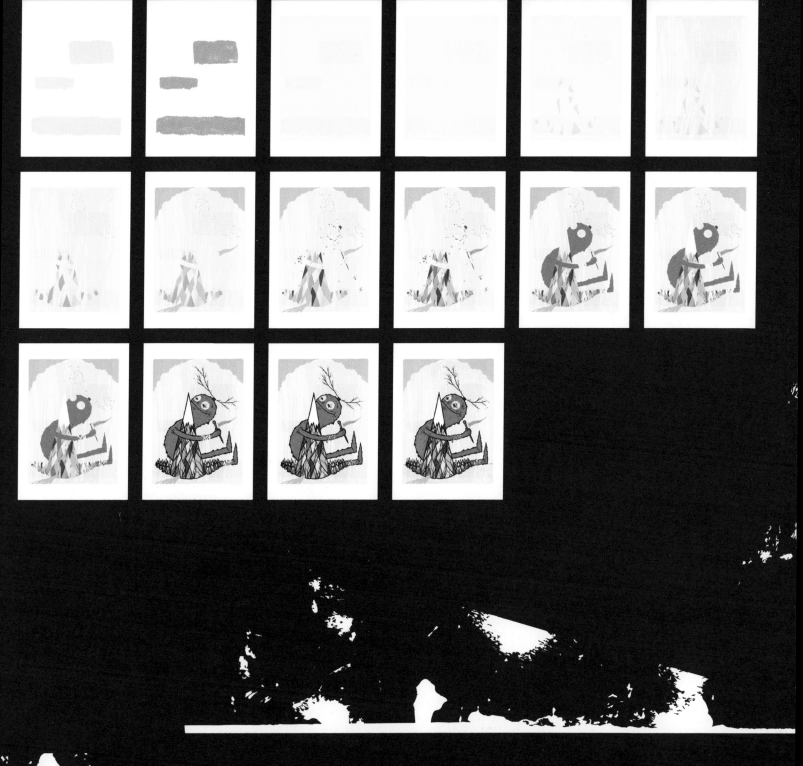

Title: *As The Mind Wanders*

Designer: Jeremy Fish

Size: 22 x 30 inches [56 x 76.2 cm]

Printing Process: Screen print

Number of Inks: Twenty-one

The master of cute and creepy, Jeremy Fish hopped in his van following a massive gallery exhibit of his work to soak in the Decoder vibe, finding kindred spirits in the need to produce work at an incredible rate. Starting from a woodblock texture for a base, he showcases his signature imagery and color palette and manages to slip a pink bunny in there, of course.

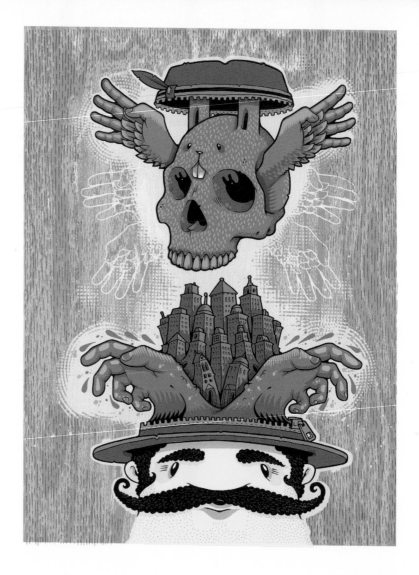

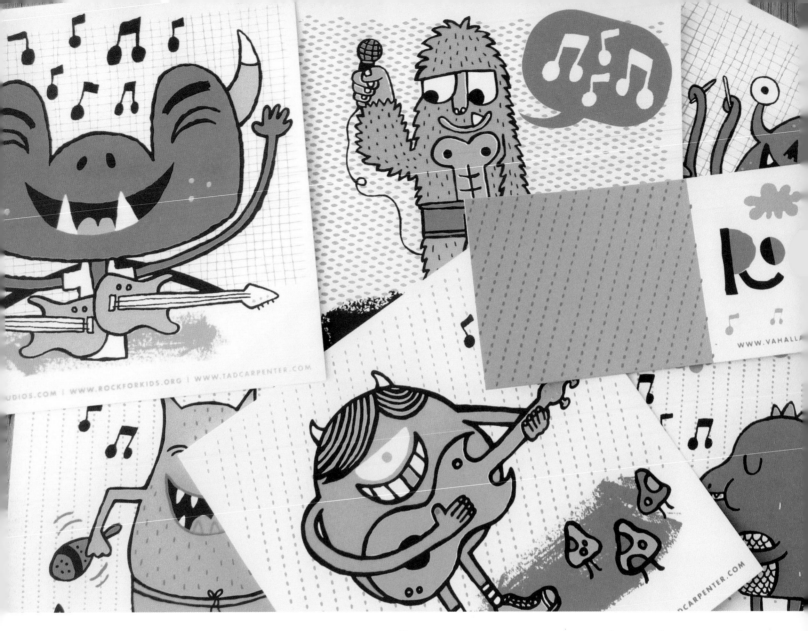

Title: *Rock for Kids*

Designer: Tad Carpenter

Size: 8 x 8 inches [20.3 x 20.3 cm]

Printing Process: Screen print

Number of Inks: Four

NOTE: Carpenter continues to find new ways to showcase his playful illustrations, whether in a card set or as art for the home on wood panels.

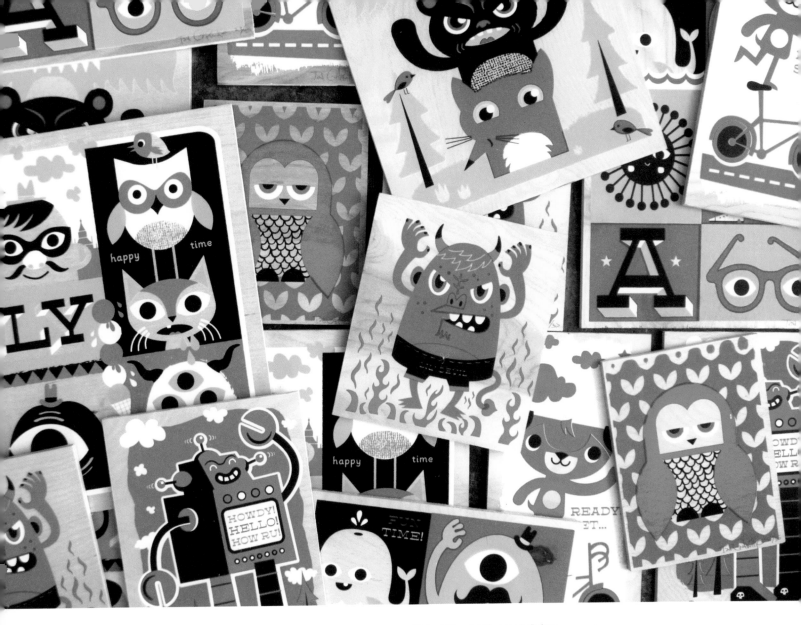

Title: *Wood Silkscreen Prints*

Designer: Tad Carpenter

Size: Various

Printing Process: Screen print

Number of Inks: Three

THE HENLEY COLLEGE LIBRARY

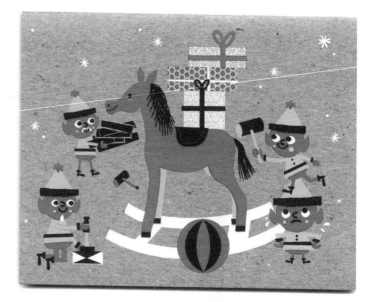

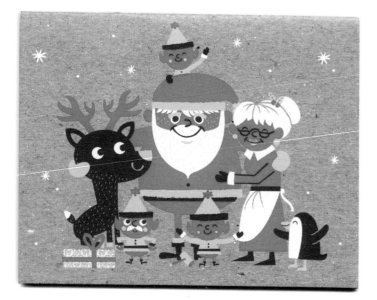

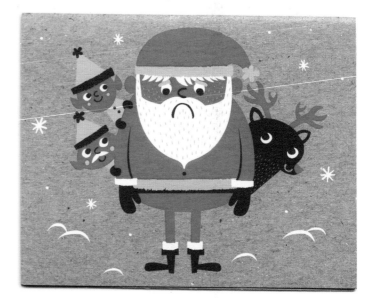

Title: *Sad Santa Holiday Goodies*

Designer: Tad Carpenter

Size: Various

Printing Process: Screen print

Number of Inks: Three

NOTE: When you have a great idea, finding multiple applications can really maximize its effectiveness. Carpenter's funny Sad Santa book looks great on pourous kraft stock, allowing the spot whites to be particularly effective. But it looks even better as brilliant tree ornaments!

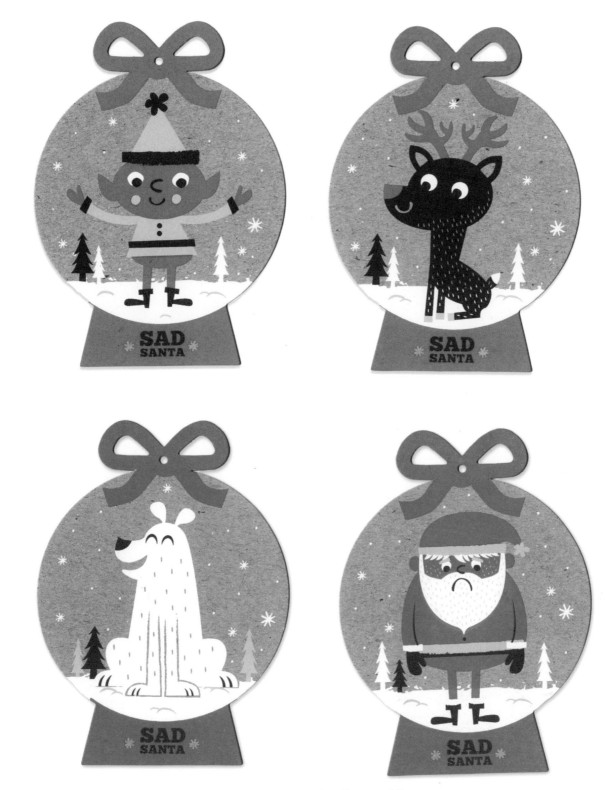

MY PRINT SETUP: KEVIN MERCER, LARGEMAMMAL

"My studio is located in the basement of my house, constructed on the cheap ten years ago, and it still runs perfectly fine," Mercer says. A decade of heading down those stairs and pulling prints has created some simple innovations that cost very little, with big rewards. "There are three pieces of equipment that are key to my studio's survival. Each of these I built myself, and on the cheap," he emphasizes. "The light table, which has UV lights in it for exposing screens, is essential. I tape my positives to the screen and then I put them into a Space Bag (as seen on TV!) to sandwich the positive against the screen. That way, I get very tight, very detailed burns. I then wash my screens out in a spray booth that is made from plywood, which drains into a 5-gallon bucket, that I then empty into a sink with a ghetto filter to catch any solids. It is a simple but effective way of dealing with one of the hardest parts of setting up a proper screen printing space.

"My printing table is adapted from Andy MacDougall's vacuum table plan. It works like a reverse air-hockey table. You plug a Shop-Vac into the side, switch it on, and it will then keep your paper firmly in place on the table," Mercer explains, adding with a laugh, "It is important to have a steady sheet of paper while you print your crappy design onto it. The only thing that I really spent any money on was a drying rack. It was $200 well spent, as I don't know how I would live without a decent drying rack." He also adds something just as important to his well-being—one that comes at a very economical price given what it gives back: "You can buy foam-padded mats for the floor for cheap, and these will honestly save your back while you find yourself standing in the same spot working for hours on end on hard and cold concrete floors." Pro tip!

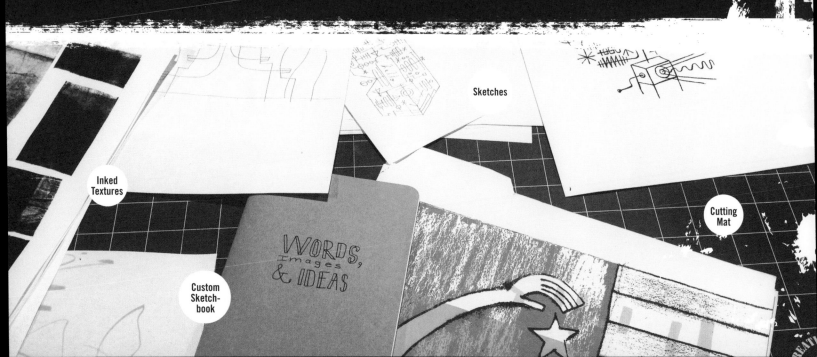

Sketches

Inked Textures

Cutting Mat

Custom Sketch-book

WORDS, Images, & IDEAS

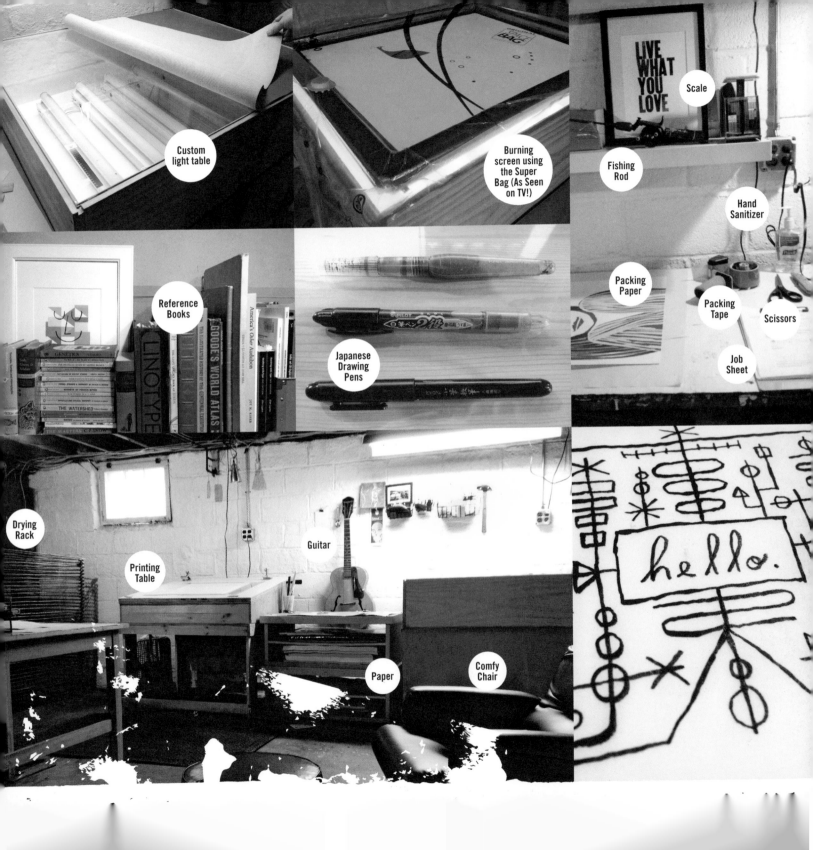

Custom light table

Burning screen using the Super Bag (As Seen on TV!)

Scale

Fishing Rod

Hand Sanitizer

Reference Books

Japanese Drawing Pens

Packing Paper

Packing Tape

Scissors

Job Sheet

Drying Rack

Printing Table

Guitar

Paper

Comfy Chair

LIVE WHAT YOU LOVE

hello.

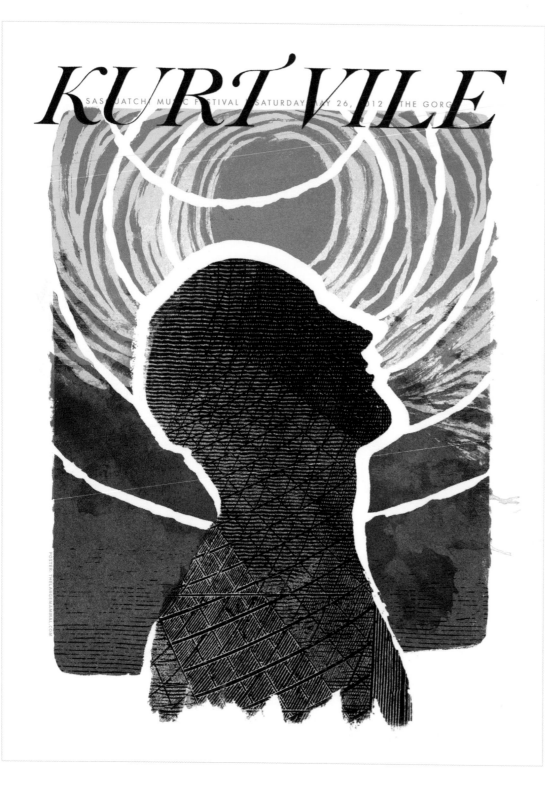

Title: *Kurt Vile*

Designer: Kevin Mercer/
Largemammal

Size: 18 x 24 inches [45.7 x 61 cm]

Printing Process: Screen print

Number of Inks: Four

NOTE: Mercer is a texture junkie in the best possible way. Each print can have ten or more handmade textures incorporated, and all of them will be used in ways that reveal something new to the viewer, and to Mercer as he prints. A true win-win!

THE MOST CHALLENGING PIECE I EVER PRINTED

Kevin Mercer, Largemammal

"Tackling this Young Widows poster was nearly the end of me," explains Kevin Mercer. "The primary reason was because I had set it up as a seven-color job. There were tons of transparent overlays that were always on the edge of becoming too muddy, so I had to give each pass a lot of careful consideration. The key color ended up being a layer of very transparent white that runs over top of the yellow and red in the area of the teeth in the image. It really adds depth and subtlety there. Subsequent colors that overprint pop more than they would if printed on just white paper. In particular, the magenta scrapes and drips in the middle. I wish everyone could see this close up and in person," he laughs. "Having to see the effect in person is a common theme that runs through my work," he smiles. Perfect for the Internet . . .

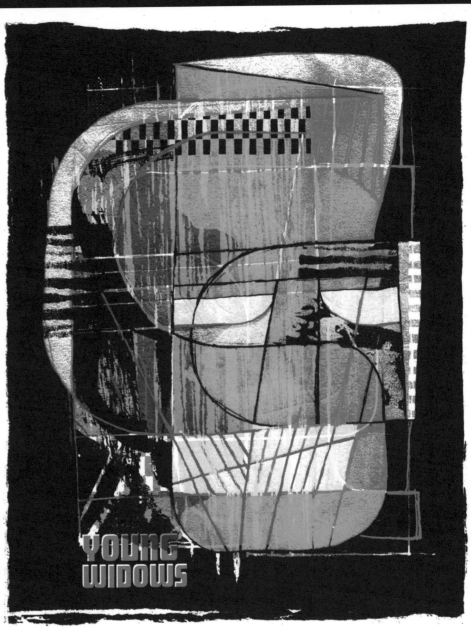

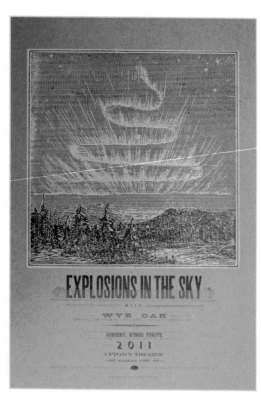

Title: *Explosions in the Sky*

Designer: Brady Vest/Hammerpress

Size: 15 x 22.5 inches [38.1 x 57.2 cm]

Printing Process: Letterpress

Number of Inks: Four

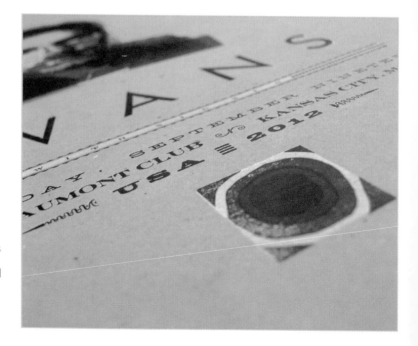

Title: *Swans*

Designer: Brady Vest/Hammerpress

Size: 15 x 22.5 inches [38.1 x 57.2 cm]

Printing Process: Letterpress

Number of Inks: Four

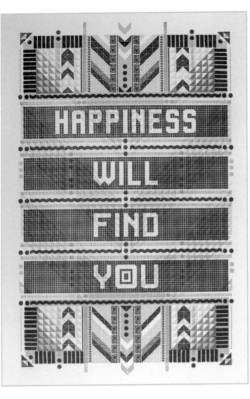

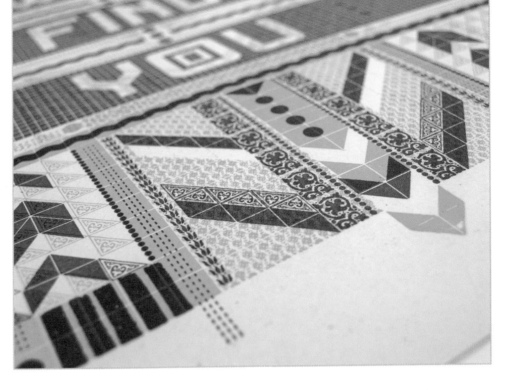

Title: *Happiness Will Find You*

Designer: Brady Vest/Hammerpress

Size: 15 x 22.5 inches [38.1 x 57.2 cm]

Printing Process: Letterpress

Number of Inks: Two

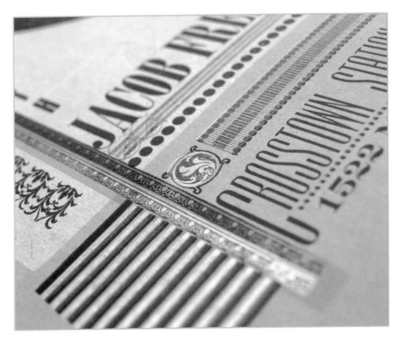

Title: *Hearts of Darkness*

Designer: Brady Vest/Hammerpress

Size: 15 x 22.5 inches [38.1 x 57.2 cm]

Printing Process: Letterpress

Number of Inks: Five

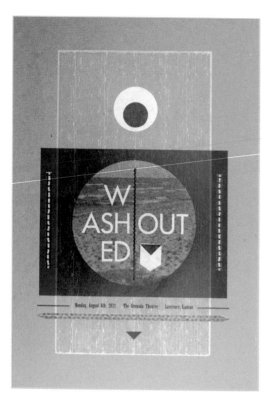

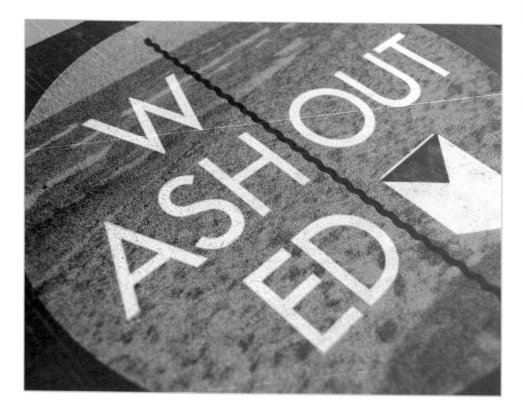

Title: *Washed Out*

Designer: Brady Vest/Hammerpress

Size: 15 x 22.5 inches [38.1 x 57.2 cm]

Printing Process: Letterpress

Number of Inks: Four

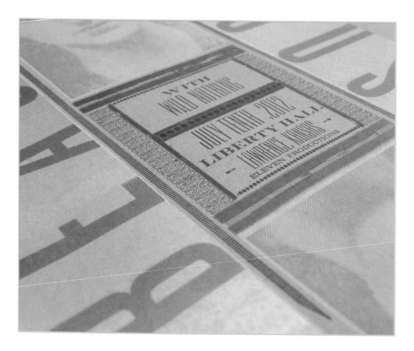

Title: *Beach House*

Designer: Brady Vest/Hammerpress

Size: 15 x 22.5 inches [38.1 x 57.2 cm]

Printing Process: Letterpress

Number of Inks: Five

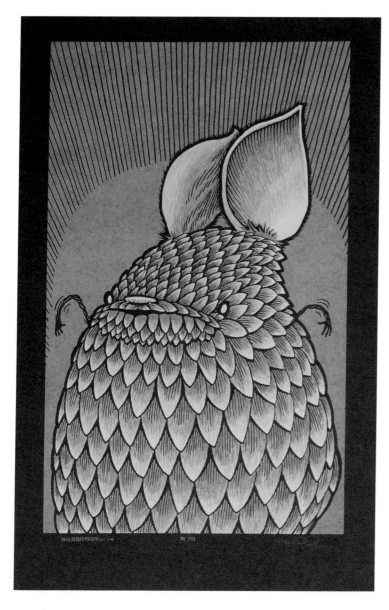

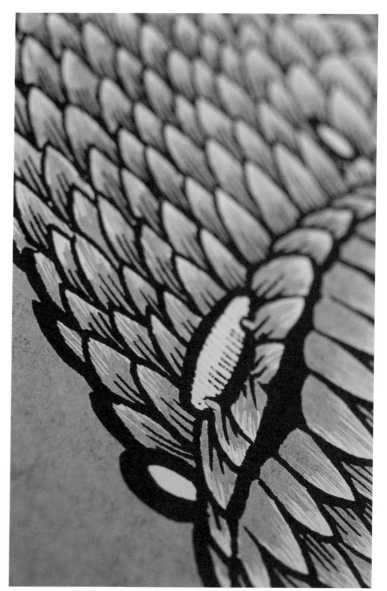

Title: *The Itch*

Designer: Jay Ryan/The Bird Machine, Inc.

Size: 14 x 22 inches [35.6 x 56 cm]

Printing Process: Screen print

Number of Inks: Three

NOTE: Ryan is always experimenting with ways to add interesting details to bring out more in his drawings, as well as in his printing. Here, the use of the black paper combines with a beautiful application of a spot white to bring out the feathery texture.

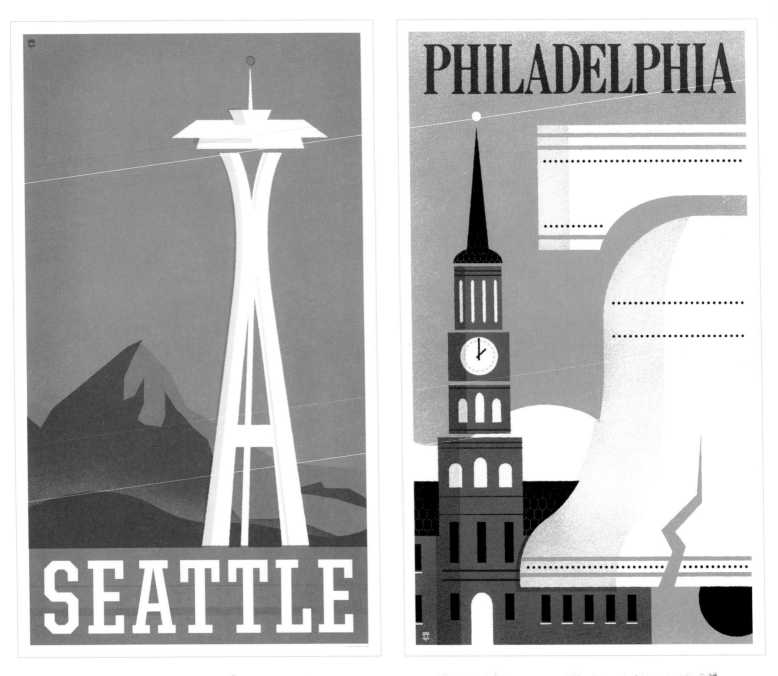

Title: *Travel Series*

Designer: The Heads of State

Size: 16 x 24 inches [40.6 x 61 cm]

Printing Process: Screen print

Number of Inks: Various

NOTE: Tapping into the love of vintage travel posters, by creating modern versions, The Heads of State found themselves with a runaway success.

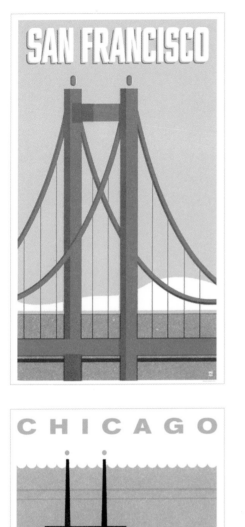

SAN FRANCISCO

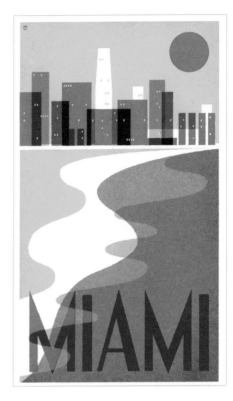

NEW YORK CITY

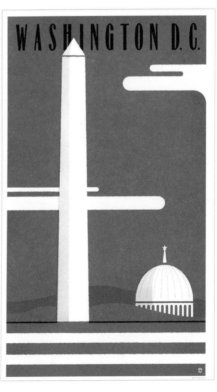

MIAMI

CHICAGO

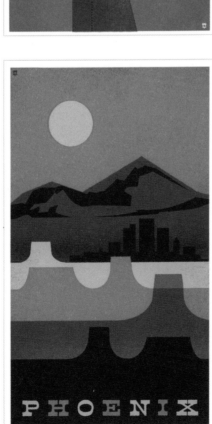

PHOENIX

WASHINGTON D.C.

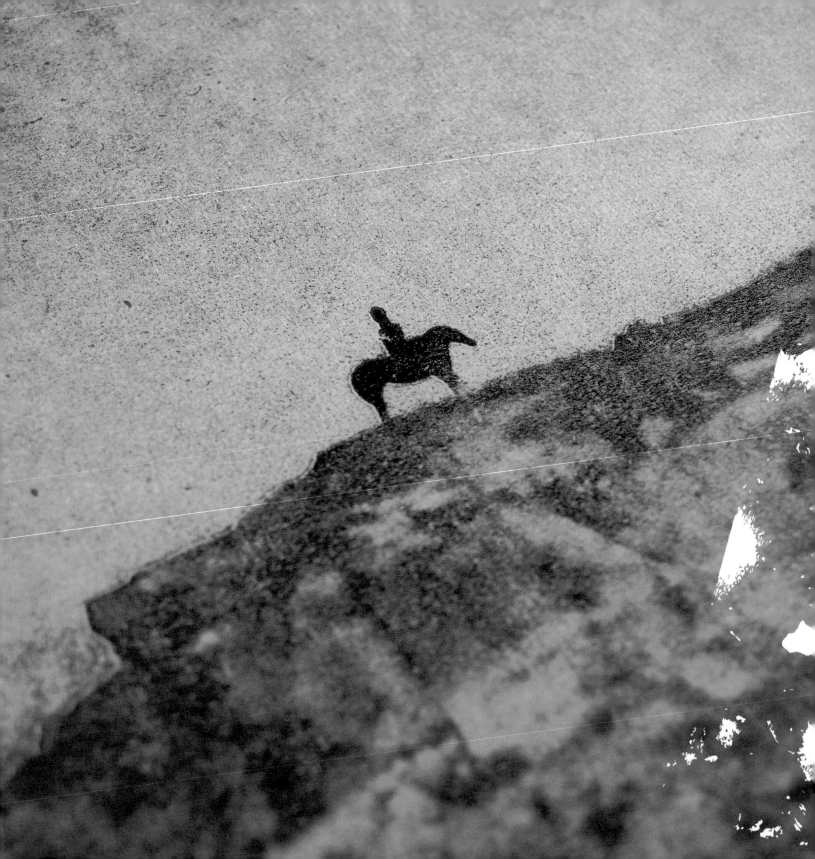

THE FUTURE OF SMALL-PRESS PRINTING

close-up of a print by Hammerpress

Several factors keep small-press printing alive today, but the one that ensures it has a vibrant future is the simple economic one: it costs less to try something new. Lessening the risk for creatives means that they can invest their time in a new idea or endeavor without fear that they won't be able to see it through to a final product. They are creating with the intent to share with other people, after all, and already have enough spare concepts resting on sketchbooks and in the bubbling recesses of their minds. It also means that they can even experiment right there on press, knowing that if something doesn't work out they are only out a few sheets of paper and some time, and maybe a touch of ink.

In the way that they can change up the details in the middle of a press run, they can also have the flexibility to change the way they operate as a studio or as a business. They can try new things and directions until one of them takes a firm grip and wrenches their car barreling about the city into another lane altogether for a long cross-country trip, with lots of sideshows to take in along the way.

FABRIC OF THE DESIGN/ART WORLD (WARHOL TO SERIPOP)

Following the investment from the WPA *(see page 9)*, screen printing managed to elevate itself into a loftier stratosphere, adopted by many of the leading figures in the Pop Art movement. It became more than just a process, or a tool, but a look and feel unto itself. It would remain a mostly American phenomenon in galleries and artist portfolios for much of the 1960s, as Andy Warhol brought it to the level of acceptance of the everyday dinner-table conversation.

During the social turmoil reverberating throughout the world in the late 1960s, screen printing became a tool in the creation of grassroots art fueled by youthful dissatisfaction. Student protests the world over would turn to the rudimentary process, often in campus facilities, to churn out as many copies of raw and direct messages as they could. Whether pushing for civil rights in the American South or trying to cover all of Paris in paper, a generation quickly learned that screen printing was a valued tool in creating art on even the lowest level.

Bringing all of these things into a positive light, the incredible work of Sister Mary Corita Kent would champion screen printing while delivering positive messages to a desperate public. Her brilliant use of typography and color, and a style that could only come from being forever in love with the process of serigraphy, still reverberates today. Her combination of grassroots messaging, political leanings, Pop Art sensibilities, and overall graphic application of her shapes and swashes fully realized everything available through small-press printing to that point.

As the art world moved through the transitional 1970s, small-press printing would continue in strong pockets but slowly get quieter on the international stage. However, more and more designers had been bitten with the bug and were slowly looking to exploit the capabilities, and the grassroots artists were always on hand when an issue bubbled up.

The overflowing excesses of the 1980s meant that more was more, and suddenly celebrated work featured expensive dishes smashed within enormous canvases and a never-ending sea of paint. Even Warhol was reduced to using his screen prints as fodder to be painted over. At this time, a funny collision of everything that had been building occurred as graphic designer/illustrator Patrick Nagel combined a passion for small-press printing and its reductive qualities into massive commercial success. Drawing from the high contrast of traditional woodblock printing, the streamlined art deco style and color palette, and the needs of screen printing, Nagel created what amounted to fake screen prints in his illustrations. (He would also make actual screen prints to sell his work to the overeager market.)

Updating the pin-up look to take on a futuristic coldness, his mixing of bold graphic design and empty sexuality would define the 1980s for many. His cover illustration for Duran Duran's massive-selling album *Rio* would bring this style into the hands of impressionable teens everywhere and serves as the nadir for the innovations Warhol had introduced to the art, design, and music worlds two decades earlier. When Nagel died of a massive heart attack following a celebrity aerobathon, it seemed to sum up this time period more than his work ever could.

Luckily, at the same time, that undercurrent of grassroots dissatisfaction, combined with rudimentary printing knowledge, grew stronger and stronger and was mobilized in the United States by a number of factors. The most obvious was that papering laws went into effect in numerous cities and prevented promoters from advertising their events using the now dirt-cheap photocopy. This had a knock on effect as political messages, and papering of any kind, were swept up in the ban. The gig-poster movement soon came above ground in the 1990s and has become home to many of the most innovative designers and artists of the past twenty years.

Title: *J'm'en suis déjà souvenu*

Designer: Seripop: Yannick Desranleau and Chloe Lum

Size: Various

Printing Process: Screen print

Number of Inks: various

NOTE: Very few prints are interactive and even fewer do so by force, but if people want to get around in the shopping center, they have to tread on Seripop's installation, revealing additional layers of prints and creating wild debris.

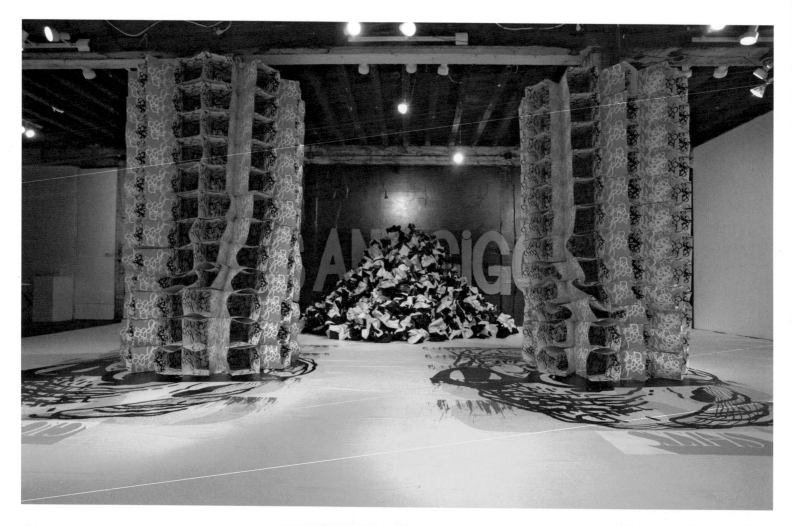

Title: *Hoarding Skin*

Designer: Seripop: Yannick Desranleau and Chloe Lum

Size: Various

Printing Process: Screen print

Number of Inks: Various

Photo by Erik Zajaceskowski and Rebecca Smeyne

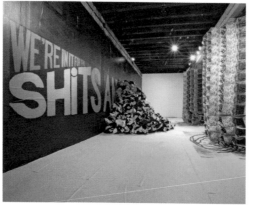

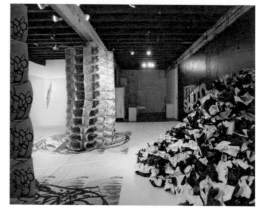

The late 1980s saw a return to protest printing (I will never forget the "Meese Is a Pig" prints from Jeff Nelson that covered my hometown of Washington, DC, for a brief but determined minute). It also saw some of the earliest gig-poster designers starting to truly push the medium. By the time the 1990s were in full bloom, both screen printing and letterpress printing were enjoying a subtle renaissance that was felt in both the design and art worlds. Often promoted as affordable "art for the people," limited-edition prints became collectibles and showcased some of the edgiest design of the day. As letterpress gained a newfound appreciation and became sought after by retail shops and crafters alike, it still more or less stood on its commercial heels, never too far removed from the iconic path laid out by Hatch Show Print and the like. Screen printing, however, was becoming a bit of an unruly beast. It was quickly adopted as the avenue of choice for outsider artists to make their mark, as the Art Chantrys and Frank Koziks found their already-wild design work joined by people like Ron Liberti, who seemed to sloppily spill and splatter creativity and inspiration out wherever they went.

A juggernaut generation of designers came to the forefront, cutting their teeth on screen printing with intoxicating relish. Theater posters from the likes of Dave Plunkert and Paul Sahre signaled that today's kids could rival the Polish masters when it came to dramatic interpretation, and do so on a shoestring budget. Modern Dog picked up Sister Corita's cause, but with an off-center sense of humor. Jeff Kleinsmith grew out of his punk rock flyer days into something altogether more interesting and abstract. Martin Woodtli made sense of Pop Art and detailed information graphics in the way only the Swiss can.

Gallery shows from esteemed institutions, down to the local coffeehouse, soon began to feature curated collections of prints. Even more frequently, international invitationals would see the majority of their entries as screen prints, dominating the design scene from Mexico to Iran to Russia. The world would join hands to help fund recovery efforts for the aftermath of Hurricane Katrina, with many

of the art prints submitted for sale coming from the screen printing world, mine included. This would inspire similar heartwarming forays into finding some way to reach out to those suffering from disaster and devastation from Haiti to Japan.

As the pool of contributors to the small-press scene exploded, the level of work became inconsistent, and at times, mannered. It was never more important to have the thrust of the firebrands driving everyone to push themselves to new heights, to experiment and grow, and challenge themselves to improve with every project. I found myself looking toward the most reluctant of leaders.

Combining design roots and discipline with a wild outsider streak, a love of cheap materials, and a desire to make work twenty-four hours a day, Montreal duo Seripop seemed to personify everything that was amazing in the screen printing world at the time. Taking the gig-poster world by storm in the early 2000s, Yannick Desranleau and Chloe Lum churned out posters on the hour. Fueled by house paint for ink and razor-thin paper, each one was even more incredible than the last. It quickly grew into a staggering body of work that left jaws permanently glued to the floor and the rest of the design world wondering how in the hell they came up with this stuff. That this outrageous imagery and impenetrable typography bathed in brash colors come from two of the most quiet people with crazy haircuts you will ever meet, seemed almost too perfect.

As the years moved on, a larger question begged for an answer: Where do they go from here?

Where others would dabble in art prints and gallery shows, Seripop committed full time to making art. Focusing their effort only on exhibitions and installations, they left gig posters and illustration behind and started thinking big, really big. Unsatisfied with the same old tired notion of throwing a print in a frame and hanging it on the wall, they began creating enormous projects with massive dimensional footprints. That they did so while relying

"THE HARDEST THING FOR ANYONE PRODUCING PRINTS LIKE THIS IS TO MAKE THE BUSINESS SUSTAINABLE AND TO STAND OUT AS AN INDIVIDUAL. SO MANY THINGS OUT THERE LOOK THE SAME NOW. IT WAS A BIG INFLUENCE IN PUSHING ME TO HIGHLIGHT MY ILLUSTRATION SKILLS IN MY WORK AND NOT APPROACH THINGS STRICTLY LIKE ANY OTHER DESIGNER. I THINK IT IS PRETTY EASY TO SPOT WHEN OBVIOUS CARE HAS BEEN TAKEN FROM CONCEPT TO FINISHED PIECE, AND MY PERSONAL HEROES IN DESIGN HAVE LIFETIME CAREERS BECAUSE OF THEIR GENUINE LOVE OF THE CRAFT."

—Frida Clements

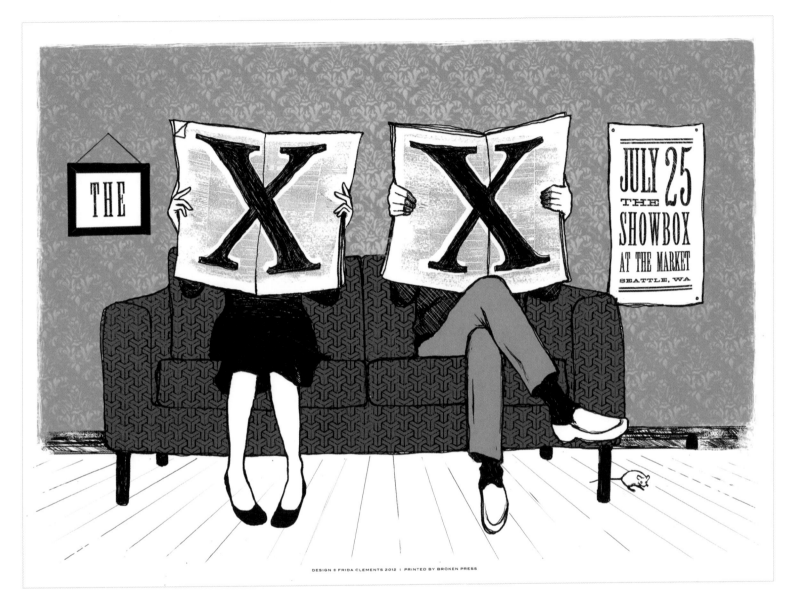

Title: *The XX*

Designer: Frida Clements

Size: 18 x 24 inches [45.7 x 61 cm]

Printing Process: Screen print

Number of Inks: Three

on a limited page size, and never once skimping on the number of inks that they are willing to put into play, proves that there may be a touch of madness underneath those haircuts.

Working in much the same way that they always have, they print traditional sheets, sometimes hundreds and hundreds of sheets, and on some occasions, even more. They layer the color on in streaks and patterns, and then they stack them up high in their studio, assembling inky workers for the construction to come. It's all in what they do once the prints are done that amazes. They build numerous shapes from sheets, cones, blocks, and so on to make the larger formations that morph into columns and creatures, creating something massive from just a single sheet of paper and some house paint and a press that they operate by hand.

Seripop have always been fascinated with the here-and-gone quality of gig posters. In part, knowing that last week's work was going to be weather beaten and torn off some wall or pole drove them to replace it with something new and better. It was a brutal, if rewarding, cycle. They would more than take it in stride, instead reveling in the constant breakdown and disappearance of what they had put out there. This feeling would fuel some of their most brilliant investigations. Creating various installations that are dependent on the erosion of the materials, they wrapped full buildings in prints and covered shopping mall floors, sitting by the side as the elements of hustling footsteps thrashed at their creation, turning it into a new piece altogether at the close of every day.

In taking the medium that Warhol had elevated to vaunted gallery walls and outlandish auction prices and placing it underfoot for consumers to literally tear to pieces, they had truly taken screen printing and returned it to the people in the most inventive way imaginable. From glamorized, eye-burning color representations of celebrities to something that goes unnoticed only to grow into an ugly irritant brings us full circle in fifty years of brilliance. One can only wait eagerly to see where we go from here.

BUSINESS EXPANSION AND EVOLUTION

The wild explosion in small-press printing in the 1990s came as quite a surprise, even to those who were long-time practitioners. The Internet exposed not only the existence of what had long been the province of a few people in every city, but it also alerted a hungry public that these prints could be had, often for very little money. Soon a global marketplace opened up, and what had been a labor of love, or freelance work that paid a pittance, became a viable side business for designers and for those willing to pull the prints themselves, a full-on vocation.

As small-press printing grew into a cottage industry of its own, many print mavens were able to carve a niche and form sustainable businesses. It remained an odd balance, as any structure built on limited-edition runs means that you are only as good as your last design, and a built-in inability to maximize profits on your most popular products is the ultimate vise on runaway success. Figuring out ways to pay the rent, while also maintaining the reputation needed to succeed in a small market, and scratching your creative itch at every turn, took some inventive thinking. For some, it meant that they leveraged their exposure from their prints into jobs in related creative fields, from editorial illustration to making vinyl toys. Others licensed their images to broader commercial products, like the quirky boutique ware from Blue Q. Others went aggressively in the opposite direction and sought out grants to create even larger works of art or manufactured numerous prints to keep a constant stream of revenue flowing. A few hardy souls took up the challenge of opening up storefronts, needing to not only stock the shelves with their work but also man the till and sweep up every night.

Letterpress stalwarts like Yee Haw Industries and Hammerpress saw their work have a big impact at the retail level. Yee Haw opened up a storefront in Knoxville, where Julie Belcher and Kevin Bradley quickly became part of the local fabric and flavor, with work playing up a regional bent, as well as a sly commentary on politics every now and again. Everything from massive posters to tiny cards had their

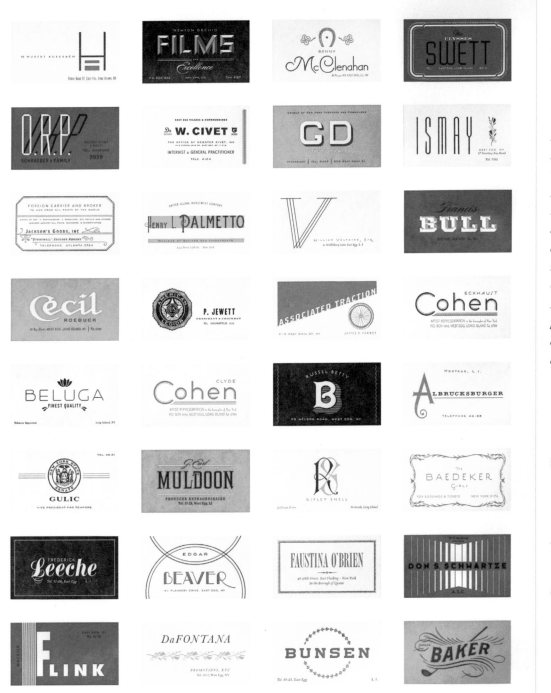

Title: *Gatsby Poster*

Designer: The Heads of State

Size: 18 x 24 inches [45.7 x 61 cm]

Printing Process: Letterpress

Number of Inks: Four

Explaining that chapter four of F. Scott Fitzgerald's The Great Gatsby *reads like "a VIP guest list of the Jazz Age," Jason Kernevich and Dusty Summers set out to "take inspiration from those pages" and create a poster filled with business cards and personal stationery, "from the movers and shakers that attended Gatsby's parties in the summer of 1922." Lending an authentic feel is "listed professions, story-specific addresses, old-time telephone exchanges, and a cameo card from a main character."*

NOTE: Celebrating a literary masterpiece along with the joys of nearly 100 years of letterpress printed business cards, The Heads of State created a unique print from multiple perspectives that appeals to many audiences.

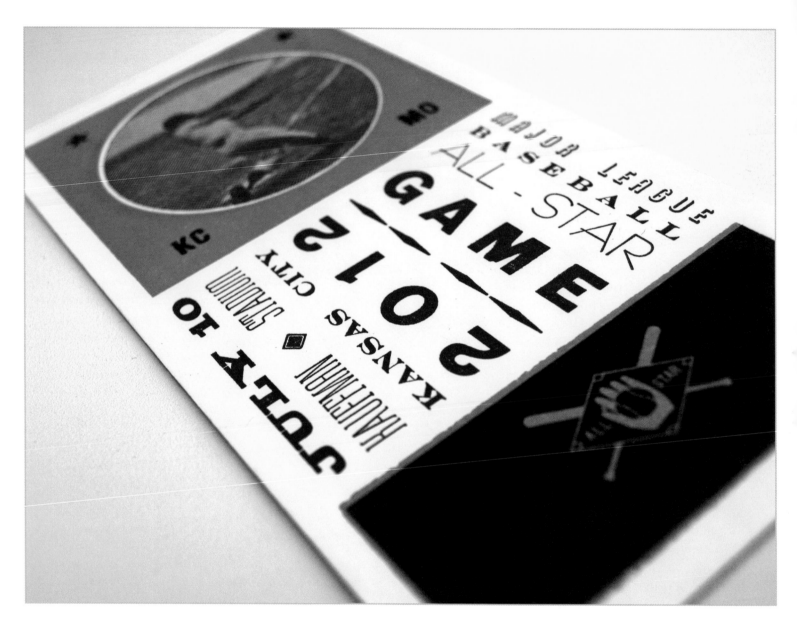

Title: *Major League Baseball All-Star Game*

Designer: Brady Vest/Hammerpress

Size: 3.75 x 7.75 inches [9.5 x 19.7 cm]

Printing Process: Letterpress

Number of Inks: Four

personality running through them, as often did their primitive-styled figures and illustrations carved out of blocks for a pass through the press. (Yee Haw Industries would close their doors late in 2012 and splinter into Pioneer House [Julie Belcher] and Church of Type [Kevin Bradley]).

Hammerpress found widespread distribution for their high-end greeting cards and gift tags at stationery shops around the country. As a proliferation of such operations sprouted up in more affluent areas, their work was often at the forefront. (They would eventually take the plunge themselves and add to the print shop a storefront for sales.) Playing the press like a symphony, adding a piece here and there and layering inks and shapes and type until they all sing together in sweet harmony, they created a continuous stream of gorgeous and tactile products that could be depended on for sales, reinventing things as simple as a thank-you card. Adding to the workload of letterpress operators everywhere was a return to custom invitations for events, and weddings in particular. Not only did this ensure steady work (even if it was hopefully a one-time-only job for each bridal client!) but the reason that people were searching out this type of printing for their special day was because of the incredible work already on display, so it was often surprisingly fulfilling on the creative side. Yee Haw would famously print over 50,000 invites to a Ralph Lauren store opening, and Hammerpress ran beautiful little handbills for the recent Major League Baseball All-Star Game in their hometown of Kansas City.

The gig-poster phenomenon took hold in a big way, and for the first time, possibly ever, kids graduated from design school thinking that making posters and operating a small press could actually be a viable career path, something unimaginable up until that point. The increased interest served to create more opportunities than ever before. The annual gig-poster gathering centered on the South by Southwest (SXSW) convention and music festival known as Flatstock quickly grew into multiple events each year around various music fests, drawing thousands of buyers and connecting the poster designers directly with their audience. It now includes international events as well. It is an amazing feeling to see all of these people concentrated in one huge convention hall, and that is only a small sliver of the folks actually practicing in the gig-poster field.

Another interesting development happened in the gig-poster arena, as poster series based on a single musical artist became wise business and introduced an element of direct competition, forcing everyone involved to up their design and printing game, lest they be shown up by their peers. Giving a limited number of superfans the chance to show their dedication by owning an exclusive poster from a massive show attended by thousands, Pearl Jam and Ames Bros perfected the formula early on, one that would be continued until today with folks like Dave Matthews Band and Methane Studios, and has even created fun pairings like No Doubt and Dirk Fowler. It was and is easy pickings to move fifty to two hundred posters with dedicated fans and enormous venues. Promoters saw the possibilities in lower-tiered acts as well, but they made one crucial change: inviting a different designer to take on each city, creating a parade of stellar posters all centered on their cross-country tour.

This has a tremendous upside, as each designer will then promote the tour and the artist playing to their own audience, and in return, the fans of that act will look to snap up prints from shows in addition to the one that they attended. It has been played out with acts all over the map, from Canadian power pop maestro AC Newman, to Memphis country punks Lucero, and everything in between. The series that all are measured against, however, is the one that drapes the sludge merchants known as the Melvins. Much like an Academy Award nomination, it is an honor just to be asked to be a part of the series. Bringing out some of the most adventurous designs that many gig-poster heavyweights have ever produced, you know that you will be left in the dust if you don't bring your best stuff to the table. No one wants to have to compete with a giant exploding penis laying waste to a phalanx of soldiers (via the iconic poster by Jeff Kleinsmith) without at least giving it their best effort.

Huge events like the Sasquatch! music festival would curate their own version of these series, assigning a different designer to each band on the bill, from top to bottom. Taking a cue from this scene, movie houses would commission many of the same designers to take a whack at creating a new poster for iconic films they were showing. The most well known of these is the Alamo Drafthouse in Austin, which elicited amazing pieces from the likes of Kleinsmith for *The Shining*, *The Godfather*, *Cool Hand Luke*, *The Trial*, *The Unholy Three*, and others. Jay Ryan would tackle *Sixteen Candles*, *The Breakfast Club*, and *Pretty in Pink*, to bring the Chicago/John Hughes connection full circle. The results were rivaling anything else in the field. The theater then created its own little industry with art print series around *Star Wars*, *Star Trek*, *The Warriors*, and others.

Business seemed to be chugging right along on so many fronts that it was hard to see past the next stack of paper and tin of ink awaiting your arrival at the studio. But the U.S. recession hit few things harder than small businesses. A glut of new people entering the fray, many of them not holding to the same ethics as the previous generation of gig-poster designers, combined with a reduction in available spending for the common music fan, served to narrow the slice of pie and then used it to fill twice as many plates. Small-press printing was as viable as ever, but dealing exclusively in gig posters was looking like a dangerous bet to place. Other avenues like Etsy and craft fairs seemed to be calling to fill some of the void, but a change in places to sell the wares clearly wasn't the only answer.

Then creatives did what creatives do best—they solved a problem in ways unique to them and their situation. Staying true to their style and mode of working, they saw other opportunities to spread their inky joy around the world. Print Mafia created a barrage of art prints around pop culture icons, all of them amazing as much for the way they assemble them and lay ink on paper as for the images on them. Aesthetic Apparatus took their dark energy and funneled it into a sly series of art prints around a graphic "doom drip." They then harnessed their midwestern humor and created several fun art prints and products, highlighted by their satirical "Sorry We're" series of signs. Admitting that they might well be "commercially useless" to a business, they stress the appeal of such an Open/Closed sign for those "not really into categorizing your availability." Pure genius, and a product that they can sell endlessly.

Many others ventured into the art-print territory with vigor, such as Jay Ryan with his charming series of prints detailing the many adventures his old stand-alone garage in the backyard had undertaken. In many ways, breaking down the barriers needed with a client allows the audience to embrace the designer for every aspect of their personality: their style of illustration, the way they print, and often their sense of humor. It leads us down the path toward the future, where the consumer can connect in a very genuine way with the creator, something that art and design created by hand can do like no other.

LINEAGE/HISTORICAL

From the earliest civilizations, we have always needed to print materials and communications as a way to capture our thoughts and feelings, and this remains the foundation for everything that has ever found its way to a press. Small-press printing has occasionally stepped out of the fast lane of modernization and reappeared when we needed it most. In a lot of ways, it feels like we are smack-dab in the middle of one of those periods now. Print media in general has come under an unending assault from various forms of digital communication, and the victims lie helpless at the roadside. Surely half the world has given up on the idea of ordering more stationery anytime soon.

But that is where small-press printing comes to the rescue. At the very beginning of the mastery of printing, the first goal was always quantity, with an emphasis on quality after the fact. The race was on to make as many editions of something, at the lowest cost and the quickest turnaround possible. Right from the start, small presses,

and what amounts to letterpresses, were employed for special projects and manned by experts crafting gold-foiled religious documents and doctrines. That got lost in the shuffle when screen printing was developed for commercial purposes. Again, it was a case of cost savings and the speed with which to repeat a simple stencil. Luckily, it was reclaimed by the sturdy hands of a more aesthetically inclined workforce, and now both forms of printing are used to operate as difference makers in the marketplace. Less stationery is being produced, but the stationery printed on a letterpress stands well above the pack and signifies someone of import and with style.

The same is true of the poster. Serving for so long as the large-and-in-charge workhorse of promotion, it was eliminated from the marketplace with startling speed as e-mail became the preferred form of digital hustling for those rounding up crowds. Yet it quickly found a home in the studios of small-press operators and returned in a more nimble form. Having done away with more than half of the posters that used to find their way to the walls around us, we now have a much more appealing selection. If something finds itself on a poster, it is usually worth our time to see what it is, and the level of design and collectibility are now through the roof.

It turns out that even in a digital golden age, we still need print. As has always been the case through cycles of innovation, we just need print that matters.

PRINTING COMMUNITY

Few communities are as tight as the small-press community. It is funny how it has evolved. Previously, all of these people operated in their own little local bubble. You might have known about an Art Chantry or the like, but prior to the Internet explosion, that was as far as it went. You knew the small handful of people in your town that owned and operated similar presses, and maybe you had a person in common at the local art supply shop or a paper vendor, but your contact with anyone else dealing with

the same problems as you on a daily basis was nonexistent. Challenging visual inspiration came from books and magazines that were most likely showcasing work that was over a year old.

I know it is overstating the obvious, but the Internet changed everything. As you now had a chance to see what was being created simultaneously in Chicago, Austin, Seattle, Minneapolis, and Chapel Hill, you also had the chance to connect with people in those cities to compare paper stocks, ink merchants, squeegee quality, and mesh count. It could take years to hunt down a tray of metal type, but now, not only could you find it (surprisingly often in your own backyard), but you also had all of your other printmaking friends on the lookout for you, sending along links and letting you know how the price compared.

Just having a receptive voice on the other side of an e-mail that could relate to everything you were struggling with, whether equipment related, or moaning about an evil client, shipping company, or vendor, or just trying to get through the day-to-day battle with your own creativity, meant the world. It also accelerated everyone's work at warp speed. Now you could see who you were jockeying with in real time, and know that your work had to always be evolving, or you had to really refine your style and own your part of the marketplace. It also meant that everyone had access to discussions on experimental printing techniques and general troubleshooting and could spend more time advancing their skills on press than dealing with the inherent quirks that used to feel like insurmountable mountains.

All of this served to bond the various personalities together. There may only be five people in a city on the other side of the country that really understand what I am doing on a day-to-day basis, but they are my people, and I will defend them and cherish them forever. Few people are as vocationally misunderstood as the designers and artists that take up small-press printing, and few

populations of creatives are as peppered with introverts and wallflowers as this group as well, so being able to connect with others just like them was priceless.

Once these like-minded souls started to gather physically, either through the American Poster Institute and its Flatstock events or large-scale weekends like the Renegade Craft Fair, the knowing looks shared while unloading heavy boxes of prints and constructing their booths, combined with tales of youthful indiscretions over beers once the customers had gone home for the night, tied them together forever. Once they all returned to their separate corners of the world, the community just continued on unabated online, until the next event where they would do it all again.

Like any "family," there is backbiting and catty behavior, and a few people have nearly upset the whole thing by brazenly stealing imagery from other printmakers (as if the Internet won't eventually catch you . . .), but in the end, it is okay to criticize one of your own, while anyone from the outside will be met with collective venom. Brothers and sisters forever.

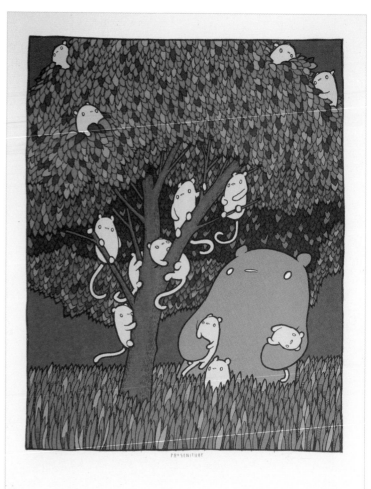

Title: *Progeniture*

Designer: Jay Ryan/The Bird Machine, Inc.

Size: 18 x 24 inches [45.7 x 61 cm]

Printing Process: Screen print

Number of Inks: Six

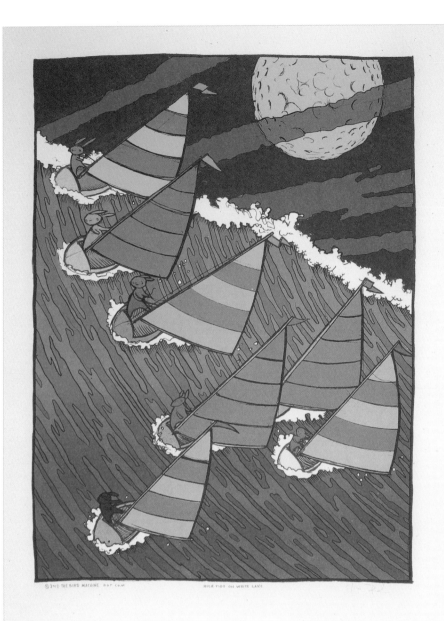

Title: *High Tide at White Lake*

Designer: Jay Ryan/The Bird Machine, Inc.

Size: 18 x 24 inches [45.7 x 61 cm]

Printing Process: Screen print

Number of Inks: Six

NOTE: Ryan's work is not only unique based on his hand-drawn images and type but also in the color palette that he chooses, creating a world that seems to be solely his, yet is always inviting.

"At The Bird Machine, we have two cameo 30 semiauto presses and one hand-pulling station," explains Ryan. "We have a couple dozen reasonably large aluminum screens, all at 230 mesh, and we use Ulano QTX photo emulsion exposed on a homemade exposure unit. All screens are washed out in a found bathtub, which we installed as a spray-out booth. The shop is all speedball acrylic inks, which we mix out of gallons, and we use French brand paper for almost everything." He smiles before adding that they also have "a weak-ass container garden out behind the shop, some skylights, and a good furnace/air conditioner unit."

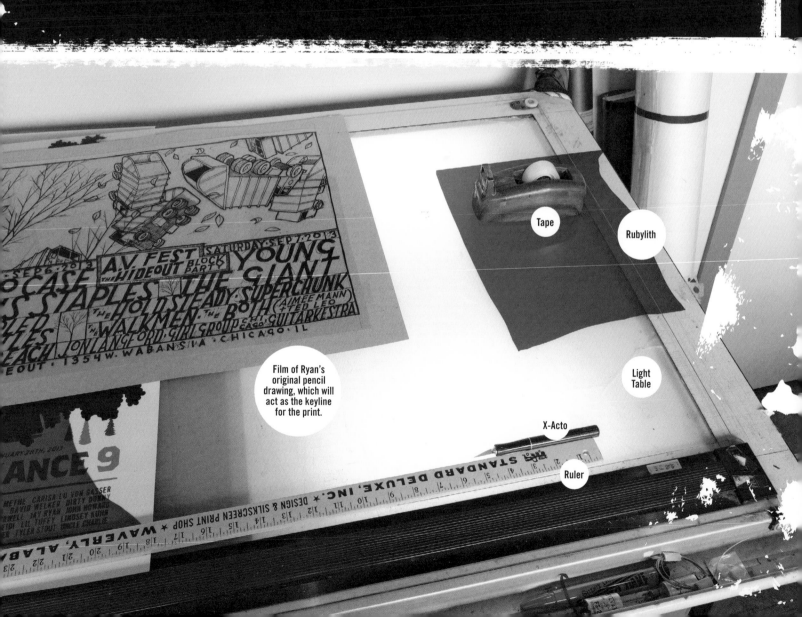

Tape

Rubylith

Light Table

Film of Ryan's original pencil drawing, which will act as the keyline for the print.

X-Acto

Ruler

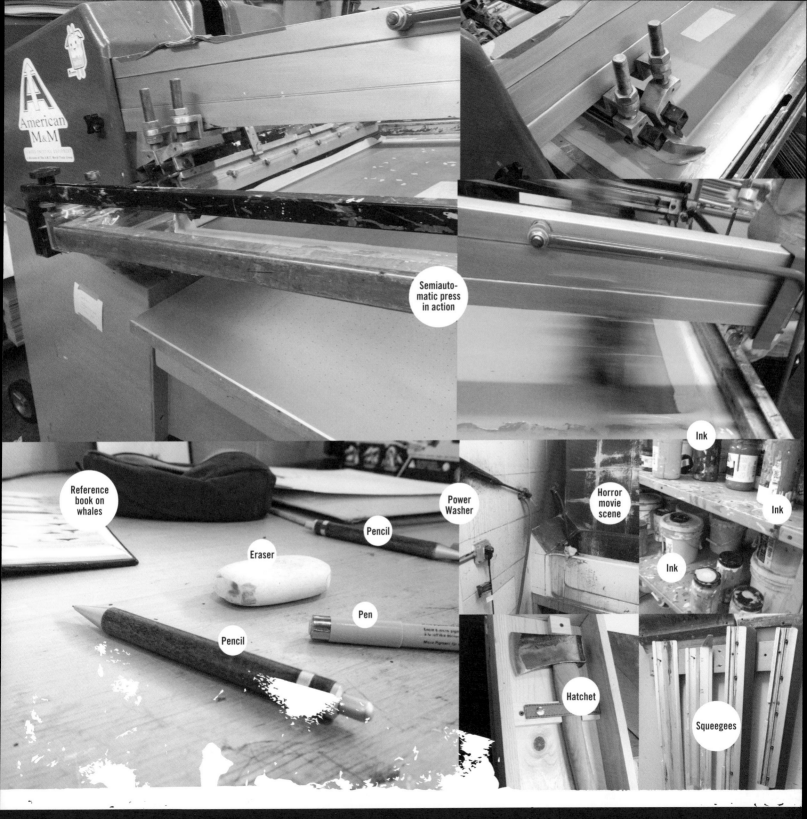

JAY RYAN/THE BIRD MACHINE: THE GARAGE SUITE

Finding concern with the state of the "small structure behind our house that is used to shelter automobiles, which, in the time-honored American tradition is called a garage, and was alas, never built correctly, even when it was new, in 1960," designer Jay Ryan had to assess whether it could be salvaged following the pounding of "Chicago's remarkable weather extremes, and a slow losing battle with gravity, which we all fight during the course of our lives." Recent years had seen the garage become a host to "various flora and fauna, such as raccoons, stray cats, and thriving moss and lichen colonies." Ryan was not hopeful. Determining that it would ultimately have to come down, and unable to cover the cost of rebuilding it, he had to come up with a manner in which to raise the funds. A plan came into place, creating a limited-edition series of prints "commemorating some of the finer moments in our garage's history" that would ultimately allow the creaky hulk to pay its own way. Ryan even went so far as to provide an opportunity to "purchase the prints at an actual garage sale, in the actual garage depicted in the collection," though he cautioned that they would also be selling "T-shirts, books, and old shoes," and begged for "no early birds, and no crazy people."

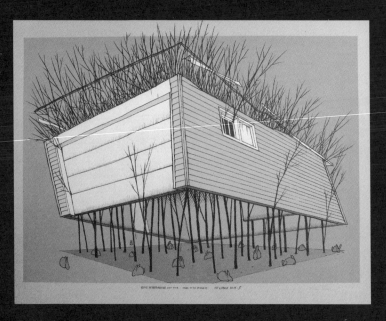

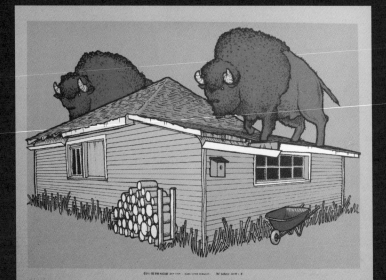

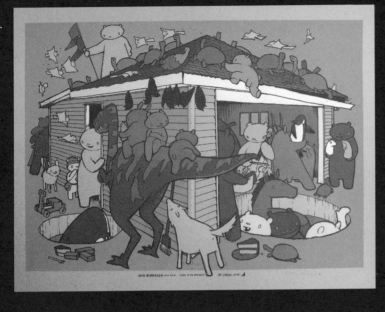

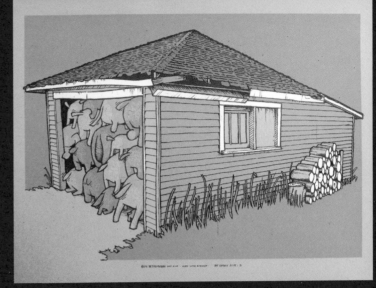

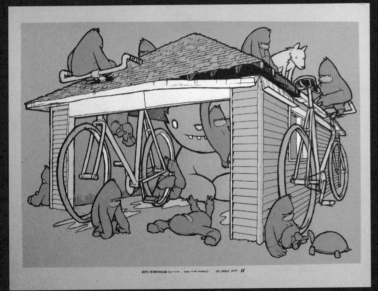

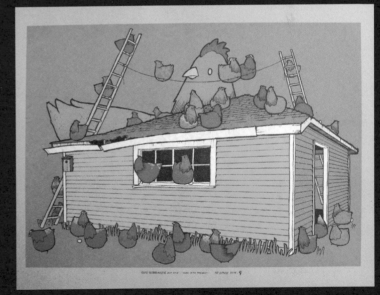

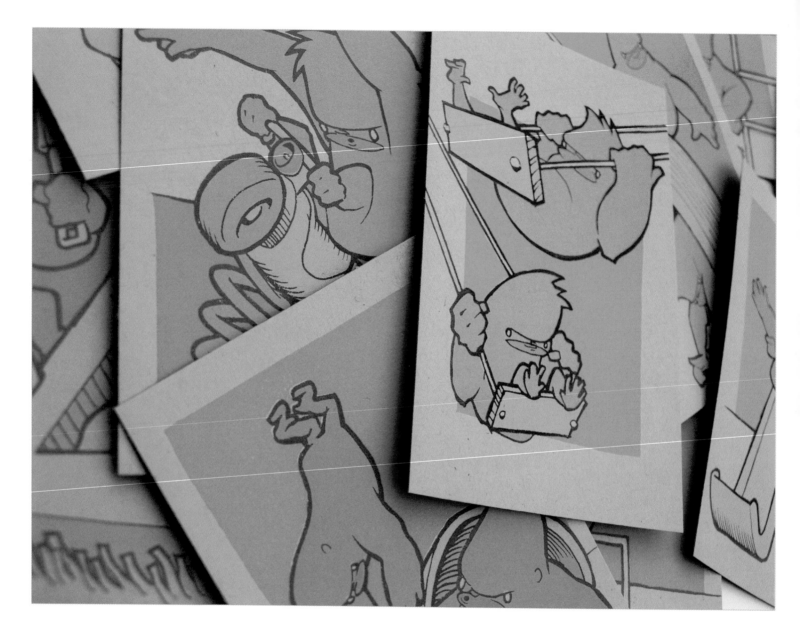

Title: *Gorillas at the Playground*

Designer: Jay Ryan/The Bird Machine, Inc.

Size: 4 x 6 inches [10.2 x 15.2 cm]

Printing Process: Screen print

Number of Inks: Four

NOTE: One of the ways to maximize the profitability of a sheet is to print multiple pieces at a time, such as these fun and witty card sets that were printed on a full-size sheet.

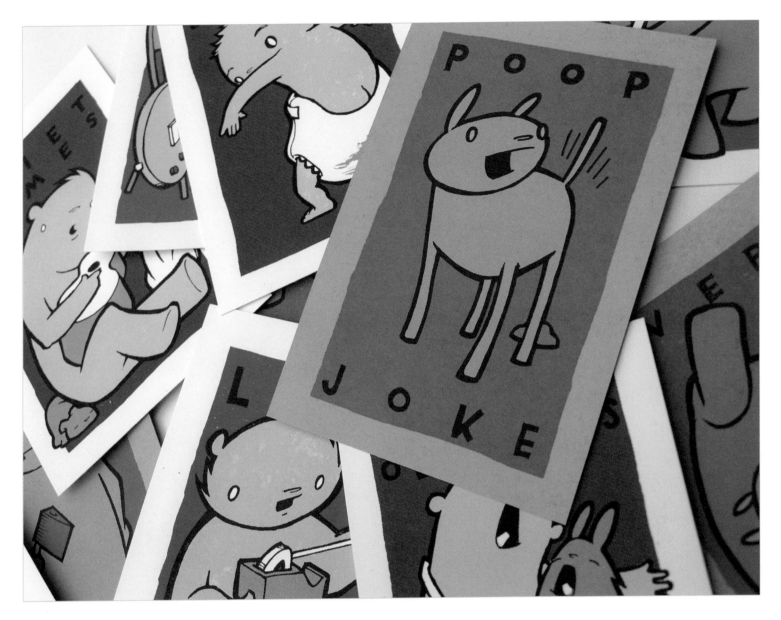

Title: *2012 Postcard Set*

Designer: Jay Ryan/The Bird Machine, Inc.

Size: 4 x 6 inches [10.2 x 15.2 cm]

Printing Process: Screen print

Number of Inks: Three

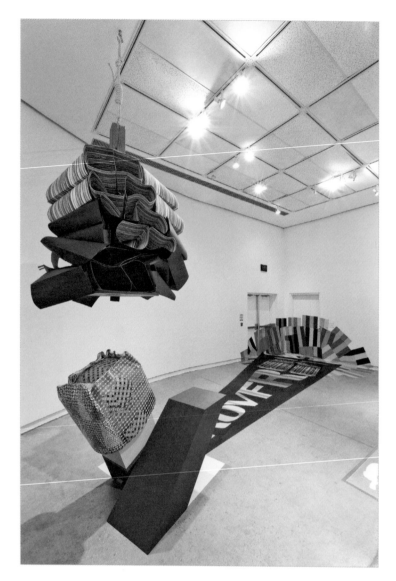

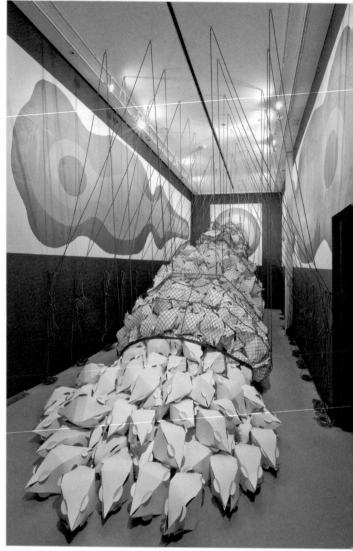

Title: *More Time Than Space*

Designer: Seripop: Yannick Desranleau and Chloe Lum

Size: 15 x 23 inches [38.1 x 58.4 cm]

Printing Process: Screen print

Number of Inks: Various

Photo by Toni Hafkenscheid

Title: *What Should Have Been and What Would Not*

Designer: Seripop: Yannick Desranleau and Chloe Lum

Size: 15 x 23 inches [38.1 x 58.4 cm]

Printing Process: Screen print

Number of Inks: Four

Photo by Toni Hafkenscheid

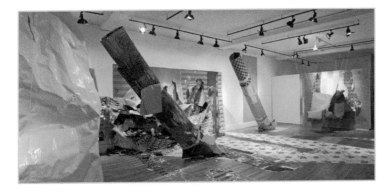

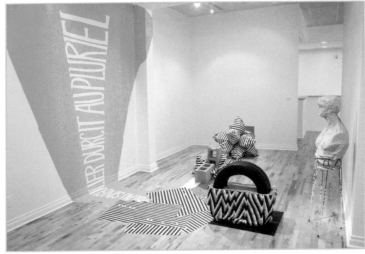

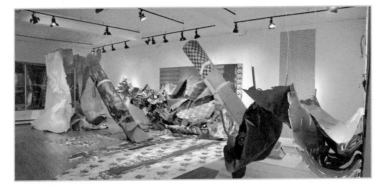

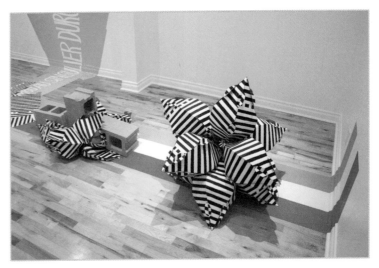

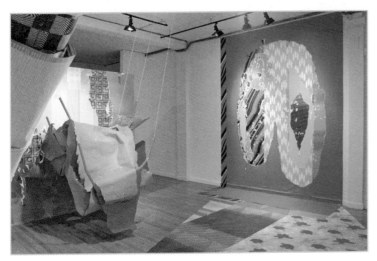

Title: *About Charles Taylor*

Designer: Seripop: Yannick Desranleau and Chloe Lum

Size: Various

Printing Process: Screen print

Number of Inks: Eleven

Title: *Uncountable (Not Comparable)*

Designer: Seripop: Yannick Desranleau and Chloe Lum

Size: Various

Printing Process: Screen print

Number of Inks: Seventy

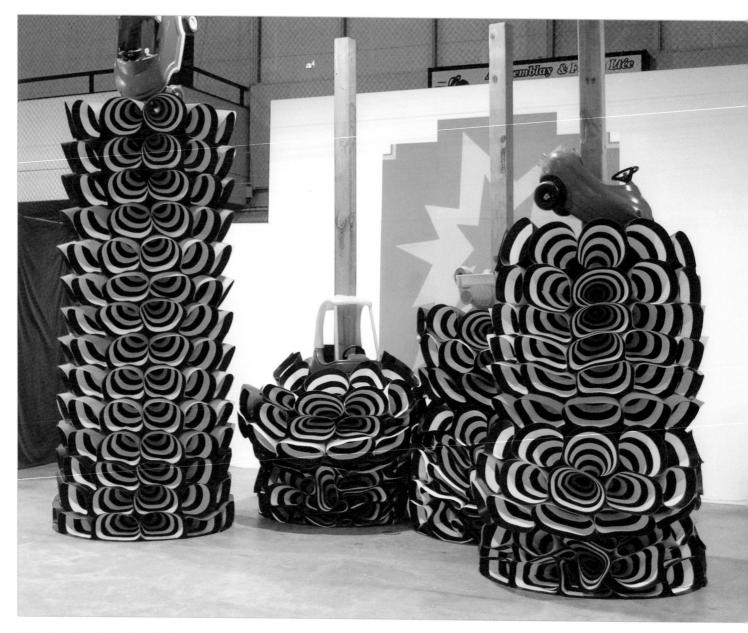

Title: *You Should Be Able To Read It From 30 Feet Away In A Car Going At 50 km/h*

Designer: Seripop: Yannick Desranleau and Chloe Lum

Size: Various

Printing Process: Screen print

Number of Inks: Various

Photo by Toni Hafkenscheid

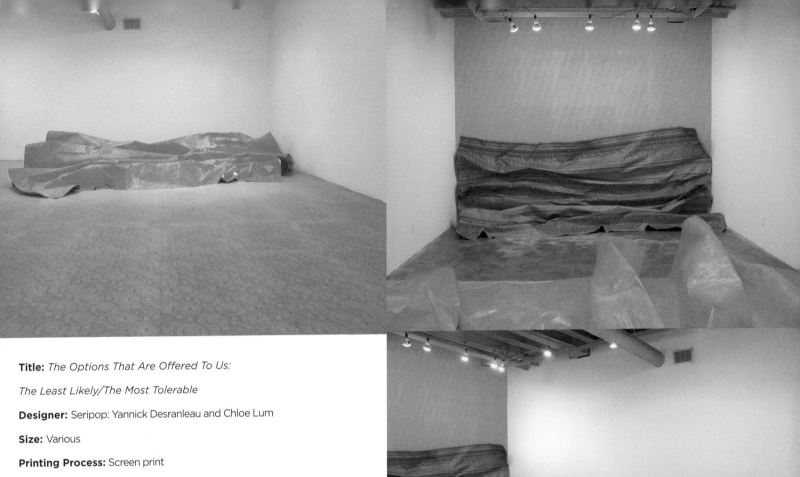

Title: *The Options That Are Offered To Us:*

The Least Likely/The Most Tolerable

Designer: Seripop: Yannick Desranleau and Chloe Lum

Size: Various

Printing Process: Screen print

Number of Inks: Thirteen

NOTE: Seripop prints based on the size restrictions of its largest press, so the art installations may ultimately be assembled from thousands of individual prints forming a greater whole.

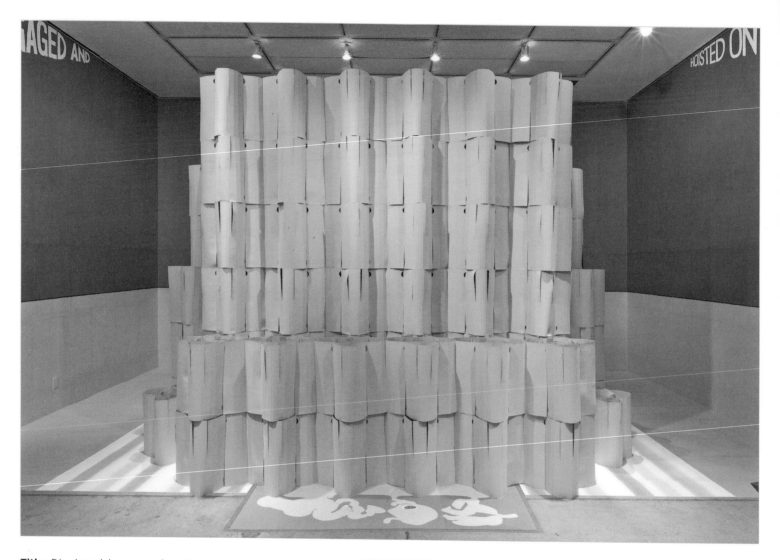

Title: *Dis-donc à la grosse de se tasser*

Designer: Seripop: Yannick Desranleau and Chloe Lum

Size: Various

Printing Process: Screen print

Number of Inks: Various

Photo by Toni Hafkenscheid

Title: *Avancez en arrière*

Designer: Seripop: Yannick Desranleau and Chloe Lum

Size: Various

Printing Process: Screen print

Number of Inks: Eight

NOTE: While many artists hope to see their prints live well past their lifetimes, Seripop has taken its celebration of the temporary existence of its work to extremes and turned it into a strength.

CLOSING

The small-press world is a pretty incredible place—one in which you can find a print that shows everyone who your favorite band is, one in which you own a piece of art that speaks to your soul, one that welcomes a visitor into your home or brightens your office, one in which you form a link to a lineage that goes all the way back to the very first printed page. It is also a place where you can support a vital creative community that has long operated as the incubator for some of biggest talents in both the art and design fields. You can reward those who take chances, those who turn the world upside down, and those who create single sheets of pure, unadulterated beauty. You can reward yourself with a connection and bond formed through the printed page—one that can never be broken.

close-up of a print by Jay Ryan/The Bird Machine Inc.

SOMETIMES, THE ESSENTIAL TOOL THAT MAKES A PRINTED PIECE TRULY UNIQUE AND SPECIAL IS SO OBVIOUS THAT IT CAN BE OVERLOOKED. "I THINK THE PENCIL AND PAPER WITH WHICH I START EACH PROJECT ARE DEFINITELY THE MOST VALUABLE TOOLS FOR ME, AND MY WAY OF WORKING," EXPLAINS RYAN. "THEY KEEP ME IN DIRECT CONTACT (LITERALLY AND FIGURATIVELY) WITH THE IMAGE, AND I DON'T KNOW THAT MY WORK WOULD LOOK LIKE IT DOES IF I STARTED WITH A DIFFERENT SET OF TOOLS."

It is a place where everything is made by hand, and you get what that entails. Sometimes, it means there are little bits of pain and frustration in every pull, combined with undying devotion and love. It is all there before you, a lifetime of work and struggle and joy, in one single sheet of paper.

Looking down on something like Anthony Dihle's Riverbreaks poster, created through screen printing on found newspapers and then block printing on top of that, just makes me smile. I want to travel to every city in the Heads of State Travel Series. As my two fingers feebly peck out the words for this book, I have been staring at some of the intricate patterns formed by the overlapping shapes and colors on various Hammerpress prints and cards and getting dizzy with joy. I am determined to bring back various paper stocks into my projects. I want to send everyone a Jay Ryan gorilla card, and I want to drink beers with Geoff Peveto and Gary Baseman and then pour the last gulp into the ink. I want a room that is covered from head to toe in Frida Clements's little Swedish horse, and I want to sit in the middle of it and read Greg Pizzoli's *Klip Klop*.

More importantly, I want all of you to do that as well, and so much more. For an astonishingly small amount of money, you can have a true piece of the very soul of these amazing artists. It is not so much a sales pitch as it is a required experience. There is magic in that ink and happiness in that paper. There just is.

CALL TO ACTION

I hope that there has been a little something for everyone here. A novice can get a top-to-bottom introduction, and maybe a master in the field can still find some inspiration; I know I have been trying to figure out how Seripop and Sonnenzimmer make these jawdroppers for well over a decade now, with absolutely no success. But more importantly, I hope this makes you dive in and get your hands a little dirty and try some screen printing on your own or take a letterpress class and find out where your muse takes you. If you have done a few prints using other printers, maybe now is the time to give it a go on your own; if you have been printing for ages, you might try a little twist or turn picked up in these pages. If you have never made a print of your own or experienced the joy of creating something special and unique, yet you can see the joy in a small stack of prints, each one just a tiny bit different from the others, to give out as gifts or to kick-start your business or event, what are you waiting for?

You will never look back once you have that sheet in your hands, marveling at the ink gripping the page. You made something. Something special. Something amazing. Something from you and only you.

INDEX

"I FELL IN LOVE WITH LETTERPRESS ABOUT FIFTEEN YEARS AGO, FOLLOWING A VISIT TO HATCH SHOW PRINT IN NASHVILLE. I KNEW INSTANTLY AFTER SEEING THE PROCESS THAT IT WAS WHAT I WAS MEANT TO DO. I LOVE THE TACTILE QUALITY, THE FACT THAT YOU CAN SEE AND FEEL THE PRINTING. I ALSO LOVE THAT IT FORCES ME TO KEEP MY DESIGNS SIMPLE."

—*Dirk Fowler, f2 Design*

ACKNOWLEDGMENTS

For anyone that has ever taken the time to read all the way to the back page of one of my books (stand up, Mom and Dad) you know that you have to nearly die to be listed at the top of the acknowledgments. Hey, it is a crowded field, and something has to single the chosen ones out. Honestly, I am starting to think that if I stop writing books, people in my life will stop needing to be in this section. A good chunk of this tome was written via my expert two-finger typing system in a hospital intensive care unit waiting room. For my liking, far too much of it was. Amazingly, following heart surgery that did not go well, my stepfather scared all of us for a few weeks and then started the steady climb to recovery, and now he is as well as he was before the surgery, which is a miracle in and of itself.

Soon after the end of that hospital stay, hoping to jettison "intensive care" from my vocabulary for as long as I could, I received a jarring phone call that one of my very best friends was being monitored in emergency care in Pittsburgh, having just suffered a stroke. Rich Westbrook is not just my college and postcollege roommate; partner in hijinks and shenanigans; the person who gave me my first real design job and helped me on the road to growing up; and one of the sweetest people you will ever meet—he is the embodiment of all that is right in the world to me. When I think of what a truly "good" person is, I think of Rich. I couldn't love that guy any more than I do, and I couldn't fathom anything bad ever happening to him. It seemed like a supreme injustice that he should ever know any pain or face his own mortality. I have never felt a weight lifted quite like the one that passed when I finally spoke to him in the hospital, falling back into our old banter and inside jokes. Most of the effects have faded away, though his vision might still be a little wacky in one eye. Perhaps it will help his designs. As I am typing this, he is off to a father/daughter dance, and I am tearing up like a big sissy. Thank God he is around to tease me about it when he reads this.

Nearly every word I have ever written on design that was worth reading would not have been possible without the vision and dedication of the wonderful folks at Rockport. They deserve far more than a kind word here, so be forewarned that you all have a ridiculously sloppy kiss awaiting you. Winnie Prentiss and her leadership; Emily Potts and her ability to make me laugh, blush, contemplate my morals and values, smile nonstop, and somehow work harder each day; Regina Grenier for her kindness and joy in swapping dog tales and high fives and for occasionally standing up for me, even if I didn't know that I needed her to; David Martinell, who always makes me smile with his unflappable nature; Betsy Gammons and her wisecracks and whip cracks; Cora Hawks for doing so much behind the scenes, and so many others—I adore you all.

Thanks to my enormous and ever-growing family, especially my wife, Suzanne, and amazing daughter, Lily! Love those girls to bits. To both sets of my parents, all of my brothers and sisters (nine of us blended altogether, the last time that I counted), James Nicholls, who is the one person I talk to every day, Clive Solomon, Michael Loveless, Daniel Early, Alex Hornsby, Lucy Hurst, Eva O'Reilly, Mark Harwood, and all at Fire Records. My old friends Bill Vierbuchen, Dave Bradbury, Chad Lafley, and many more I am forgetting. Svetlana Legetic, Cale Charney, and everyone at BYT. And last, but certainly not least, all of the girls (almost women!) that I coach on my soccer team that teach me way more than I could ever give back to them every season.

You know it is impossible to make a book like this without a cadre of talented designers and artists to draw on—so a big thank-you and too-tight hugs to everyone included in this collection. You are an inspiration.

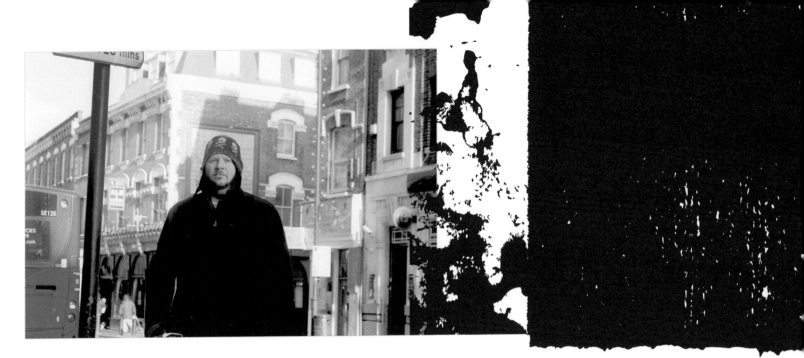

ABOUT THE AUTHOR

John Foster is a designer and writer in Washington, DC, as the principal and superintendent of Bad People Good Things LLC. He is the author of *New Masters of Poster Design* and *New Masters of Poster Design: Volume Two* (Rockport Publishers), *1,000 Indie Posters* (Rockport Publishers), *Dirty Fingernails: A One-of-a-Kind Collection of Graphics Uniquely Designed by Hand* (Rockport Publishers), *For Sale: Over 200 Innovative Solutions in Packaging Design* (HOW Books), *Maximum Page Design* (HOW Books), as well as a contributing author to *Thou Shall Not Use Comic Sans* (Quid/Peachpit) and *The Essential Principles of Graphic Design* (HOW), not to mention a long-rumored monograph on the work of Jeff Kleinsmith for Sub Pop Records. He writes the "Poster of the Week"

column for rockpaperink.com and "Judging a Cover by Its Cover" over at brightestyoungthings.com. He is an international speaker on design issues and has appeared several times at the world's largest design gathering, the HOW Design Conference, and was recently named the curator for the poster collection for the University of Maryland. His work has appeared in every major industry publication, and he is the proud recipient of a Gold Medal from the Art Directors Club of Metropolitan Washington and a Best in Show from the ADDYs. His work has been shown in galleries all over the globe and is also a part of the Smithsonian's permanent collection. Foster resides in Maryland with his lovely wife and daughter and three of the world's goofiest dogs.

Photo by Alex Hornsby

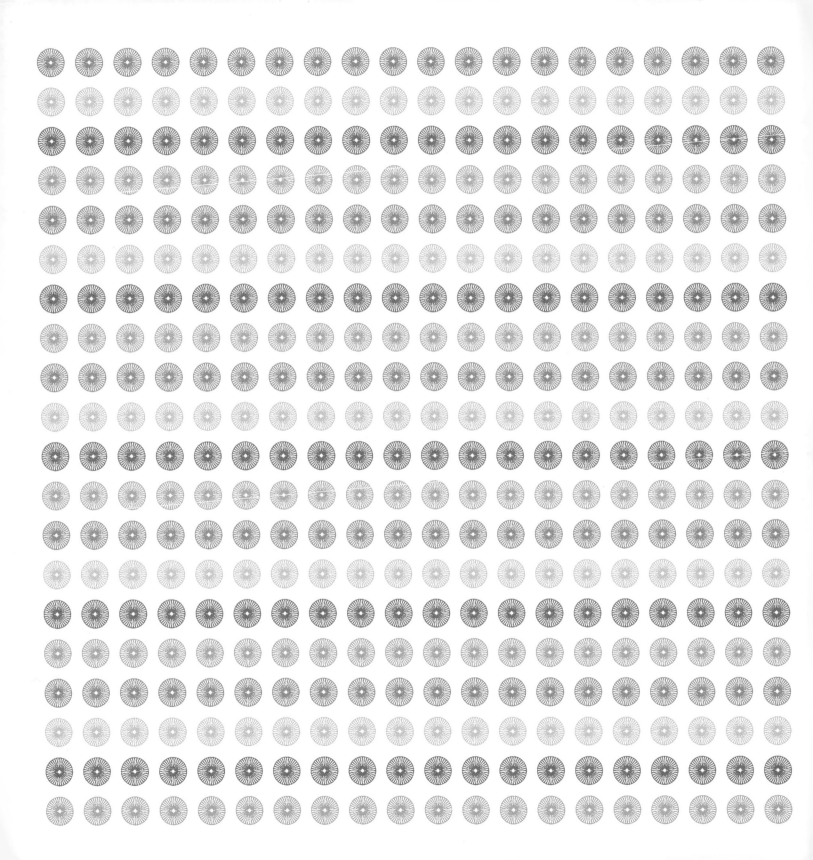

THE HENLEY COLLEGE LIBRARY